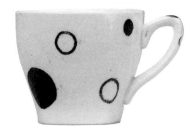

midwinter pottery

a revolution in British tableware

Steven Jenkins

Edited by Paul Atterbury

Richard Dennis 2012

To my mother, father and Nick.

Introduction

I first became aware of Midwinter in the early 1980s when I was studying illustration at college. The 1950s had been revived musically with *Grease* and in fashion during the 1970s, but the wealth of decorative art of the period had largely been ignored. Midwinter seemed to have a fresh appeal to those of us who had not lived through the Festival of Britain era and the designs were as new and exciting to us as they had been the first time around. The atomic, spiky, colourful textiles and pottery of the 1950s became the inspiration for prints, drawings and photographs in my group at college. When rifling through markets and junk stalls for the remnants of this decade, it soon became apparent that there were style leaders. The name Midwinter became a hallmark of quality, Jessie Tait our icon and *Savanna, Primavera, Fiesta, Saladware* and *Chequers* the treasures for which we were searching. The accumulation became a collection and, eventually, an obsession.

 Ann Eatwell wrote an article on Midwinter in 1986 and from then on more and more people succumbed to the Midwinter 'bug'. This book will, I hope, become a 'bible' for collectors and enthusiasts, answering their questions and giving the background to the many plates and pots we have been proud to collect, document and illustrate.

S.J.

Acknowledgements

Special thanks are due to the following for their help during the writing of this book: Jessie Hazelhurst, Eve Midwinter, David Queensberry, Bess Wells, Esther Turner, Jennifer Opie, Anne Eatwell, Alun Graves, Hilary Bracegirdle, Kathy Niblett and Josiah Wedgwood & Sons Ltd.

 My thanks to friends and fellow collectors for loaning their valuables: Pamela Baker, Karen Boller, John Bostock, Andrew Casey, Greg and Julie Chetland, John Clark, Phil Colechin, Anton Creasy, Daryl Davies, Mark and Eileen Foxwell, Keith Francis, Ritchie Franklin, Paul and Brigitte Goodridge, Ruth Kempler, Steve MacDonald, Martyn Palmer, Susan Scott, Gianmarco Segato, Jamie and Lisa Smith, Ian and Anne Strover, Stephen Walker, Ian and Jane Watson, John and Anne Whitten, Anne Wilkinson, Colin Dixey, Mark and Tullia Randall, Ali Barwani, Adrian Grater, Alan Jennings, Del Julier, Andrew Darbyshire, Mike Crabtree, and special thanks to Colin O'Brien for the launch photographs and everyone else who has helped.

 I would like to thank Richard Dennis and Paul Atterbury for their support and encouragement and for the confidence they have shown in this project.

 I would like to give my grateful thanks to Gary Hopkins, and also to Joan and Bob Anderson for their untiring efforts and without whose help the compilation of the Design Directory would have been impossible. The second edition owes much to the hard work of Magnus Dennis and his travelling photography studio.

 For the third edition, many thanks to Jessie Tait's family for the loan of precious items and artwork, Nigel Collins for allowing us to turn his house into a studio, Brett Moxom and Rob Higgins for supplying images from their collections, Adrian Grater, Chris Marks, Saori Yamabe and Natsuko Aoyama in Japan and finally especial thanks to Dan Young for emergency computer and technical help.

Digital Photography, Print, Design and Reproduction by Flaydemouse, Yeovil, England

Published by Richard Dennis, The New Chapel,Shepton Beauchamp, Somerset TA19 OJT
© 1997 Richard Dennis and Steven Jenkins. Second edition 2003. Third edition 2012.

ISBN 978 0 9553741 7 3

All rights reserved

British Catalogue-in-Publication Data. A catalogue record for this book is available from the British Library

Front cover: **Flower Mist** tea trio, **Caribbean** plate.
Back cover: **Country Garden** and **Mexicana** teapots.
Title page: **Ming Tree** ice jug 1953.

Contents

Foreword

As a designer working in the potteries in the mid-50s it was inevitable that I would meet Roy Midwinter. Terence Conran, who had designed the Midwinter showroom and a number of patterns for the *Fashion* shape, introduced me to Roy in 1955. This was the beginning of a long friendship which was to last until Roy's death in 1990. Roy was amongst the very few pottery manufacturers in the 50s who believed passionately in modern design both ideologically and pragmatically. He was also in the enviable position of having a family company that he was able to persuade to back him.

When I first met Roy, his father, who was in his seventies, was still in charge of the business. It was not until the late 50s that Roy took control of the company and its design and product development policy. Roy was not really a designer himself but was a great 'ideas man' and had excellent design antennae. He knew through exhibitions, books, magazines and constant visits to department stores, particularly in North America, what was happening in the world of style and design. Roy never restricted his interest just to ceramics as he believed that, particularly with pattern, design trends were led by textiles. The most successful design commercially on the *Fine* shape was developed by Jessie Tait from a Liberty textile design.

The contemporary style that Roy believed to be right for the company was inspired by the innovative designs of Eva Zeisel for various American ceramic manufacturers. Roy though was the first ceramic manufacturer in England to develop and mass-market this style of design.

Although I did a minimal amount of design work for Roy in the 50s I knew and respected his achievements with the *Stylecraft* and *Fashion* ranges. By the late 50s I could see that the 'contemporary design' was dating. Roy knew this too but he had become so committed to 'contemporary design' that he was unable to see how design trends were moving. I had become interested in the design that was coming from Rosenthal under the inspired leadership of Philip Rosenthal in the late 50s. In 1959 Hans Theo Bauman produced the cyindrical shape *Berlin* for Rosenthal. This was the beginning of a new fashion in tableware that rapidly overtook the contemporary organic forms of the 50s. It was *Berlin* and my love for eighteenth-century creamware that were the inspiration for the *Fine* shape which Roy commissioned me to design for the company in 1960 and came on the market two years later. I was undertaking my first design assignment for Midwinter's just after becoming Professor of Ceramics at the Royal College of Art. Many of the pattern designers who worked on the *Fine* shape were colleagues of mine at the College, in particular Barbara Brown in the textile department who was the leading designer for Heal's textiles at the time.

Roy was a brilliant design entrepreneur and because he cared so passionately about design, other aspects of the running of the company were of little interest to him. His design ideas in the 50s and 60s led the British pottery industry and were widely copied by other manufacturers.

David Queensberry
London 1997

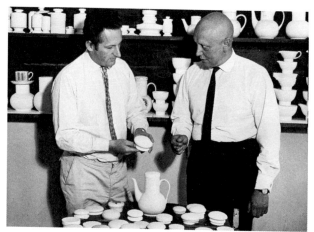

David Queensberry and Roy Midwinter, 1966.

midwinter pottery

W.R. Midwinter

Founded in 1910, the firm of W.R. Midwinter was initially a very small pottery at Bournes Bank in Burslem, Stoke-on-Trent. At first, the factory produced only Rockingham teapots but after four years William Robinson Midwinter felt sufficiently optimistic to expand his production and moved to the nearby Albion Pottery, and soon after acquired another neighbourhood factory producing sanitary ware. With the outbreak of the First World War in 1914, William Midwinter handed the business over to his wife while he served in the Royal Navy.

After the war W.R. Midwinter acquired another factory, Stewart Maddock Ltd., to increase output and reduce overheads. Toilet ware production was phased out and dinner ware introduced in the years before the Second World War. The business must have grown rapidly as the average number of employees in the late 1930s was 700, making it one of the largest in the country at the time. The onset of war once again disrupted production, and the payroll was reduced to a minimum and a mere token production maintained. The Ministry of Supply and the Ministry of Aircraft Production then took over a large part of the premises for the duration of the war.

William Midwinter's son, Roy, returned to the pottery after five year's service in the R.A.F., eventually becoming managing director. First of all though, his father wanted to give him a thorough training and so Roy started by cleaning the factory with a team of labourers. He then worked in each department for several weeks to learn all aspects of production which he had previously studied at Stoke-on-Trent College. After spending three years with the works management his father moved him into sales, a job he was not keen to do at first.

Whiteware was all that could be produced for the home market in the years after the war and a mere 10% of production was exported. In order to make it more competitive the pottery was completely modernised and a new clay body was introduced to improve the quality of the ware. New machinery was brought in and a decorating department with underglaze and on-glaze print areas was established with a continuous-firing enamel kiln.

Although basic production was domestic tableware the production of animal figures with other fancyware was starting to prove a lucrative market. Many of these were designed by Nancy Great-Rex, an excellent artist and modeller who later moved to Wade, Heath and Co. and continued modelling figures.

In spite of post-war gloom and tight restrictions on production, business continued well and 1951 saw record sales. Staff numbers had risen to 625 and the factory was occupying $2^{1}/_{2}$ acres. Pattern number 4000 had been reached and there were about 100 designs in production, mostly floral sprays with gold edge decoration or traditional print and enamel patterns like *Landscape, Rural England* and *Roger,* many of which were still being made in the 1960s. The company was doing well but needed to expand its export orders as this was potentially the greatest source of income. The commitment to modern production methods and the continual upgrading of the factory were to prove invaluable for the new directions the pottery was to pursue in the near future, and to help secure the orders from overseas.

Jessie Tait

Dorothy Jessie Tait was born on 6th March 1928 the youngest of three children. She was named after her mother and always known as Jessie. At the age of thirteen she went to study at the College of Art in Burslem. After two years in the Junior Department she moved up to the Senior Department where she stayed another three years supported partly by her elder brother. A wide variety of skills were taught at the College, from pot-throwing to lithography, but the great emphasis was on draughtsmanship, which was an invaluable starting block for Jessie's future career.

The College was run by Gordon Forsyth, the man who had encouraged the young Susie Cooper while he was at Grays Pottery. Other tutors were Millicent Taplin of Wedgwood, Reginald Haggar (designer and watercolour painter), Leonard Brammer (engraver), Harold Thomas (potter) and William Ruscoe (potter and sculptor). Among Jessie's contemporary students were Arthur Berry and Colin Melbourne, who also worked for Midwinter later in his career.

Design was taught and, bearing in mind the world of difference between old and new styles in the market place at the time, the aim was to get the students to be 'thinking designers'. As Jessie says, 'we weren't buried under tradition but it had its place'. Originally she had ideas of

becoming a painter after leaving college as that was where her real interest lay at the time, but it became increasingly likely that she would take up a job in the local industry.

> '...My parents were working class and there wasn't a lot of finance in the home. Like a good many people it was a struggle but my mother and father actually in some ways both had talent but never had the chance to develop it. When they had children they wanted to give us the best they could in the situation. They were keen on us having an education...my elder brother passed for Hanley High and ended up with a scholarship to London University studying Mathematics and Physics. He went in that direction while I showed an artistic talent...I know my mother wanted to push me along a more academic road but it wasn't for me so I went to the Art school...'

Jessie's father retired when she was seventeen and so she decided to look for a job. One of her tutors helped her to secure a job at Wood and Sons, in the position of assistant designer to Charlotte Rhead, who had great commercial success with a style known as tube-lining, a technique using wet clay or slip trailed through a glass rod or pipette onto the 'leather-hard' ware to form a relief image. These were then decorated in rich colours and lustres. Although the ware was decorative, the style was relatively traditional and not a creative challenge to someone fresh from college.

Due to the huge number of export market orders coming in for this ware, and the lack of paintresses with tube-lining skills, Jessie was working as a paintress rather than learning the trade of design. On mentioning this to Charlotte Rhead she was told to be patient but, after six months, an enquiry from one of her college tutors, Professor Baker, found her very disillusioned. She was told of a vacancy for a designer at the Midwinter factory and shortly afterwards was offered the post. She did, however, manage to get one pattern into the Charlotte Rhead pattern book before she left.

Many of the potteries in Stoke after the war were still small family concerns, employing from the neighbourhood and from within their families. W.R. Midwinter was such a factory and very much a family concern. During the 1930s a hand-painting department was employed to decorate ware in the style now referred to as Art Deco. Many of the smaller factories worked in the shadow of larger ones and, with Clarice Cliff and Susie Cooper becoming household names, a certain influence found its way into the output of most of them. Midwinter were more daring than some companies and used some modernist shapes for teaware. Everyday china no longer had to be cheap and dull with a simple band at the edge, or beautiful but expensive. As Susie Cooper pioneered the sale of good, modern taste to the middle classes, so other factories followed as the market place changed. Despite restrictions and closure for part of the war period, Midwinter survived and started the moves that were to enable them to lead rather than follow fashion.

Jessie soon found her feet in the new factory and an outlet for her creativity. Hard work was rewarded and credit was given where it was due. At the time factory workers put in long hours, and had to work Saturday mornings as well. Throughout her career, whenever the everyday work has become mundane or lacked inspiration, she has found ways to keep creating, by learning to throw pottery or decorate ware for pleasure after office hours at the local evening classes.

Handcrafts

For some years after the war there were great limitations on the type of ware and decoration that could be produced for the home market. Many factories had been forced to close during the war, either because the raw materials were unavailable or, as in the case of Midwinter, because the premises were requisitioned for war use. When the potteries reopened after the war most picked up where they had left off and continued to produce the same designs for export, and for the home market if they complied with the Utility restrictions still in force during the post-war period. Most of Midwinter's output at this time was simple banding with gold lustre decoration, print and hand enamelling or transfer ware in an Art Deco style.

Much of the ware produced during the period before *Stylecraft* in 1953 was aimed at the export market as part of a drive to raise the country's finances. A certain amount of fancyware was produced for the home market and the *Handcrafts* range was W.R. Midwinter's offering to help fight post-war gloom. Boots The Chemist was then a large retailer of ceramics, and the bowls produced in this new range sold almost exclusively through their shops.

Half a dozen or so paintresses and college leavers decorated bowls and other ware with an underglaze crayon technique or simple paint effects. These are particularly appealing as they were drawn freehand and, by their nature, are all quite individual. Stylised floral designs were the most popular but, as the girls were given a free rein to draw whatever they liked, a wide variety of subject matter including scenery and animals was produced on this ware. The outside of the bowls was stippled in green or blue and the artist usually initialled her work on the base of the piece. Nancy Great-Rex, Esther Barnish, Mary Beardsall, Pamela Huntbatch and Jessie Tait, among others, worked on this

W.R. Midwinter at the pottery in the mid-1960s.

Jessie Tait in her studio in 1964, with *Everglade* and other sample wares.

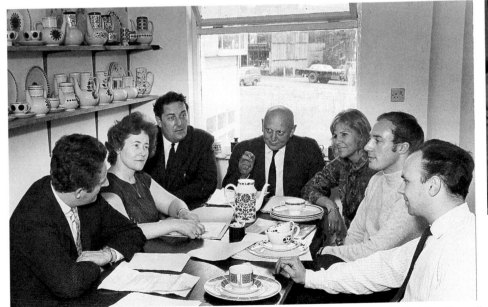

Design meeting at Midwinter, 1967. From left: David Queensberry, Jessie Tait, John Russell, Roy Midwinter, Eve Midwinter, Nigel Wilde, Alan Dean. Trial *MQ2* and *Pedestal* items are on the shelves.

John Russell working on a pattern design in the 1960s.

range. Mary Beardsall, a teacher in textiles at Burslem College of Art, came in to work on the bowls in her spare time. The paintresses' fee was half a crown per piece. If someone had spent too long on one design the next one would have to be simpler, or at least quicker, to execute to ensure taking home a good wage. Esther Turner, (née Barnish) says that five bowls a day was about the average output from one designer.

Jessie Tait remembers walking into the room to work with the biscuit ware stacked up high on one side:

> '...you used your imagination and did what you felt like producing for the day..they were sold as quite individual, the fruitbowls with a chrome lid were reckoned as a fancy item but they were taken by Boots, so were many of this shape with various designs on. There was a great market for this sort of thing years ago...'

Some of the pieces from this period designed by Robert Lamont Midwinter turn up now and again. He was William Midwinter's brother and had worked previously at Royal Doulton in the accounts department. He was given a small room in the factory and worked as a decorating manager, also producing designs, some of which went into production. He had a backstamp which bore his name, as did Nancy Great-Rex. One of the Robert Lamont patterns was adapted for the new *Stylecraft* range in the 1950s.

Nancy Great-Rex was responsible for many of the figures produced in the 1940s, notably *Larry the Lamb* and *Run Rabbit, Run*. There is a broad range of wildlife models and even a selection of Madonnas. There are varieties in the finish of the animal figures as some were decorated using a clay stain rather than hand-painted. This swifter method of preparation meant only the eyes and finer details had to be applied by hand.

One method of decorating ware that Jessie received credit for was another part of the *Handcrafts* range. One pattern in this style, *Moonfleur*, was stylistically quite adventurous with the design incised into the ware and a clay stain in grey and blue applied by hand. It was also produced in at least two other colourways. The patterns are abstracted floral motifs, some of which have spot or scalloped borders. The range was extended from fancy through to teaware though still Utility grade. Some of these pieces are marked 'A Jessie Tait Production' and, looking closely at the patterns, one can see hints of the new designs to come.

First commercial designs

The only designs likely to be put into production in the immediate post-war period were slight variations of old favourites or traditional patterns. Jessie's early designs were based on the banding and gilding tradition, a popular seller at home and abroad. Maroon, navy, lime, dark greens and gold lustre, (a metallic oxide) was the colour range she had to work within. 'Gold stamping' was another popular technique for giving depth and richness to ware, with a rubber stamp being used to transfer a pattern onto the ware.

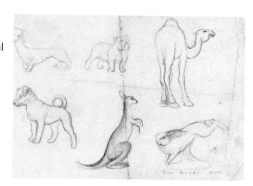

Right: original sketches by Nancy Great-Rex for animal models, including *Run Rabbit, Run*.

Below: group of animal models designed by Nancy Great-Rex, 1940s.

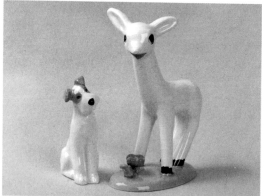

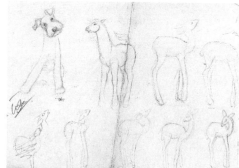

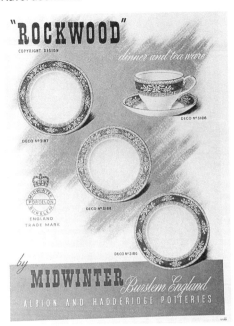

Pottery and Glass, February 1953.

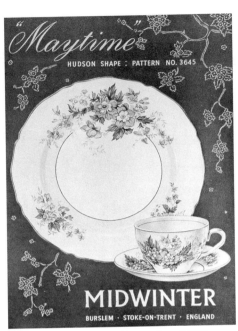

The Pottery Gazette, December 1952.

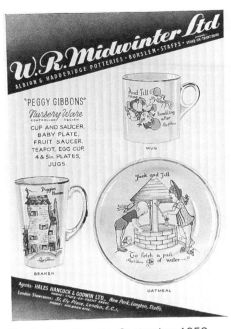

The Pottery Gazette, September 1952.

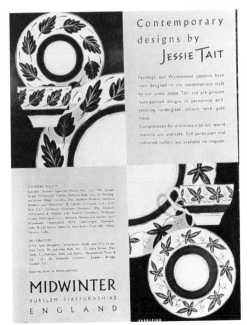

The Pottery Gazette, July 1952.

The Pottery Gazette, October 1954.

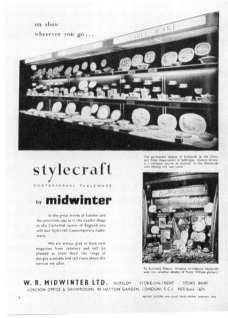

The Pottery Gazette, January 1955.

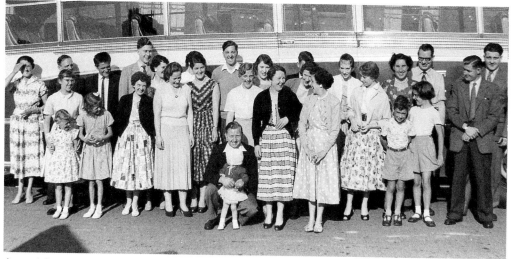
Annual factory outing to Blackpool, 1950s.

Factory ladies, late 1950s.

One of Jessie's earliest hand-painted patterns, *Regal*, is a maroon border 'sprouting' vertical leaves with gilded detail and spots, traditional enough not to scare the buyers but with a distinctive style. Lithograph patterns were also used at this time and Jessie painted floral studies that were translated for print. *Maytime (3645)* is an example of the typical factory output of this period, a floral transfer on the *Hudson* shape with banding in creamy yellow and a gilded line, shown in a *Pottery Gazette* advertisement of 1952. The year before a painted floral pattern, *(3697)*, was shown in a display of wares for export and in *The Pottery Gazette* of July 1952 Midwinter had a full-page advertisement of Jessie's two new 'contemporary' designs.

Wynnewood and *Parkleigh* are entirely hand-painted with a border pattern of leaves and banding. Gilding is utilised to enhance the design. The overseas agents are listed on the advertisement and it is interesting to note where Midwinter products were being sold: Australia, Canada, Rhodesia and Nyasaland, New Zealand, Denmark, Norway, Sweden, Cuba, U.S.A., Pakistan, India and Burma.

The other range of ware worthy of note from this period are the nursery patterns by Peggy Gibbons first produced after the war. Redolent of a childhood long past, these illustrative scenes from popular nursery rhymes were part of the factory's mainstay and were re-launched in 1960 in a smartly designed box with a free painting book. The range comprised an eggcup, beaker and saucer, teaplate and oatmeal bowl. Other pieces include Utility teapots, mugs and beakers.

Birth of Stylecraft

After his period of training, Roy Midwinter began to revitalise the company. In August 1952, on a sales tour to Canada, he was disappointed with the response to the factory's ware. The selection was a sample range of new designs, primarily floral and mostly rose motifs. Having been sent away empty-handed from a second appointment at Robert Simpson's, Roy Midwinter turned for advice to Colonel Louis Keene, the buyer for Eaton's stores in Canada and a man of great influence in the market, and was told to take a look at the American West Coast output and new design.

The work of designers like Eva Zeisel, Russell Wright and Raymond Loewy had helped to promote a radical departure from the traditional shapes and designs of the sort that Roy Midwinter was trying to sell. The 'new' plates were coupe or rimless, and jugs, pots and other holloware were fluid and organic in shape. There was a new look in colours as well, a move away from the drab post-depression colours to cleaner pastels and brighter primaries.

The Festival of Britain in 1951 had whetted the appetites of some sections of the public here, showing a cleaner and brighter future with design and modernity applied to everything from the outside of a building through to the smallest item in the kitchen. Microscope pictures had been used as source material for surface pattern design and applied to ceramics and fabrics. Jessie said of her visit to the Festival that there was a sense of movement in the design world.

Jessie Tait, c.1964.

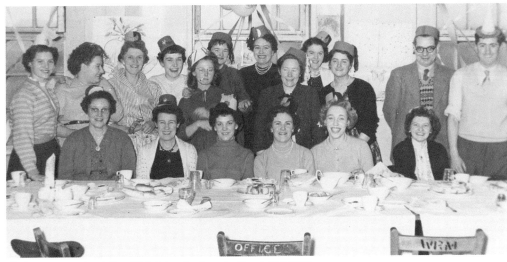
Christmas party at the Midwinter factory in the mid-1950s.

Roy Midwinter persuaded his father to send him to the West Coast of America and the changes in the potteries there was proof that the public were buying this 'new look'. Older companies were struggling, and smaller, new firms were leading the market. Roy Midwinter sent samples of this new ware back to Stoke and on his return to England he immediately began work to try not only to compete with American design but to better it.

Meetings were held between William Midwinter and William Lunt, his co-director, to discuss the new project and a launch date of February 1953 was decided upon. This gave the factory less than six months to produce not just a new shape but new patterns to suit it. This was timed perfectly to coincide with the lifting of restrictions on ware produced for the home market, the end of the Utility period. The slow sales of the dinner and teaware that was available to the British public was put down to a lack of money, but Roy Midwinter now believed that the younger market were after something new and different. Young people wanted modern interior styling to reach every corner and surface of their living areas. *Stylecraft* was to be the name for the new line for the younger generation that wanted to make a statement with their home style.

As with other areas of industrial design there was a move towards streamlining and the new range was intended to reflect this and also to consider the smaller living spaces that newly-weds and the younger generation had available to them. In terms of decoration, conventional and floral motifs with heavy gold patterns were thought to be on the decline even though they were still a lucrative part of the Midwinter repertoire. In *The Pottery Gazette* of February 1953, the company was at pains to say:

'Despite the large-scale new production of coupe-ware to which we are committed, I want to allay any fears which might arise in the trade that there will be any difficulty in obtaining supplies of traditional productions. We shall continue to fulfil all requirements, though at the same time watching very carefully the ratio of demand between the contemporary product and the traditional.'

A silver nut-bowl was the unlikely start of the new shapes. Roy remembered this item of his father's from his childhood and somehow the shape seemed to be ideal for the new plate. This idea was developed and the small rim was retained for condiments despite the trend for coupe-ware and rimless plates in the States. The holloware, (cups, pots, bowls etc.), was designed for ergonomic use and practicality and great care was taken to avoid projecting spouts or handles that would be prone to damage. Given the ridiculously short time (between four and six months), that was allotted to the design process before the launch, the shapes were a great achievement.

W.R. Midwinter's new London showroom in Hatton Garden was described in an article of June 1953 in *The Pottery Gazette*. as:

'...one large room, three walls of which are fitted with handsome mahogany showcases housing well tried and popular patterns, and a smaller room for the most up-to-date

The Midwinter stand at the British Industries Fair, 1954.

Stylecraft window display with contemporary fittings, c.1954.

ware. Entering the showrooms, the visitor will find himself in the smaller room first. Here, in a modern setting of black shelves against silver grey walls, are the latest designs and shapes. The American 'starter sets', for which there is an increasing demand in this country, are neatly packed and ready for despatch, and attractive displays of the firm's new Stylecraft earthenware can be seen to advantage under the peach strip lighting...'

The article goes on to say that the other room is 'tastefully furnished...providing an adequate setting for the older and better-known patterns.' It must then have been quite galling to the traditionalists when, after twelve months, 'contemporary' style accounted for 60 per cent of sales. Within a short space of time the factory showroom would be redesigned by the young Terence Conran and the ratio of traditional and contemporary ware displayed would be overturned.

Although the creation of *Stylecraft* was clearly to expand the lucrative overseas market there was a feeling of determination and belief in the new ware for the British public. The older, traditional patterns were thought to have no place in the modern home, leaving people wanting something 'contemporary' to fill the gap and co-ordinate with the rest of their homes. The launch of a major advertising campaign in the press, the award of a 'British Good Housekeeping Institute Guarantee' and a television appearance all helped to underline the success of Midwinter's 'new look'.

Stylecraft

Stylecraft was a very well thought-out innovation in tableware, with shape and all aspects of design and presentation being thoroughly considered. Ease of cleaning and economic storage were other important factors in the production. Smaller homes and tighter budgets meant that the new product had to be durable and practical.

The television screen-shaped plate was easy to stack and many of the dinnerware items boasted dual functions for extra economy. Rules on etiquette were more relaxed with the younger generation. A vegetable dish looked much the same as a soup tureen, and a jug and saucer made a respectable gravy boat and stand. Six months from the initial concept stage, the new range was ready to present to the public. In February 1953 the press announcement was made – '40 new shapes and 36 contemporary patterns prepared'.

Although it is generally thought that Jessie Tait designed all thirty-six of the launch patterns in the *Stylecraft* range this is not so and would, in any case, have been impossible bearing in mind the length of time from concept stage to the High Street. She did, however, style and work patterns from concept to the finished ware so that transfers sat well with their borders and motifs were not too large or too small for the item in question.

The patterns were probably launched slowly over a period of months to allow a breathing space for the different designs and to allow the production of traditional wares to continue

Midwinter stand at the Blackpool Fair, 1954.

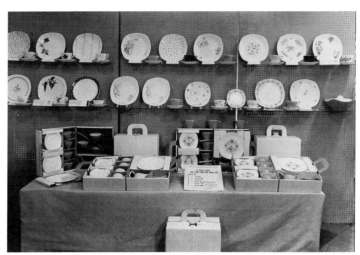

Midwinter *Fashion* display, c.1960.

normally. *Encore* was the first pattern launched and was so successful that it led to an embarrassing backlog of orders. The lithographic transfers for designs like *Pussy Willow* were bought in from a local company and Jessie would then 'style up' the patterns using the different size transfers for the different ware, deciding on borders, gilding or banding and then getting all the designs approved. In the case of *Woodside* and *Mountain Lily* the borders were aerographed in a bright green. The pattern had been used on earlier traditional shapes. *Ming Tree* and *Shalimar* were designed straight onto the ware to ensure the design 'worked' on all the different shapes.

Jessie was very impressed with the new shapes – she saw them as very functional and well balanced. The plate was particularly pleasing to use and the holloware lent itself to decoration. Having access to a large hand-painting department in the factory, it seemed an ideal opportunity to design a range of patterns that could make the most of this. The inspiration for many of these designs came from textiles. She says that when setting up home:

> '...I always felt that home furnishing came first and then you were looking for pottery to fit in with that...I think the textile side tended to lead a little bit...'

One of the most obviously textile-inspired designs for this range was *Homeweave*, a plaid in two colours and two colourways – green and red. Both versions of this were tremendously successful and many other potteries produced similar designs. T.G. Green had already produced their pattern called *Gingham* the previous year for export on the 'modern' *Patio* shape, and another popular version was made by Empire Porcelain. There are variations on this pattern in *Stylecraft* with a broader check and, later in the decade, the holloware was glazed in solid colours. Even today versions of checks and ginghams remain popular. As Jessie says many of the contemporary patterns today echo the ground-breaking work of the 1950s.

Because of the public's fondness for gold and silver on their pottery, two designs were produced using a 'stamp': a central motif of barley in silver with a red or blue band and a design of snowflakes with a red line to the edge – *Starlight*. The snowflake design was successful on the *Fashion* shape as well with a blue or red border. Another pattern, *Gold Brocade,* was an exclusive for a Stoke-on-Trent stockist using gold stamping of floral motifs and a gold band.

'Print and enamel', the hand-colouring of a printed design, was another popular technique. *Ming Tree* and *Shalimar*, oriental-inspired designs, were produced using this method. A drawing would be translated into line and a copper or steel plate engraved with the image. The image is then printed onto paper which is pressed onto the biscuit ware, and then transferred to the item with a firm brush, like a rub-down transfer. A solution seals the image and the ware is left to dry. The hand- colouring or enamelling is then applied and the item is finally glazed and fired. If a gold line or detail in a

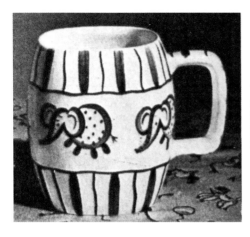

Tankard decorated with pink elephants, from Jessie Tait's nursery ware range, 1950s.

lustre (metallic) colour is required, this is done after glazing as another firing.

Riviera was one of the most popular print and enamel designs of the *Stylecraft* era. This was based on a set of sketches by Hugh Casson of typically French scenes. Having been impressed with the style of Casson's line drawings of the Coronation route in the *Daily Mail* a commission was offered to him by Midwinter and accepted. The change from the traditional views on plates in a mock-Victorian style to the lively sketches with bright splashes of colour was a clever move for the factory and its success helped to popularise their new image. Jessie Tait worked on translating these sketches onto the different shapes; different sized plates, for example, have different drawings. The ware was produced with a cream or 'honey' glaze which gives it a distinctive appearance next to other patterns in the range. In 1960 the pattern was relaunched on the *Fashion* shape with coloured holloware and a bright white background. This proved so popular that it was on sale into the 1970s. In a Midwinter advertisement of 1956 there is a hint that further Hugh Casson designs were in the pipeline but these, for one reason or another, did not materialise.

The other credited designer or artist commissioned to work on this shape was Peter Scott. His *Wild Geese* design of 1955 has different illustrations on various pieces making a table layout 'full of interest and in harmony with both contemporary and more traditional furniture and furnishings'. The design for the plate was worked directly onto the ware and adapted for the other pieces. Jessie Tait shared her studio with him while he worked on these designs. The transfer-printed design in blues, greys and orange with banding in blue grey seems to have become a firm favourite with the collectors of today and the teaware is particularly popular. Available on all the *Stylecraft* shapes the pattern moved onto the *Fashion* shape and stayed in production until at least 1967.

Fir was a design originally produced for the Canadian market. This was taken directly from a painted study by Jessie Tait and a lithographic transfer was made. At the time many litho-transfers were of poor quality but the transfer for this design came out well and the pattern was popular in Britain too. Jessie says that something was always lost in reproducing a design for a transfer and then a happy medium had to be found between the original and the best available transfer of the time.

Encore was another well-received pattern with a central floral transfer in two colours and a banded rim in either blue and grey or green and grey. The shallow rim of the ware was picked out in a bold band with a fine line to pick out the central well of the flatware. *Arden*, a transfer print of leaves in pinks and greens, had a graduated grey band at the rim with a fine line in maroon. The technique of obtaining a graduated band was called 'tar banding' – aniseed was used to keep the enamel thin enough to flow, rather then soaking right into the biscuit ware. Graduated bands in concentric lines were widely used by potters before and after the war following Susie Cooper's great success with her *Wedding Band* patterns. These sometimes have the backstamp 'An Alice Barnett production'.

Making a feature of the rim on *Stylecraft* was shown to best effect on *Red Domino* – a bright red enamel was applied to the rim and relief polka dots were applied in white on top. This became a best seller almost instantly and has become one of the design icons of the 1950s. *Blue Domino* was launched in January 1956 but it did not take off in quite the same way, perhaps because T.G.Green's Blue Domino ware was already well established. Versions in green were mostly used on fancy ranges but an egg cruet is known and other items are all-over green with raised spots. A few examples of *Black Domino* have survived, possibly a special order. *Red Domino* had a few variations and incarnations as it moved into the *Fashion* shape, and was even adapted for the *Fine* shape as *Casino*. A version with raised spots in red on the holloware, and a thin red band with raised white spots on flatware, is thought to have been for a particular outlet or chain of stores. The original version was so popular that twenty paintresses were employed at one time, alternately to band and spot. Because of the strain on the eyes the

paintresses swapped from one to the other as they were seeing spots before their eyes long after finishing.

Other hand-painted designs of the period include *Spruce*, a bold pattern in green and brown, the edge decorated in a textured manner using brushes that had been cut leaving spaces in the bristles. The same edge was used in *Fantasy*, a design in grey and brown known affectionately in the factory as 'cod's eye'. The central motif has a grey texture behind it created with a pad of horsehair. Jessie Tait was constantly experimenting with paint effects and new techniques and this was a method used well into the 1960s on fancyware and vases. A version of *Fantasy* was produced for Maxims with a different central motif. Another pattern utilising the same colourway as *Fantasy* was *Silver Bamboo*. Hand-painted bamboo stalks in brown have grey leaves – this pattern was reworked and re-coloured for the *Fashion* shape. *Catkins*, *Bulrush* and *Orchard* are early patterns entirely hand-painted and particularly elusive today.

Pageant is a design seldom seen on dinnerware, with the bulk of the output on fancyware such as cake stands. The title was obviously inspired by the overwhelming media coverage for the Coronation. An advertisement from about 1954 in *The Gift Buyer* shows a clover-shaped dish and a two-tier cake stand in this pattern. Executed in one colour entirely freehand, these heraldic swirling leaves in dark green are a tribute to the work of the paintresses. Another pattern seldom seen although produced in quantity is *Leopard Lily*. This was a pattern aimed at the Canadian and U.S. market but was widely available in Britain. Hand-painted in four colours this design shows the quality of the factory's work of the period.

When a new design was approved for production the paintresses would have to be taught the method of working the pattern. Jessie would sit with them and, step by step, demonstrate the brushstrokes needed and the order of colours. This made for an economic use of the hand-painting department and also helped to maintain the high standards

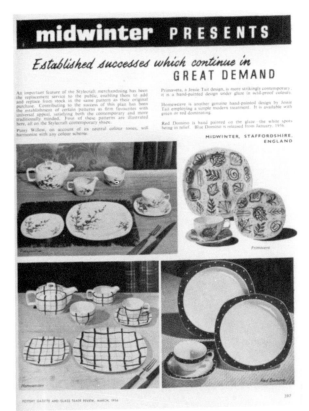

Advertisement in *The Pottery Gazette*, March 1956.

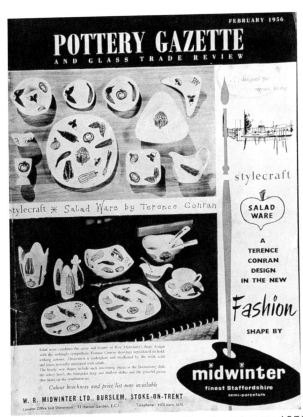

Cover advertisement, *The Pottery Gazette*, February 1956.

stylecraft

by

midwinter

GOLDEN

PATTERN

BROCADE

in a utility grade

SOLE DISTRIBUTORS

Jas. I. Taylor

LIMITED

KING ST. FENTON, STOKE-ON-TRENT

Telephone: Longton, Staffs, 33843

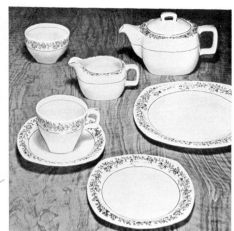

Advertisement in *The Pottery Gazette*, August 1955.

of output. Any problems with the design could then be worked through before any backlog in orders or production difficulties occurred. As she took on greater responsibility in the factory, Jessie spent an increasing amount of time at meetings and less time on the shop floor, leaving the overseeing to her assistant, Bess Wells.

Each paintress was given a mark so that any sub-standard work could be traced back to the perpetrator; this also helped in the matching of sets, as the 'handwriting' of one paintress might not sit well with the work of another. These dots and other hieroglyphs found on the bases of ware were a kind of signature to ensure the finished ware was of the best quality. A good guide to ascertaining whether or not a piece is factory made is to check for these marks, for student pieces decorated on blank, glazed ware are signed on-glaze. Many factories donated blanks to the local colleges for training and many Midwinter pieces turn up from these sources. As a result, a new discovery or 'rare' pattern can often turn out to be a piece of coursework from a student. Invariably, these are painted in enamels on the glaze and really have no connection with the factory.

Always popular with collectors is something so redolent of its era that it encompasses the feeling of the times; for example the Staffordshire figures of the last century or the *Bizarre* Clarice Cliff designs of the 1930s. Some of the patterns of the 1950s have this instant association and sense of nostalgia. In the *Stylecraft* range the two designs that stand out the most are *Primavera* and *Fiesta*. The latter was a design meant to have a carnival air and the bright yellow stripes are reminiscent of curtains and wallpapers of their day. Both were

launched in July 1954 when the new shape had been on the market for over a year. *Fiesta* was one of the big successes on *Stylecraft* and, hence, was produced in large quantities for home and overseas with a sister design, *Hollywood,* its successor on the *Fashion* shape, substituting hatching and paintstrokes for stars and circles.

Primavera was a wonderfully exuberant design created after a visit to London. Jessie started work on it the next day and the ensuing design must owe some of its inspiration to that trip, following her visits to the larger London stores and the sight of what was new and fresh in design. Using organic motifs against amoebic and abstract shapes surrounded by a 'texture' of dots the whole mood of the 1950s seems to be evoked. Worked in a palette of rust, green, grey and yellow, the pattern fills the flatware and details are picked out for the holloware. Larger motifs are used on jugs and pots and even the eggcup has a motif all to itself. Already one of the most popular designs in this range with collectors, the design originally did not catch on with the British public until Heal's sold it in their London store. It was then stocked around the country from Harrods to the provinces. When the *Fashion* shape was launched, a re-coloured, simplified version was produced using the new palette of colours.

Many hand-painted designs with stylised leaves or flowers are to be found on *Stylecraft*, and *Leopard Lily* and *Catkins* are among the first produced. However, as the pattern books are missing and presumed lost, possibly in the move from factory to factory, there is no chronological comprehensive listing. An educated guess can be made about many of the designs, as most of the hand-painted designs of the period are likely to be by Jessie Tait. The colours are a good indication as well, the darker colours dating from the earlier 1950s, with browns and greens predominating.

Part of the thrill of collecting is the feeling of finding something previously unrecorded and, as many patterns were trials with only a handful of pieces made, there are likely to be a great many 'unknowns' turning up in the years ahead.

Starter sets

With the launch of *Stylecraft* in 1953 a new marketing strategy was offered to the British public, inspired by the American market. Instead of selling people a whole dinner or tea service, a 'starter set' was produced to enable couples with a smaller budget, or people who did not need a full service, to purchase just what they needed. The 20-piece starter set was planned to retail at 39s9d – just under two

pounds! The set consisted of four each of teacups, saucers, tea plates, dinner plates and cereal bowls (oatmeals), thus giving a taster from the tea and dinner service that could be added to, as and when required. For example, on the back of a promotional leaflet of the period the starter set was considered ideal for breakfast. To make it into a teaset you needed a teapot, jug and sugar bowl or, for a dinner service, a covered scallop, (dish and cover), meat plate, gravy boat, and even salad and luncheon plates could be added. As with most companies, once you purchased a set, replacements and additions could be ordered but, as Midwinter proudly boasted on their stands, 'any piece can be purchased' from a range of over fifty items. This open stock method of purchasing must have been very appealing to the 'newlywed' market as it offered contemporary taste at an affordable price. From the sales point of view a starter set left a customer with the option to buy more and add to it, whereas the traditional tea or dinner set was complete and, in effect, the customer was lost until they broke a piece or needed a new set. Later in the decade a clever idea was to market the traditional 21-piece teaset, (six cups, saucers, tea plates and a jug, sugar and sandwich plate), with an extra cup as that was generally considered to be the first piece likely to get broken. Obviously not every store could have held a comprehensive stock but displays of the period from Bentall's in Kingston to Godfrey May's in Padstow, show an extensive range of patterns and shapes.

Stylecraft was a constantly evolving range. From the date of launch the factory took note of comments and adapted or re-worked items that were problematic. Teacups were a problem in the north of the country, for the Scots liked their tea hot. The low style of teacup was not popular there and so a tall teacup was put into production. The need for a similar style of cup in the breakfast and coffee size was not as great and these were not adapted. Cups do seem to have been produced with any number of small variations in size. Some of this can be put down to the different shrinkage rates of different 'bodies' or clay mixtures, but various moulds seem to have been used as well. Baking dishes were produced for a while, some with covers, but these would have a particularly low survival rate today if they were used. In the shape books the baker is overwritten with 'Cheese dish' so we can assume these were not produced for long. Jugs were also a problem at the beginning as the 'snip', or lip, of the jug was not high enough, resulting in spillage if used on a tray. Scallops or bowls were made deeper to increase capacity and a bridge was introduced on the lids of pots to

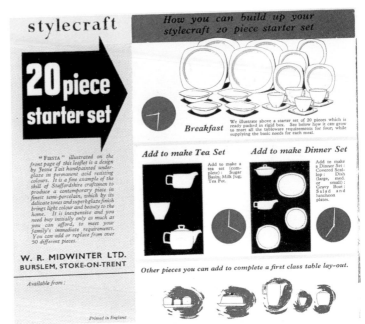

Detail from a *Stylecraft* leaflet promoting the starter set, 1954.

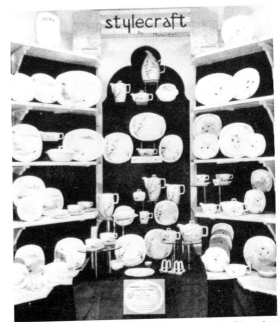

Shop display at Court Brothers, Guildford, 1955. The elusive ice jug can be seen at the top of the central display.

19

prevent over-pouring. A three-quarter-pint teapot was introduced in February 1954 as an early morning teapot. One of the most elusive items in this range, partly because they do not often bear the factory name, are the toast racks. The seven-bar toast rack was available for about a year and this was followed by the five- and three- bar racks. The five-bar is the most commonly found *Stylecraft* period toast rack and most of the early *Fashion* designs offer a three- or five-bar in their promotional literature. The central brass or chrome fitting remained as standard with the handle echoing the shape of the plates. The toast rack designed to supersede the *Stylecraft* shape was a flat ceramic tray with a square well at each end. A chrome fitting covered the middle section with a handle and bars leaving the spaces at either end for butter and marmalade. This was easier to clean and less likely to break than its predecessor. These are mostly seen in the later *Fashion* patterns with floral transfers against a grey cross-hatched ground.

The listing of shapes normally carried in stock on various promotional and advertising leaflets of the period is a good guide to the availability of items to the collector today. It is likely that none of the pieces in open stock can be counted as rarities unless the pattern was a short run or trial design. 'Special items' were those that generally had to be ordered unless the stockist had a large enough display area to carry extras. Shapes designed for export which are likely to be difficult to find are the covered sugar bowls and the double eggcups. The stockists were given a choice of patterns for stock but they had to be compatible with each other. A small stockist would not be allowed abstract and floral patterns but would be given two in the same style, for example *Pussy Willow* and *Arden* or *Fantasy* and *Homeweave*. No other stockist in the area would be allowed to sell *Stylecraft* and there were no special deals for the larger buyer. Every order was treated as received. Crates were put together in the factory with a good range of shapes, and the larger the order the more variety as there was more display space. Stockists were sent newsletters with all developments in the range and a binder to keep all the information to hand. The cool professionalism of these leaflets must have impressed prospective customers, and, in turn, the buying public who kept the factory busy to capacity with their orders with customers waiting for up to a year for special order pieces.

Clayburn

The Clayburn Pottery, a small family concern, was founded by William Lunt, production director and general manager of

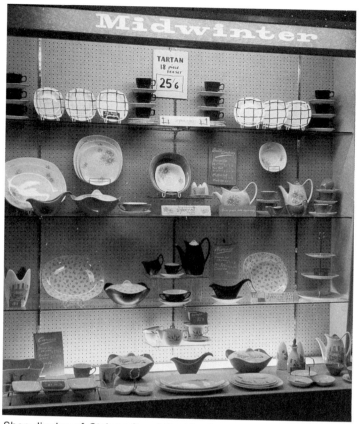

Shop display of *Stylecraft* and *Fashion* items, late 1950s.

Midwinter Ltd. He had worked for Midwinter before and after the war and for other large firms. He had also worked in Canada, where he had spent six months advising on production methods. The two potteries had a close relationship with each other from the time of *Stylecraft* through into the late 1950s. Jessie Tait says of William Lunt:

'...he was very hard working and he set up a studio pottery to run in the evenings, he had a friend in the business and I think his wife did some of the decorating...He asked me if I would mind doing some work for him...he used to bring me boxes of clayware which I decorated. I could do any decorating on them that I felt like. It wasn't reproducing patterns so perhaps I'd have a box with a dozen pieces, vases and lampbases. It was a case of sitting down and painting directly onto the clayware - doing what I fancied.

Unfortunately they weren't signed as I was working for Midwinter and I had got publicity through them... Mr. Midwinter

went in as a director later, though not for long. So he must have said that they could use some of the Midwinter designs.'

Clayburn was sold through Midwinter's outlets and examples of the ware can be seen in publicity photographs of the period. A *Fiesta* lampbase was on show in the British Industries Fair of 1953, and many of the displays in department stores show the cruets and fancyware that Clayburn produced. *Fiesta* was produced in maroon instead of yellow to differentiate it from the Midwinter original. The *Festival* pattern is also known on a lampbase with a lime green substituting the yellow, and *Tonga* was also painted onto lampbases in black. The earlier work that Jessie did for the Clayburn factory is largely blue and white decoration in a traditional style on oriental or eastern-influenced shapes. Some of these were dipped into a clay stain to give a turquoise tint to the body. Later pieces became more contemporary in shape and style. Jessie asked to keep one of the early examples as a record of her work at the time. This is based on a mural she designed for a local hospital. Although at first glance the pattern is traditional and the theme unusual for Jessie Tait, the borders and foliage bear her unmistakable trade mark. The factory mark on the underside was usually a sgraffitto or incised reference number and the name Clayburn, or 'Individual pottery by Clayburn, Staffordshire' .

Some of the contemporary lampbases Jessie executed in black and grey, as was all her later work for the factory, used sgraffitto, a method where the design is cut through the painted area to reveal the body colour underneath. This technique was widely used by Susie Cooper and others from the 1930s to the 1950s but was not a regular technique in the Midwinter repertoire as it worked best on unfired clay. Variations of other Midwinter patterns like *Triangles* were produced by Clayburn using the sgraffito method of decoration.

Generally the only shapes that Jessie worked on were the lampbases and vases, though by no means all of them. Much of this ware employs banding as part of the decoration as Jessie had a banding wheel at home; the patterns are almost exclusively black and white or blue and white which makes it distinct from the general output of the factory. Other fancies and ware were decorated by friends and family of William Lunt. Jessie was paid piece-work and had no special rates for being 'a name' at Midwinter. Despite the length of time she worked for Clayburn, Jessie never saw the factory as the blanks were dropped off and the decorated ware collected from her home.

Designs based upon the Midwinter patterns that were already in production are not the work of Jessie as these were done through William Lunt's paintresses. Some of the motifs Jessie used were adapted into other Clayburn designs, so similar pieces are not necessarily her work. As there was a free rein on all her designs it is very difficult to attribute pieces and so a certain amount of caution should be exercised, especially if a weighty price tag accompanies a Clayburn vase or lampbase. Other fancy items are not attributable to Jessie as they were produced as the mainstay of the factory ouput.

Outside work

One of the most interesting and least seen sides of Jessie Tait is the volume of work she produced in evening classes through the 1950s and into the early 1960s.

Returning to wheel work and throwing after her years at Burslem College of Art gave her complete creative freedom and great enjoyment. Refreshing her skills in tube-lining also came in useful with the studio range that Midwinter produced in 1956 and working in different clays gave her a feel for different finishes. For her, terracotta was the perfect medium for tube-lining, and a couple of items Jessie still has are an excellent record of this work. A doorstop has been worked in a plaid with black and cream tube-lining against a rusty-brown body colour. A vase in the same colourway has foliage and an alternating coloured border. Blue tube-lining was also employed on some of these pieces and a lampbase was worked using this method. Most of these items produced over the years were given to friends and relations and, therefore, are unlikely to be seen for sale. Even so, a very few have reached the market place over the years. They are all signed and dated on the base with the incised or tube-lined mark, 'J. Tait 1959' (or corresponding date), in the well of the base of the pieces. These were actually fired at Midwinter's glost oven because there was a bottleneck in firing at the college. At the factory, they had to be placed at the base of the trolleys of ware as it was cooler, but there was a height restriction and so many of these pieces are quite small.

Roy Midwinter took sufficient note of these to ask Jessie to decorate some samples of small *Fashion* trays specially cast in terracotta, but this project was not taken any further, perhaps as the cost of preparing a different clay and employing tube-liners would not have been viable. One other interesting anomaly is a Clayburn blank that Jessie decorated with clay stains in a mock *Pierrot* pattern. These pieces of personal work had an influence on the design work for Midwinter.

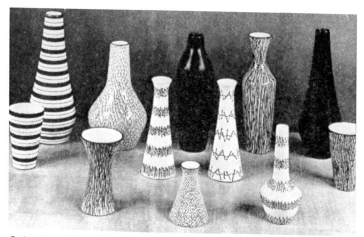

Selection of freehand decorated vases and beakers illustrated in *Pottery and Glass*, 1958, two years after production started.

Another little known area of Jessie's activities in the early 1960s was some freelance work with John Russell. His company, John Russell Design, sold his illustrative work to various potteries or lithograph companies. He also prepared designs for wallpaper, a booming area of design in the 1950s and 1960s and asked Jessie if she would like to have a go. Jessie hand-painted designs in gouache on sheets about 25insx15ins in the evenings and weekends which John Russell, acting as her agent on a commission basis, then took to his clients. After a while the small financial return proved insufficient for the long hours and intense work and Jessie stopped producing these designs. Only a few of them have survived and those sold are almost impossible to trace as no records exist. Once again these were not sold as 'Jessie Tait designs' but as anonymous work through John Russell's company. The surviving samples are an excellent demonstration of Jessie's talent as a flat pattern designer and for capturing something of the period and putting it onto paper.

Flasks and beakers

When Midwinter became the hottest tip in the collecting scene in the early 1990s one of the ranges of items guaranteed to be hidden by antique dealers for a rainy day was the Jessie Tait studio vases for Midwinter. Striking items in bizarre contemporary shapes, these were highly influenced by the work she was doing in evening classes, and stylistically could not belong to any other decade. The ten shapes were decorated in a number of patterns, mostly tube-lined. The first of these shapes was a water flask, and the second a beaker designed to be reversed and form a lid for the flask and these were marketed as a lemonade set, with one flask and four beakers. The decoration was an alternate thick red band and thin black band or thick blue and thin black bands. The whole range was at one time decorated with these banded patterns as they were quick to execute. The lemonade sets were a popular item and the paintresses worked flat out on them. There were also six vases, all with a different influence and style, and two candlesticks in the range The vases were intended to retail at less than £1.00 each.

The pattern *Tonga* was later adapted for the whole range. Other patterns used were an abstracted music score on a wavy line, vertical lines and dots in bands, a stubble pattern all over the piece, and a solid matt black glaze. A grey brushed finish was sometimes used around 1960, a white floral transfer and dots on a maroon ground, or floral transfers like *Apple Blossom*. Doubtless, other patterns were produced and, as the latter design was produced around 1962, it is fair to assume that a number of variations will be found. As plain black, turquoise and pink items are known as finishes, it seems likely that all the *Fashion* holloware colours could have been used, either as a special order or a range for a particular client. One pattern found on the candlesticks has the 'music score' and wavy line in black interspersed with bands of red and dotted with tube-lined red dots. Some of the paintresses at the factory used to say that you could tell a Jessie Tait design because there was invariably a spot there somewhere. Extra tube-liners were brought in as freelancers to decorate the vases, one of whom had worked for Midwinter during the *Handcrafts* period:

'...you had to make your own glass tube over a bunsen burner stretch it and break it in two, put a balloon tied with string on the end...it would sort of scratch at first on the clay and then it would round off with a bit of wear or a bit of sandpaper to take the scratches off...it would last for ages. I used to be able to ice wedding cakes because I could do that...' (Bess Wells, Jessie's assistant)

As in any factory, if there was undecorated biscuit ware around, it would eventually be put to use and so there may be all sorts of unusual patterns. It was thought that these were in general production for only a couple of years but that would still account for a great number of pieces reaching the market. One paintress said that she did 'hundreds and hundreds' of vases and flasks. Any 'left overs' would probably have been decorated and sold, resulting in the odd mix of

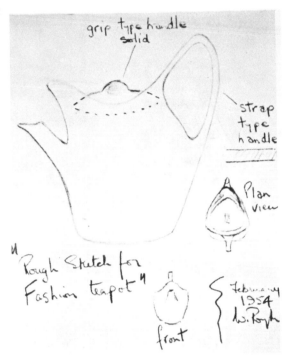

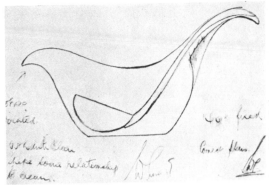

Left and above: early sketches showing the development of the *Fashion* teapot and sauce boat.

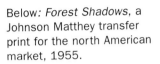

Below: *Forest Shadows*, a Johnson Matthey transfer print for the north American market, 1955.

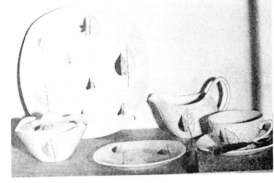

contemporary shape and traditional pattern that seem at odds with the original intention. Complete lemonade sets are likely to be a lucky find and the beakers in particular seem to be quite elusive but with so much of output 'tucked away' it is difficult to gauge the true numbers produced.

Unusual contemporary shapes on functional and decorative ware were later added to the *Fashion* range – asymmetric vases and strange dishes with knop handles. One range was produced by pressing hopsack into the mould for a textured lining. These pieces were generally produced in turquoise with a yellow interior, and are found on a number of shapes.

Fashion Shape

Roy Midwinter's one concession to British taste when he designed the *Stylecraft* range was the retention of the rim on the plates. Eating habits in Britain were still different to those across the Atlantic and whereas the Americans sprinkled salt on their meal, the British placed a small pile of salt on the rim of the plate. The inspiration for the *Stylecraft* range had come from America and Roy Midwinter felt that the new shape

could not be entirely successful unless the plates became rimless or coupe. One of the biggest influences for Roy Midwinter was a style called 'organic modernism', a style which expressed the influence of natural forms on modern industrial design, best expounded in ceramics in the work of Russell Wright and Eva Zeisel. The flowing lines of their ceramics can be seen reflected in much of the design of the post-war period. The fluid quality and a 'melted' appearance characterise this 'new look' with colour playing an important part. There was a move towards a looser and less formal approach to meal serving – a mix and match approach was now acceptable with different coloured lids and dual functions an option. Russell Wright's *American Modern*, and *Museum* and *Tomorrow's Classic* by Eva Zeisel, were the ranges that inspired Roy Midwinter's new *Fashion* shape. In January 1954 the new, rimless 'quartic' plate was illustrated in *The Pottery Gazette*, accompanied by comments that show how Midwinter were still wary of frightening their new clientele:

'...the manufacturers emphasise that the new plate and holloware shapes will not interfere in any way with the standard *Stylecraft* range which will continue to incorporate the plates with modified rims.'

23

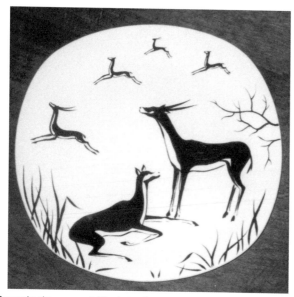

Deer design on a 14" plate, hand-painted in black, c.1955.

Sixty other shapes were ready for launching that year and a good many patterns were prepared although, at first, they were offered for export only. Perhaps it was felt that the British public were not yet ready for another change. *The Pottery Gazette* described the *Stylecraft* range as 'contemporary but not extremist in character' and added that 'the more conservative-minded users of tableware were by no means frightened by the general appearance of the new-style products'. It went on to say that, 'it was a carefully designed product to meet a demand that was as yet difficult to assess.' Roy Midwinter later felt that they had gone 'a bit wilder' with the *Fashion* shape in terms of shape and decoration and had perhaps lost some of the practicality to aesthetics. The success of *Stylecraft* had given them the confidence to be a little bolder.

In one of the first advertisements for the new shape in *The Pottery Gazette* the text is careful to accentuate the change as an advancement based on the accepted and successful *Stylecraft* shape:

> '...this new range of shapes for tea and dinner ware is based on the same outline as seen in the former range but it is characterised by free flowing curves seen in the coupe style plates and the lovely graceful holloware pieces...'

Six patterns were launched initially on the *Fashion* range, one of them by the young designer, Terence Conran. After meeting Roy Midwinter, he produced a number of designs for the company on a freelance basis through the 1950s. David Whitehead, the Manchester-based textile manufacturer, had produced some of Conran's designs on their fabrics in the early 1950s and so had experience of surface pattern work. Highly influenced by the work of Italian designer, Piero Fornasetti, Conran had redesigned the Midwinter showroom with a strong emphasis on black and white. His first design for Midwinter was also monochrome, a series of naive studies of leaves and insects called *Nature Study*. These sketchy drawings, printed on the white body in black, were matched with holloware in black, utilising a new semi-matt glaze. The motifs are very similar to an Old Glamis fabric of 1954 called *Woodland*, featuring a dragonfly and skeletal leaf forms in black and white. He also prepared a series of drawings for a collectors' series of small trays. Trains, vintage cars, paddle steamers and other modes of bygone transport were depicted in a pseudo-cartoon style. Some larger patterns were reproduced on rectangular and square trays with bi-planes in turquoise, black and yellow and a 'Kandy box' set with a London bus on the lid and four rectangular trays was another fancy item. Roy Midwinter produced these as a contemporary version of the floral and traditional trays that were popular at that time in the market place. Some of the drawings, the London bus, steam train, and early motor car, have also turned up on a divided buffet tray with hand-tinting in blue. In *Pottery and Glass*, 1958, these are also advertised on a range of nursery ware :

> 'Nursery series (but adults love them too!), by W.R. Midwinter Ltd featuring old engines, motor vehicles and buses. A set of mug, bowl and plate sell for about 14s.11d.'

This ware is on a traditional shape, *Classic,* but the other Conran patterns are on the *Fashion* shape.

It was about the time that *Fashion* was launched that the Midwinter backstamps became almost as decorative as the main design. Some of the early *Stylecraft* patterns such as *Ming Tree* have a highly decorative backstamp and this idea was developed as the range moved on. The motif of a butterfly with the title and a large credit for the designer and company takes up all the space on the base of the *Nature Study* vegetable dish. The front of the large meat plate shows all nine of the motifs used on this pattern. Jessie Tait worked on the styling and placing of the motifs on this range as she did for the other Conran designs and recalls that 'bugs' were always supposed to be unpopular on ceramics. However, the stark new look of this ware seemed to over-ride any fear of insects and the pattern was very popular. Examples rumoured

to have been seen in dark green are likely to be misfired seconds.

Magnolia was a transfer print from a John Russell painting, with a large motif offset on the flatware designed primarily for the Canadian market as was a Johnson Matthey silk-screen transfer, *Forest Shadows*. During the *Fashion* period Russell produced a tremendous amount of work for Midwinter and many other companies. His style of illustration using an airbrush was quick and he was a prolific artist. Although this style has been called the 'chocolate box' end of the market, the number of patterns he produced for Midwinter shows his popularity with the buying public. *Magnolia* was the 'safety net' design, retaining a naturalistic floral motif to allay fears that the company was ignoring the traditionalists and, also, wisely not alienating the public by only selling 'contemporary' style on the modern shape. This halfway mark was a clever move as it broadened the potential sales for the new shape.

Jessie Tait designed the other four patterns for the launch of the *Fashion* shape. Her initial reaction to the shapes was not as enthusiastic as her feelings for the *Stylecraft* range. There were obvious production limitations regarding the application of decoration to shape and she felt the holloware had, perhaps, too 'futuristic' a quality, but she saw the move as pioneering and liked the idea of treading the unknown. Despite her reservations, the patterns she produced for this shape are among her best.

Pierrot was a design with black circles and grey rings placed all over the ware almost like bubbles. The holloware was decorated in the same way, rather than given a colour glaze. A promotional leaflet says that this contemporary design:

'...expresses both the gaiety and melancholy of this fabulous pantomime character...the design...will blend with any colour scheme. A smart effect could be obtained by using bright coloured table cloths or mats.'

Falling Leaves was a transfer print in autumnal colours of stylised leaf motifs with spots and stripes. These again were placed all over the ware and complement the fluidity of the shapes with their movement. The backstamp was a small leaf with the pattern name curving around it.

Capri was a print and enamel design which covered the flatware with a textile or wallpaper quality. Leaves, seeds and floral motifs are interspersed with circles of dots. These were then hand-coloured in grey, rust and yellow. The holloware had a larger motif taken from the pattern decorated in the same colours, and the backstamp too was an indulgent exercise with a hand-coloured leaf and bold lettering. This pattern was

re-coloured with yellow holloware and re-named *Bolero* later in the decade.

The last of the launch patterns was *Festival*, a free hand-painted design in grey, green, yellow and rust. Inspired by a visit to the Festival of Britain in 1951, the pattern was designed a couple of years later. Jessie had felt that there was a feeling of movement towards something new in the design world, but that it took a while to come through and what had seemed quite futuristic then, was now becoming more acceptable to the public. The Festival was the germination of much of what was to develop in British design later in the century. The Festival Pattern Group of designers had produced wallpaper, ceramic and textile designs based on crystal structures and microscope

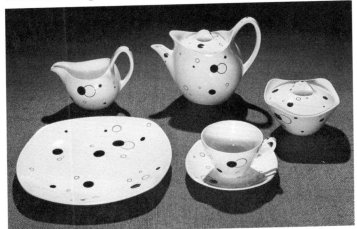

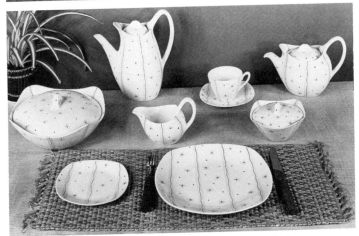

Factory promotional photographs. Above: *Pierrot*; below: *Hollywood*. *Fashion*, 1950s.

25

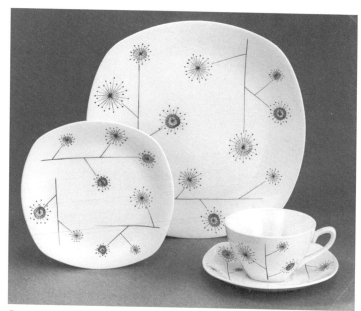

Promotional photograph showing *Flower Mist* on the *Fashion* shape, c.1956.

'The house of Midwinter has always been noted for its figures and figurines, and it is fitting that they should now be developing along contemporary lines. The figures here are the first in the *Stylecraft* range, and are the work of designer Colin Melbourne. He has captured the grace and beauty of these animals in a way which will please animal lovers and purists of contemporary art at the same time - a rare feat indeed. They are matt finished in black, white and fawn, and the range of six shown here is being regularly augmented...'

The figures shown in this *Pottery Gazette* advertisement from January, 1956, are the bison, seal, two cats, a polar bear and an otter. Two African figures were added and three 'abstract shape' single-flower vases. Altogether over two dozen pieces were produced, including a range of dinosaurs and a cat with an arched back nicknamed 'Humpy' in the factory. These were very popular but were, by their nature, quite fragile and so few are likely to have stood the test of time in one piece, particularly the spindly-legged giraffes and the over long brontosaurus.

Saladware

Alongside the launch of the *Fashion* shape, Roy Midwinter and Terence Conran produced a range called *Saladware*, inspired by the 1955 salad set designed by Piero Fornasetti in Italy. In this design whimsical images of vegetables with faces are scattered over the ware. Midwinter's version is a less riotous affair with naive black line drawings of different salad items in a more ordered pattern on the new shapes, hand-coloured in rich yellow, dark green and maroon. The range of shapes for this pattern included a salad bowl and servers, which were used for *Pierrot* as well, a celery nest, a giant condiment set, a boomerang tray and deep and shallow triangular dishes, all designed by Roy Midwinter. Teaware was also decorated with this pattern to complement the set.

The vegetable motifs created for the range were red pepper, marrow, gherkin, cress, tomato slice, bay leaves, sweetcorn, radish, garlic clove, mushroom, asparagus, spring onion, artichoke and carrot.

Changes in eating habits and the increase of affordable holidays to Europe had broadened people's outlook to food. Elizabeth David single-handedly revolutionised the way we ate with her Mediterranean recipes, romantically illustrated by John Minton. Garlic was no longer frighteningly foreign and salad was an altogether more exciting experience.

The new pattern was widely advertised and in an illustration in *The Studio Yearbook 1956-7* a small range of

images and *Festival* seems to pay homage to this work with the use of 'cell' or 'atomic' motifs, even though the marketing at the time described the pattern in terms of streamers, balloons and confetti. Maybe this was a cautionary exercise by the marketing team.

Other patterns produced at this time were *Autumn* and *Liana* – print and enamel patterns, *Gay Gobbler* – the Thanksgiving pattern for the American market, and *Carribean*, an abstract all-over print in black with hand-colouring in yellow. Ironically, this sought-after pattern was at the cheap end of production as it was made using the 'jelly-bomb' or Murray Curvex printing machine that was then new to the industry. Bess Wells remembers:

> '...plates would be done on the machine but lids would have to be done on the old method – hot printing. It was very cheap though and the hand paint was done after...'

The metal engraving was not big enough to produce a meat-sized plate so that would have had to be transfer-printed. The holloware for the design was acid yellow with transferred wavy lines flowing down the handles.

Added to the range of dinner and teawares, vases and beakers, was a series of 'contemporary figures' all designed by Colin Melbourne.

Advertisements

The Pottery Gazette, October 1955.

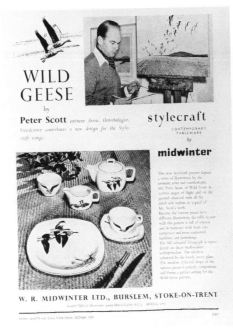

The Pottery Gazette, December 1955.

The Pottery Gazette, May 1956.

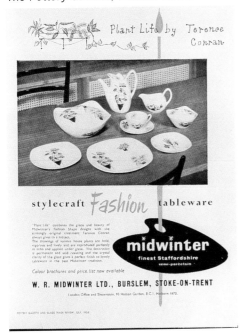

The Pottery Gazette, July 1956.

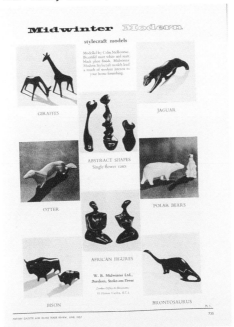

The Pottery Gazette, June 1957.

The Pottery Gazette, September 1957.

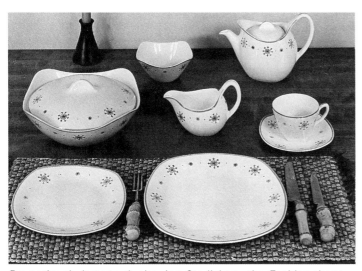

Promotional photograph showing *Starlight* on the *Fashion* shape, with *Studio* candlestick, mid-1950s.

the ware is shown in colour. Items like the double eggcup and dish with a single lug handle are on show. One of the early promotions boasts of compliments in the press and writes that the pattern is 'designed for modern terrace living'. Variations are known, such as a pastel-coloured version of three dishes in lemon, pink and light blue forming an hors d'oeuvres set with the vegetables painted in lighter colours. Another variation has green brushstrokes forming a border.

The saladware shapes were not used for all patterns by any means and an educated guess can be made as to whether some designs would appear, for example, on a celery vase or large salad bowl as they plainly would not translate onto all the shapes. *Savanna*, *Cuban Fantasy, Cannes* and *Mosaic* are known on most of the shapes and the salad servers are thought to have had very few patterns on them.

Fashion succeeds

After the initial launch of the *Fashion* shape, *Stylecraft* was still very much on the market, and a number of patterns were available into the 1960s, with many of them moved onto the *Fashion* shape. *Flying Geese,* for example, is found dated as late as 1967 on *Fashion*. *Tropicana* and *Galaxy* were among the last patterns to be designed for *Stylecraft*. Designs were added to the *Fashion* range by John Russell and Terence Conran, the latter producing his self-promotional *Plant Life*, named after a lesson in art college and featuring his own

design for a plant pot on wrought iron legs containing different houseplants. Some of the Midwinter publicity material of this period shows the vegetable dish on a similar wrought iron stand which could be ordered as an extra item.

Jessie Tait was producing designs for fancyware as well as dinner and teaware. *Liana* and *Autumn* were two designs produced predominantly for cake stands and tid-bit sets (the latter an American term for a cake stand with a dish or bowl on the top tier). *Liana* is an all-over pattern in brown of lilies with hand-colouring, and *Autumn* is a print in black of leaves and swirls with hand-colouring. Both these patterns are known on other ware so production was not limited to the fancy market.

Many of the hand-painted patterns required a consistency of line and the motif(s) had to be reasonably standard across the range. To enable designs like *Primavera, Leopard Lily* and *Festival* to have a consistent appearance a traditional method was employed. Many potteries, including Woods where Jessie worked for a short time, used a 'pounce' as a short cut to transferring a hand-painted design from paper to biscuit ware. She found that the best material for the *Stylecraft* and *Fashion* ranges was a heavyweight silver foil with the design pierced through it. Jessie would draw the original onto the foil, (making a number of copies of each), and her assistant, Bess Wells, would pierce them so that they were ready for use. The foil could be moulded to fit a bowl or dish and be used time after time. Graphite or carbon was rubbed into the foil when in place, leaving an outline image in dots on the ware. This could then be followed by the paintress and the carbon residue would burn away in the kiln leaving no trace, and a perfect painted image. There was still the style of 'handwriting' to be considered. Each paintress would have a different interpretation of a line or curve and had to mark the pieces they worked on. If one person was veering too far from the original or was too slapdash in their work the item could be traced back to them. The paintresses would paint the back of each item with their own mark, one would be a line, the next person a line and a dot, the next two lines etc. Letters were also used and in any set or service there may be a number of different 'signatures'.

Zambesi was launched in 1956 and was not only an instant success but widely imitated by other companies. Jessie remembers designing it and at the time there was a great fashion for red, so she decided to make the inner rim of the holloware, the handles, the cruet base and sauce stand, red. A red stripe was also painted down the cup and pot handles. This pattern was widely collected in the 1980s

and has maintained its following, becoming one of the 'collector's classics' of the period.

Other patterns of the same year include *Monaco,* a black and white design with black holloware which was hand-painted on early versions. *Driftdown* has transfer-printed 'star' motifs and *Savanna,* a black transfer with yellow-sponged squares and matching holloware. This was produced in large quantities on a wide variety of shapes and sold through stores like Boots. *Patio* was also a print pattern decorated with painted squares in yellow and matching holloware. *Galaxy* was launched at the same time as *Driftdown* in 1956 but was on the *Stylecraft* shape, decorated with hand-painted stars in red, and lines in grey on flatware forming a grid with grey bars on handles. *Astral* was a variation of *Driftdown* with stars in pink and turquoise and, sometimes, pink holloware.

Toadstools was an unusual design which today still seems quite modern. Brightly coloured toadstools were silk-screen printed on both flat and holloware. Roy Midwinter was in the habit of bringing in items to 'inspire' Jessie in a certain direction and, for this pattern, he gave her a sample of Rosebank fabric, having asked the manufacturer's permission to adapt it onto pottery. Another example of her versatility is the design *Gay Gobbler,* a prime turkey with a stylised border of feathers, with corn plants in the background on the large platter which is over 21ins. wide. Possibly based on the backstamp for a traditional Midwinter design called *Turkey* this print and enamel design was sold primarily on 'chop sets' in the U.S. and Canada (six large plates and a serving plate). The decision to produce the

design on *Fashion* dictated the style somewhat and the less serious approach was considered to suit the shape better than the traditional realistic style. 1957 saw the launch of another Terence Conran design, *Chequers.* David Whitehead had originally produced this design as a fabric in 1951, and Roy Midwinter decided to turn it into a pattern for the *Fashion* shape using sponged squares of colour, a technique that Jessie had been experimenting with. The pattern was launched with grey holloware at first but it was later changed to yellow. The grey was perhaps not popular as it was not a complementary colour with food. This is one of the designs that the Midwinter family used at home, *Cassandra* being another.

Conran's next design for dinnerware was *Melody,* a stylised sketch of a bunch of roses in pinks, yellow, green and black, later with light yellow holloware. This transfer has also been noted on 'Midwinter seconds' on the *Fine* shape.

Roy had been introduced to David Queensberry by Terence Conran and, on one visit to his flat, Roy commented that the potteries lived on roses and that they were the most abused flower that God had invented. However, he went on to say that there must be a way to update or modernise the image of a rose. Terence began drawing and, in Roy's words, '...these things just flowed out of the pen like magic'. *Melody* was the resulting pattern.

About this time Roy Midwinter decided to launch a range of small fancies. Using Conran's whimsical interpretation of vintage cars, paddle steamers and bi-planes these little trays demonstrated the Midwinter approach to giving anything

The Midwinter showroom as re-designed by Terence Conran in 1956 showing the extensive range available at the time.

mundane a modern flavour. Larger trays with planes are coloured in turquoise and yellow. These were launched as the 'collectors series' presumably because of their 'historic' theme. The range included:

Paddle steamers: 1830, 1835, 1837.
Bicycles: 1818, Hobby horse; 1850, Tricycle; 1884, Penny Farthing; 1872, Spider wheel bicycle.
Cars: 1894, Panhard; 1900, Benz 3 h.p.; 1903, De Dion Bouton; Wolseley.
Locomotives: 1815, 1838, 1845, 1847.
Bi-planes: 1894, Maxim's Flying Machine; 1911, Farman Bi-plane; 1912, Dunne Inherently Stable Biplane; 1926, Autogiro.

Fancies were also produced with Peter Scott designs in a number of patterns. These were watercolour images with captions and are found on small rectangular trays, the 'new English tray', divided dishes with chrome fittings, fashion trays and traditional shapes. As these were marketed through the Wildfowl and Wetland Trust shop in Slimbridge, Gloucestershire, their distribution was limited to the locality and to tourists visiting the area.

Happy Valley, one of the most difficult of the *Fashion* patterns to place in any category, is a print and enamel design of an idyllic scene with small buildings in a rural setting. A new print and enamel design was needed for the market place, and particularly for North America, and it was decided to try to marry the contemporary shape with a traditional engraving technique. The resulting design by Jessie Tait was an all-over pattern on the flatware with enlarged details on holloware. This was also produced in a single colour print (blue), on a matt glaze with holloware glazed white. Sales figures for the pattern are not known but it is not one of the more commonly found designs.

Another popular pattern of this period is *Bella Vista* a floral spray in bright colours with a scalloped border. Roy Midwinter brought in a sketch by Eve Midwinter and asked Jessie to adapt it for production. Jessie translated the design into brushstrokes and added the scalloped border, (originally in lilac and green, later only in green). Mainly found on flatware, it was produced on a wide variety of shapes and has been noted on a cakestand and slice. This pattern was also used on the *Classic* shape. The same two-colour scalloped border was used on two designs, one called *Woodford,* a hand-painted pattern of leaves, flowers and berries in grey, rust, yellow, brown and turquoise.

Many of the patterns of this period are simple transfers with coloured holloware, for example *Cassandra, Quite Contrary* and *Alpine*. These were obviously cheaper to produce than the hand-painted ware and were likely to have been produced in greater quantities. Print and enamel designs like *Bali H'ai* (John Russell), *Cannes* and *Savanna* were very popular and in production for a number of years, along with many of the stylised floral transfers of the 1950s, such as *Marguerite* and *Blue Harebells*. As with *Stylecraft*, there were still a great number of trial designs and one-offs and so it is impossible to get a clear record of the output. Many designs were launched but if little interest was shown by buyers in the trade or the general public then they were soon phased out. The samples, one-offs and trials are likely to have been circulated because, when pieces or part-sets were not put into production, they were sent to the 'second' warehouse where staff, locals or trade buyers could pick them up cheaply. This explains the number of mysterious and elusive items that turn up from time to time.

Re-colouring designs

Towards the end of the 1950s there were many changes in the designs in production. Designs on *Stylecraft* were adapted for the *Fashion* shape, *Riviera* became *Cannes* with a move to coloured holloware, and other designs like *Starlight* and *Flying Geese* adapted quite easily from one shape to the other. Patterns like *Cherokee,* based on Red Indian head-dresses, were simplified and re-coloured to a pastel range without the black line and holloware in turquoise. This, and other similar patterns including *Magic Moments,* were not produced in great quantities, their most popular form being the 22-piece teaset which limits the range of shapes on which these patterns are likely to be found. *Magic Moments* is a pattern of vertical lines over rectangles of colour resembling abstracted windows. *Chopsticks* is one of the most interesting patterns of this period, with swiftly executed paintbrush strokes in two colours covering the flatware.

Mosaic was produced in 1960 as a result of experimentation with the *Fashion* shape moulds. Jessie had been successful with this style during the *Handcrafts* period with *Moonfleur*. This time she carved an irregular grid into them to form a pattern which became *Mosaic*. The colours were sponged on and the palette was similar to *Chequers*. This was mainly available on larger and fancy shapes. The bases of these pieces have an incised shape number.

Capri, one of the first patterns on *Fashion,* was given an update. The flatware retained the all-over engraving but this was coloured in yellow and turquoise and given yellow holloware to become *Bolero. Flower Mist, Harmony* and *Chequers* were also produced with yellow or coloured

holloware. This may have been a move to keep the costs down on the print and enamel or difficult transfer patterns.

The unusual pattern names that turn up came from a number of different sources. If a sketch or painting was sent to a local lithographic house for reproduction a working title may have been adopted, and sometimes this stuck in the absence of anything better. Jessie Tait and other designers sometimes named their own patterns, but only if the marketing department, who often had different ideas, approved. Occasionally, a competition would be set for the staff on the factory floor to come up with a name for a new design. Today, without the promotional literature of the period for many patterns, it is difficult to find names for many designs. Designs for bestsellers like *Cassandra* were produced 'on spec' by the local print companies and then offered to the factories. Many of the floral and more traditional patterns would have been bought in this way, and during the 1960s there was a blurring of styles between companies as many used the same transfers from open stock. Other enigmatic designs like the *Fishing Boat* and *Desert Scene* illustrated by Charles Cobelle are likely to have come via this route. Some transfer prints were commissioned from outside sources and one bright floral transfer with stylised sprays was inspired by an American Hallcraft pattern on Eva Zeisel shapes and, in the process, became *Bouquet*.

Arguably the most commonly found design on the *Fashion* shape is John Russell's *Riverside*. In production for at least ten years, this traditional motif of bulrushes and leaves is set on dark green holloware. Russell's naturalistic designs marked the departure from the 'hand craft' side of Midwinter and the move to commercial mass production.

Another move away from the hand-crafted ware was the launch of the *Classic* shape in 1960. This was not only a regressive move style-wise, but also the patterns produced for this range tended to be safer and directed to a more mainstream market. This was basically a relaunch of the conventional shape used after the war and during the 1950s for traditional designs.

Nursery ware used to have a part to play for most companies and the Peggy Gibbons range seems to have been a success over a long period. During the *Fashion* era, Jessie designed some motifs for use on a contemporary styled nursery ware. Transfers of a spinning top, a bat and ball, a drum and drumsticks and an aeroplane appeared on mugs, plates and bowls, while a hand-painted design of pink elephants standing on a striped base was produced on two sizes of *Stylecraft* tankard. Very little of this ware is thought to have survived.

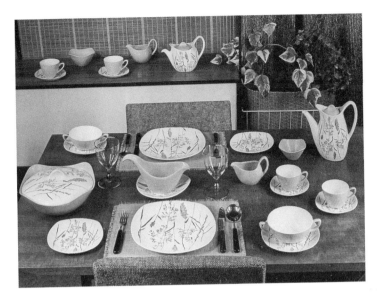

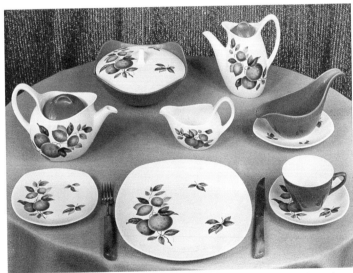

Promotional photographs. Above: *Whispering Grass,* 1960 and below, *Oranges and Lemons,* 1962, both on the *Fashion* shape.

Break-resistant Tableware

During the 1950s people were excited by the future, looking in a rather naive way to space and science to improve their lifestyles. This explained a widespread feeling among potters that conventional ceramics might not have a place in the

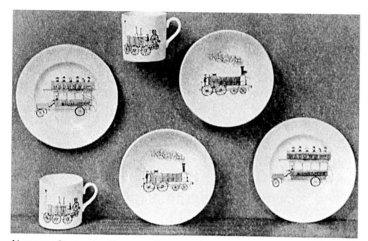

Nursery Series by Terence Conran, *Pottery and Glass*, 1958.

home of tomorrow, having been replaced by plastic which was easily disposable and, even better, unbreakable.

Melamine had been discovered in 1834 but had lain dormant until the 1930s when the American Cyanamid Company patented rights for the production of melamine formaldehyde, a malleable form of the plastic suitable for tableware. and explored its potential.

American designer Russell Wright was approached to design melamine tableware for the public after it had passed its trial stage and been used by the U.S. Navy throughout the Second World War. The first examples of this ware were launched onto an uninterested public in 1946. Having seen the disadvantages of other plastics like bakelite, they were not easily convinced. National advertising campaigns helped to raise awareness and by 1950 it had achieved a certain amount of popularity and acceptance.

If the Americans were slow to be convinced then the British housewife was even more of a challenge to melamine manufacturers. Costing about the same as the equivalent item in bone china, the disadvantages of plastic seemed quite obvious. However, the positive advantages of a durable, 'unbreakable' and colourful tableware did appeal to some and it was very much in keeping with the ethos of a 'modern home'.

W.R. Midwinter launched their version of melamine tableware in about 1958. As usual, something had to make it a shade better than its competitors and so, 'Midwinter Modern break-resistant table ware ... the first decorated ware in melamine...' was offered to the public.

This range was based on the *Fashion* shape and was made in Sutton Coldfield by the Streetly Manufacturing Company, Limited. The ware was made with a powder called 'Melmex', the name often taken to be the Midwinter brand name. It was available in eight colours, four modern and four pastel and, initially, one pattern, *Meadow Flowers*, a floral in blue and white. A 12-month guarantee against breakage, chipping or cracking, (in normal use), was given with each piece.

The ware was widely advertised in the press and also promoted at trade fairs such as Blackpool alongside the 'traditional' ceramic output. One advert from 1960 showed long-distance sailors, James Wharran, Ruth Merseburger and Tutta Schultze-Rhohof, taking Midwinter break-resistant tableware for their three-year journey in a catamaran, the ware having been chosen for its hard-wearing qualities!

Meadow Flowers was launched on new oval plates in 1965 but by this time it was broadly accepted that plastics were never going to oust ceramic tableware. It was also realised that the guarantees against breakage had, perhaps, been a little ambitious as the ware was not quite as durable as first thought. It is interesting to note that a company selling picnic sets in the 1960s offered a choice of *Evesham* or *Mexicana*

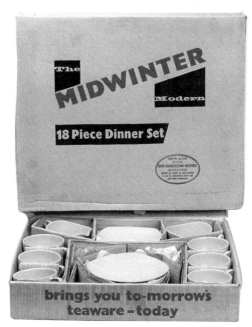

Melamine tableware in original packaging.

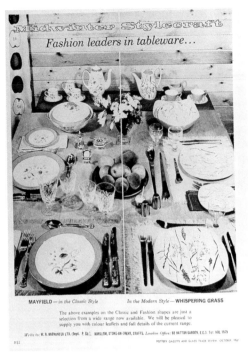

Advertisement in *The Pottery Gazette*, October 1961.

bone china on a practical and aesthetic level. The ingredients or ratios of different clays that were used to create the range were a closely kept secret and the production of different 'bodies' meant extending the sliphouse and putting a temporary stain in one mixture to differentiate between them. A special new glaze was also needed to fuse to the body successfully.

The shape was designed in a practical way by first rejecting the conventional styles of the day, a move away from the flowing lines of the *Fashion* shape, as described by David Queensberry:

> '...the very strong look in 1950s design was, by the end of the decade, beginning to look like yesterday's fashion. It had come from people like Eva Zeisel and was a dominant style which we now see in historical terms. What took over in the 60s was the cylinder which had its origins in eighteenth-century creamware. One of the great advantages of cylindrical forms is the marvellous surface that is available for decoration. It is much more difficult to decorate shapes that are based on compound curves. This was what influenced me in designing the *Fine* shape for Roy that became known on the factory floor as the churn.'

Scandinavian and American influences were not to be considered and an ability to carry different styles of decoration from classical to modern was essential. The shape that was eventually developed as a starting point was loosely based on a milk churn, though the creamware teapot shapes of William Greatbatch in the last quarter of the eighteenth century are likely to have been as strong an influence. These were seen to have proved their durability as practical and functional designs. For cups and cream soups the shape could be inverted and the proportions adapted to

on the new *Fine* shape in their sets. If plastics could not even dominate this outdoor market then they certainly could not take over the kitchens of Britain.

Fine shape

In 1962 eight new designs were launched on a new shape which had been designed by the Marquis of Queensberry in collaboration with Roy Midwinter. The *Fine* shape was a development intended to be a distinctly British creation. David Queensberry, then Professor of the School of Ceramics at the Royal College of Art, had known Roy Midwinter for some time before this venture, and had amended the design of the spout of the *Fashion* teapot. Queensberry had also designed shapes for Crown Staffordshire in the late 1950s so it seemed natural that the two would team up when Roy was looking for a new range.

Among the requirements for a new shape, one of the first to be considered was the 'body' or clay mixture. Improved colour (whiteness), strength and durability were important but the new body would also have to compare favourably with

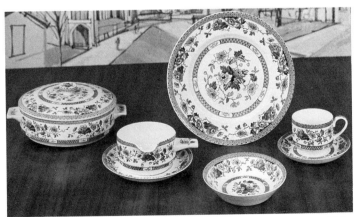

Promotional photograph showing *Jacobean* on the *Fine* shape, 1962.

form a vegetable dish or salt pot, while lug handles were applied for a gravy boat or tureen. The straight sides were a perfect vehicle for decoration, allowing larger areas of pattern than the *Fashion* range.

Once the coffee pot was satisfactorily designed, the teapot was begun and so through the range. One of the most difficult items was the cup, and *The Pottery Gazette* wrote:

> '..some of those who were privileged to see the prototype, thought it a little revolutionary - perhaps too revolutionary...'

but the idea of a straight-sided teacup was willingly accepted by the public. Twelve new patterns for this shape were tested on the South African trade buyers and were well received. Patterns launched and in production in 1962 were: *Sienna, Whitehill, Queensberry, Evesham, Kingcup, Meadow, Olympus* and *Golden Leaves. Queensberry* was the first of the stripe patterns that swamped the market in the 1960s. David Queensberry says:

> 'if you introduce something in the potteries, it goes through it like a dose of salts...by the end of the sixties there were 20 or 30 stripe patterns...funnily enough if you have been successful with a design then the copies don't tremendously bother you - and the copies are less good.'

As with earlier shapes the practicality of storage and cleaning was an important consideration. The range would have to stack well and the dual function of some items was considered. Flatware was available with different rim sizes;

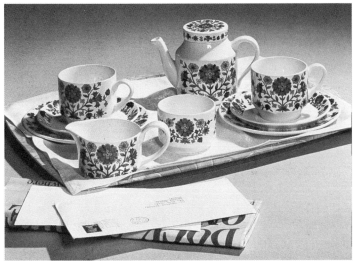

Promotional photograph showing *Country Garden* on the *Fine* shape, 1968.

Queensberry had a small rim and *Sienna* and *Whitehill* a larger rim more like a bone china plate. A coupe version was considered but not produced. As before, the trade were encouraged to sell this shape as open stock with no extra charge for matchings 'for well into the forseeable future'.

The *Fine* shape was a success and, while the *Fashion* shape became more and more 'chocolate-boxy' with the bought-in floral transfers and John Russell's naturalistic studies, exciting new designs were appearing on the *Fine* shape. Innovative patterns by young artists appeared on the shape. *Focus* by Barbara Brown was a variation of a textile design in the Op-Art style of the period, and *Diagonal* by Nigel Wilde was vaguely Op-Art influenced but proved difficult in production as the spacing of the transfer had to be perfect to achieve the desired effect. *Madeira,* by Nicholas Jenkins, was a popular abstract pattern but was beseiged by production problems as the slightest difference in the size of the ware once again altered the spacing of the motifs and the aesthetic of the pattern. Eventually pieces were sized before decoration began to prevent this problem.

In 1963 four patterns were put on display in Harrods and members of the public were asked to choose which they would like to go into production, and which colourways they preferrred. When Roy was asked about this he explained it was simply a marketing exercise and he was not literally letting the public choose their own patterns. One of the four on display was *Everglade*.

Jessie produced only one hand-painted pattern for the *Fine* shape, *Mexicana*, a stripe pattern reminiscent of a *Fashion* pattern often found on teaware. Painted in rust, ochre, olive, grey and black the pattern was later produced as a transfer, possibly to speed up production. Her other designs include *Graphic* and *Contrast,* both in black and white; *Nordic*, a repeat pattern in blue and brown, (re-coloured as *Chevron*); *Oakley*, (exclusive to Boots) and *Paisley* with a lively orange motif.

Perhaps the best-selling pattern on this shape was *Spanish Garden*. This is another pattern that owes its inspiration to textiles, this time the source being a Liberty tie. Almost psychedelic in form, the swirling leaves in blue and green effortlessly evoke the 1960s. Jessie thinks the success might have been due to the more traditional colouring rather than the high-fashion colours of the time, giving more scope for longevity. The pattern was in production for over eighteen years and was also used to decorate co-ordinated items for the kitchen and cookware – another innovation by Roy Midwinter that was quickly taken up by other companies.

Lord Snowdon at the launch of Midwinter's *Spanish Garden*, 1966.

The *Fine* shape was remodelled to some extent in 1966 to streamline the teaware. The lids were thickened and the knob taken off the top leaving a prime surface for decoration. This made the items cheaper and the shape look newer, like the re-modelling of a popular car. The flat surface of the lid was particularly suitable for designs like *Spanish Garden* as it allowed another floral spray to sprout on the top and the set to appear more colourful and fitting for the 'flower power' mood starting at the time. Another of Jessie's designs of this period, *Lakeland*, uses a plain coloured lid to emphasise the flat colour in the design. Initially referred to as *New-look Fine* the range became known as *MQ1* when the Marquis of Queensberry and Roy Midwinter joined forces for a new shape – *MQ2*.

1960s changes

After purchasing the A.J. Wilkinson factory in 1964 Midwinter had an expanded workforce and was in a better position to compete with the larger manufacturers. The factory had formerly been associated with Clarice Cliff and many of her original moulds, biscuit wares and a 'ceramic' giraffe (made from vases and tableware and originally produced to promote

the *Bizarre* ranges) were thrown out to make way for Midwinter.

New shapes were now appearing more frequently and, as ever, innovative moves were made, though not all of them were successful. 1963 saw the launch of the *Fluted* range. Some fifteen fancy shapes were produced, from vases to cigarette boxes. These mainly had glaze finishes, matt black and gloss white for example, but transfer-printed motifs like the *Arethusa* range, designed by Tom Taylor, were also used.

About this time some vases called *New Shapes* were produced with severely plain shapes like a triangular or oblong vase but there is no record of the designs or the finishes used. By this time many of the more exaggerated shapes of the *Fashion* range must have looked a little dated and the range was streamlined. Tureens lost their raised 'prongs', and were flattened or, in some cases, returned to a *Stylecraft*-style base. It is unlikely that many of the 1960s *Fashion* designs were produced on the 'salad' shapes as many of these shapes were deleted early in the decade.

One interesting accessory, produced for a couple of years in the early 1960s, was the stainless steel cutlery. Marketed as an accompaniment to the *Fine* tableware, Midwinter Stainless was also available from outlets of Arthur Price and

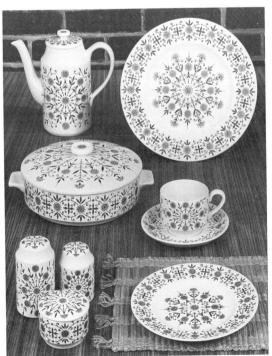

Promotional photograph of *Valencia* on the *Fine* shape, 1960s.

35

Co. under the name *Merlin*, (the original name), but the Midwinter logo only appears on the cutlery sold through outlets selling the tableware. The cutlery is regularly shown with the tablewares in many of the advertisements and promotional material issued for the *Fine* range.

An idea sweeping through the pottery industry at this time and soon to became standard was oven-to-tableware. Serving or vegetable dishes and traditional gravy boats were losing their place on the modern table and items that could cook-serve were welcomed. July 1965 saw the launch of the *Trend* shape, designed by David Queensberry, and both Poole and Johnson Brothers had designed a similar fluted range for launch at the same Trade Fair. Wedgwood and Denby also jumped onto this bandwagon The Midwinter range boasted non-stick qualities and was ovenproof to boot. These qualities were only achieved after much experimentation and outlay and though the range was succesful for a while, the limitations in designs, because of the fluted sides, left the ware too plain. Thought and common-sense factors were again employed in the design which were then used in promotions:

'..the teapot is one the biggest handed man can wash up conveniently; and the two areas most liable to damage, the handle and spout, sit quite clear of the draining board...'

The non-stick finish, called 'fluon', was problematic in production and not terribly durable in use. Midwinter did, however, manage to secure a worldwide patent for the application of ICI Fluon to ceramics and were still promoting the range in 1968. Most of the finishes on the *Trend* shape were coloured or clear-glazed, mostly blue, green, or black and white but one pattern that Jessie designed called *Sherwood* utilised the green glaze as a finish for the holloware and a geometric transfer motif in blue, green and black for the lids and flatware. Much of the ware of this period simply bears the backstamp 'fine tableware' rather than the name of the shape. The Blackpool Fair of 1966 saw the launch of a version of *Trend* with the fluting removed. The pattern illustrated, *Mediterranean,* was later to surface on the *Fine* range, the unfluted version perhaps not securing enough interest from the buyers.

The *Portobello* or *Studio* shape seems very much at odds with the rest of the factory's output over this decade, particularly in its conceptual glaze finish. The interior design magazines of the day were promoting a handmade and hand-crafted look with the emphasis on wood, natural stone and earthy homespun fabrics. The sleek lines of the *Fine* and *Trend* shapes had no place in this environment and so another

new shape was called for. Rather than produce a shape from machine-turned plaster blocks, a studio potter was called in to create a design straight from the wheel. David Long, a Canadian craft potter, produced the original shapes that the *Portobello* range was based upon. Originally this ware was intended to have only coloured glaze finishes but these proved too difficult to produce to a definable 'standard' as the colours were so unpredictable. Some transfer patterns had to be commissioned to save the range. Large floral transfers in natural, earthy colours were produced by John Russell to go with the plain glazed lids or bodies. The original plan for the *Maple* and *Conifer* glazes proved too unreliable for a consistent finish and were, presumably, only available for a short period, particularly as they are so seldom seen now. Jessie Tait produced a couple of floral designs with a hand-painted feel for this shape, the holloware being plain brown, but these were probably reworked for the new *Stonehenge* shapes then in development. *Portobello* was rescued to some extent when it was relaunched in 1970 and patterns like *October* and *Sunflower* actually sold very well. Advertisements for 1970 show the new factory, and the patterns *Spanish Garden, Cornfield* and *October*. They also apologise for late delivery, with promises to rectify any problems and to give extra help to their stockists with more advertising and promotional support.

MQ2

David Queensberry and Roy Midwinter teamed up for a follow-on to the hugely successful *Fine* shape. The inspiration for *MQ2* was the idea of combining the cylinder and the sphere to echo the shape of a laboratory retort. Many versions were turned in plaster and cast from moulds before a suitable shape was arrived at. The cup was a hemisphere on a cylindrical foot and looked quite good in elevation but, when finished, somehow did not look right. Decoration did not show on the outside and a transfer motif had to be placed inside to make the pattern work. As with the *Fashion* range, some of the other *MQ2* shapes left little scope for transfer decoration as there were curves in two directions and any reasonably sized transfer would crease or split. The tall neck of the tea and coffee pots, the centre band of the body and the lid were the prime areas for decoration. This limited the styling of the ware though the idea was to market the range in plain white as well.

Jessie designed some contemporary florals in spring and autumn colours, *April Flowers* and *September Song*. These

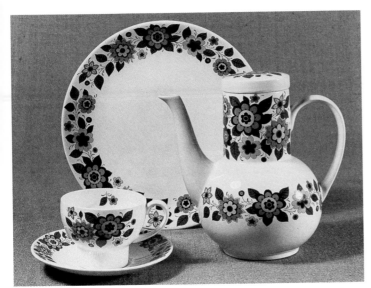
Promotional photograph showing *September Song* on the *MQ2* shape, 1968.

made use of the easiest areas to decorate, covering the slim neck of the pot and adding a motif inside the cups. Very few patterns went into production on this shape but *Pierrot,* by Nigel Wilde, is very much a period piece with its wild blue swirls. Overall, the shape was unsatisfactory. The plates and the larger pieces worked well, but the cup for the *MQ2* range was an unsatisfactory shape and did not look right when viewed from above. When it reached the shops the public were not convinced and the range never took off. As David Queensberry says today, '...if we had made the cup as a simple hemisphere with a tiny little foot the range would have been a success...the cup destroyed *MQ2*'.

Despite its credentials the *MQ2* shape was not a success but the *MQ1* continued to sell well, and new designs like *Tango* by Eve Midwinter and *Kismet* and *Bengal* by Joti Bhowmik were tailor-made for the times.

Returning to the popular *Fine* shape, Jessie's later work shows how well she adapted to the changing requirements and production methods. *Sunglow* flower-power images in orange and brown and *Country Garden* all have a late-1960s hallmark while the abstract designs of the period, *Shetland, Berkley, Oakley* and *Broadway* still look clean and 'modern'.

In 1968 a new shape called *Pedestal* was ready to be launched on the home market with a full colour front page advertisement in *The Pottery Gazette*. Designed as a range

of fancies with a 'classical' feel harking back to the drinking vessels of ancient times, it was prepared for production. Jessie had designed a pattern with blue and yellow flowers in a repeat pattern with corresponding green lids. The footed shapes were reminiscent of the current fashion for white tables and chairs with a single 'space-age' pedestal, the shape used for the soup goblets designed by Susan Williams-Ellis at the Portmeirion factory.

The whole range was developed by Sid Machin, the head modeller at Midwinter. From original sketches he started with the bases and worked the bodies of the ware, bearing in mind the dual or multi-function of the piece and stackability. The process of designing a shape is detailed in *The Gift Buyer*, February 1968:

'Starting with the designer's pencil sketch, Sid sees every item through from the first original mould in plaster to the final moulds of the production run. He says that often something drawn on paper turns out quite differently when you get into the third dimension and the pieces may be altered a dozen or more times before he arrives at what will be the finished product...Even when Sid and the artist decide what they would like the finished product to look like, it may be quite impossible from a mass production point of view and it becomes necessary to compromise to strike a balance between the functional and the aesthetically pleasing. All Midwinter tableware must be designed to fit into the latest modern mass production machinery, but in the early stages the accent is more on design than on the actual productivity of the articles.'

Pedestal was intended to be a full range of giftware with jam/honey pots, large mugs, butter dishes, sugar shakers, trays, cruets, eggcups and candle sticks. The range was also planned to have presentation boxes with a 'smart surface design' but it is unlikely that these have survived, if indeed they were put into production.

Jessie produced a number of surface patterns for this range, from stylised florals to overlapping 'tile' patterns, many of which went no further than artwork stage. Trial runs of about two dozen of each piece were produced and used in promotional photography with finished transfers on them. These are unlikely to have the factory backstamp on them and are attributable by shape and pattern only and are one of the true rarities in the production history of the factory.

After the takeover of the Wilkinson factory and the relative failure of the *Portobello* and *MQ2* shapes, there was a financial strain on the company. J. & G. Meakin took over Midwinter in 1968 and one of their first moves to cut losses was the cancellation of the launch of this new shape. The

Midwinter team moved offices, and some designs that were in preparation for Midwinter were then used on Meakin shapes. It is thought that the pattern books for the *Stylecraft* period were lost at about this time. In 1970 there was another takeover when Wedgwood bought out J. & G. Meakin and thereby gained control of the Midwinter name. This had no immediate effect on the Midwinter output except the addition of the words 'Member of the Wedgwood group' on the backstamp.

Stonehenge

Following the set-backs in producing new shapes in the late sixties, Roy Midwinter came to the fore again:

'Midwinter took the biscuit for the most daring version of the all-pervading 'casual' look at Blackpool, with 'Stella', a mottled, rough cast pattern in the *Stonehenge* range. Exciting in shape, decoration and modelling proficiency, the latest offering of the enterprising factory was the joint effort of Roy Midwinter, Jessie Tait and Sydney and Derek Machin.' (*Tableware International* March 1972)

Relaxing attitudes in table etiquette meant that companies were kept on their toes to meet changing public tastes. *Stonehenge* was a studio-finish shape with modern undertones – the geometric body and the curve of the handles combining with the tactile lid on the teaware to make a contemporary statement.

Four patterns had been shown initially on the new shape, *Medallion*, *Blue Dahlia*, *Flowersong* and *Bluebells* all by Jessie Tait. These were underglaze litho-prints with a matt finish. Roy had been keen to achieve a 'bargeware' feel with the shape and decoration and the print quality has a brushstroke-look to some of the designs. *Caprice* was designed as a follow up to *Spanish Garden* and other patterns like *Fresco*, *Woodland* and *Hazelwood* have a distinct feel of the times and co-ordinate well with the holloware glaze colours, such as maize, nutmeg and cinnamon. These were also available as plain sets with the flatware having a simple band of the holloware colour.

Rather than being a shape too advanced for public taste, like *MQ2*, *Stonehenge* fitted the period. The development of the speckled *Creation* glaze with its iron oxide edging added durability and was the perfect finishing touch. This finish was partly inspired by the 'mocha ware' of the nineteenth century where an organic 'tree' motif was produced with a spot of tobacco and urine that 'grows' in the firing.

Roy Midwinter's wife, Eve, was one of the innovative forces

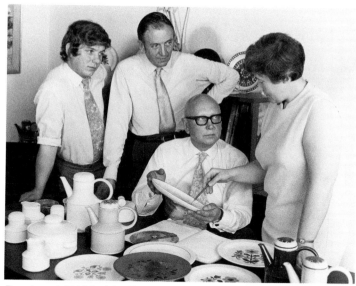
Derek and Sid Machin, Roy Midwinter and Jessie Tait with *Stonehenge* patterns, c.1972.

behind the finish and the first sets of designs utilising this effect. Following *Bella Vista*, Eve went on to design *Tango* and *Roselle*, (a best seller for Midwinter), for the *Fine* shape but it was *Stonehenge* on which she left her mark. Having worked for the Portmeirion factory for a while, Eve had a good understanding of glazes and finishes. She managed to trial some glazes that she had asked Ron Carter – 'a wizard glaze chemist' – to make up for her. Midwinter had achieved the whitest body colour on earthenware with the *Fine* shape and now Eve set about making a texture and giving it colour. This was at a time when brown bread, brown eggs and homegrown produce were the 'fads' of the day. Ron worked out a way of suspending reactive speckles in the glaze by coating them with plastic. This would then fire away in the kiln and leave the speckle in the glaze finish. Ron then made a small amount of iron oxide solution that could be painted or used for banding, with the same reactive quality as the speckles. Eve took her trials to the kiln for firing. The first batch of glaze had been mistakenly thrown away as it was thought to have been tainted but eventually Eve had the finished articles back and could see their great potential. Mike Eccles, a Canadian buyer, was excited by the plate and placed an enormous order for what was to become the *Creation* glaze pattern. The problem then was to work back to find a commercial way of producing the finish to a standard. At the height of its popularity the *Creation*

glaze was being ordered at the rate of five tonnes a week. Another friend of Eve's, Gordon Stanley, found a way of screen printing coloured glazes onto sheets which could then be cut and placed onto ware. Eve cut out some circles in yellow and gold and painted some of the iron oxide between the colours on a plate. This experiment became the hugely popular *Sun* pattern. *Moon* and *Earth* followed and the advertising cleverly said, 'Having given you Creation, we now present Sun, Moon and Earth'.

Sun and *Moon* are tremendously popular with collectors today along with the third of the series, *Earth* – bold, brown stripes on cups and concentric rings on other ware. *Sun*, has vibrant yellow and gold concentric circles and the same design in blues forms *Moon*. All these were very successful at the time and the factory kept them all in production until 1982. *Sun* continued after that date, which explains its more frequent occurrence today than the other two.

The other ground-breaking pattern on this shape was *Wild Oats*. Harry Webster, engraver at the then small company, Transgrave Studios, produced a copper plate from Eve's artwork of grasses. Eve wanted real depth to some areas of the engraving to help the reactive quality of the print on the finished article and the copper plate was adapted to cater for this. This became a bestselling pattern and, like many others, was widely copied.

Jessie Tait produced *Nasturtium,* her last pattern for Midwinter, at about this time. Roy Midwinter was then Design Manager of the earthenware division of Wedgwood and one day gave Jessie a few fresh nasturtiums and asked if she could 'do anything' with them. The resulting pattern fully exploits the effect of the reactive and the vivid colours of the printed glazes. This pattern was withdrawn from general sale because of legislation on cadmium but matchings were available until about 1982.

Stoneware and Style

Stoneware was the next innovation in shape, once again employing the talents of a studio potter, Robin Welch. The gap between studio and commercial pottery seemed to be closing with many factories producing a range similar in feel to *Stonehenge,* but Midwinter *Stoneware* used a different body far closer to real stoneware. Robin Welch produced prototypes which were adapted for production by Sid Machin, and Roy Midwinter undertook extensive market research to ensure the success of the new shape. Initially the concept was to leave the glaze as the only decoration but, as a commercial venture, it was felt that it had to be decorated with some sort of pattern. Eve Midwinter used her skill with reactives to produce patterns and four were shown in September 1979. *Natural, Hopsack, Denim* and *Blueprint,* as the names suggest, are earthy and natural, and *Petal* and *Provence* were added to the range soon after. There were the usual problems in production, some of the shapes proving difficult and, inevitably, concessions had to be made. The range was a success and some of the patterns remained in production for a good many years.

The *Cookware* range was added to the factory output with patterns like, *Ratatouille, Still Life* and *Invitation* and a Clarice Cliff influenced pattern, *Crocus,* was put on souffle dishes and other ware. The oven-to-tableware range was now hugely popular and items such as avocado dishes, orange squeezers, oil and vinegar sets and flan dishes completed the range. Oven-to-tableware was described as, 'tough as they come' but advice was given on care and cleaning.

Eve Midwinter produced three ranges for Midwinter in the 1980s, one of which, was a return to clean white tableware and the simplest decoration. *Forget-me-knot* is a design in greys and black with three strands forming a knot as they travel over the ware. Tea and dinner ware was produced, the covered sugar often being mistaken for a ginger jar, and the

Eve Midwinter working on the *Stoneware* range, c.1979.

vegetable/casserole dish had a lid that could be reversed to act as another serving item.

Style was elegant with extravagant handles sweeping over oval bodies. The plates were round but the oval theme is echoed in the rim, a feature that was picked out for some designs. Eve felt that fashion was moving away from natural and earthy tableware to a softer, feminine look and she spent three years with a design team coming up with the range. As she now had a reputation for glaze treatments a new finish was required for the range. Five colours were chosen to speckle the clear glaze and they were a mixture of hard and soft glazes, some of which would spread when fired and some would just be a coloured spot. *Confetti* was the name given to the finish and it was considered suitable to stand as a pattern in its own right, though the same glaze was used for two other patterns with transfer motifs. The promotional material shows the new range on high-tech surfaces with different foodstuffs sprayed silver and most of the launch patterns began with 'c' for an extra stylish touch. *Calypso, Cameo, Carnival, Coral Mist* and *Crystal* were displayed alongside the simple, undecorated version, *White*. Patterns such as *Chromatics* with bold diagonal stripes were very influenced by the clean, graphic textiles of the period.

Reflex, issued in 1986, was the final shape put out with the Midwinter name, designed by Eve Midwinter and her team, and issued in 1986. Traditional in form with a hint of homage to the 'Utility' or 1930s eras, the range was not in production for long. The patterns issued, such as *Enchantment,* were among the first of a new style of floral that is still found on new ware today. Swirling leaves and flowers flow along the body lines and around rims like the organic work of designers in the Art Nouveau period.

By the mid-1980s the interest in Clarice Cliff and her work was in full swing. Midwinter, having bought her Wilkinson factory back in 1964, retained the rights to her designs and Eve set about trying to produce high-quality copies of some of the more popular designs. The colour of the body and the bright enamels were a challenge as many of the old colours were now banned because of toxic contents and some were almost impossible to reproduce. Despite the problems, the range went ahead as a strictly limited edition issue. Eve brought in some unemployed school leavers on the Youth Opportunities Programme and set about teaching them traditional hand-painting techniques. Any pieces left over after the numbered issue were destroyed.

The Midwinter factory closed in April 1987 although some patterns still bore the Midwinter name for some years afterwards and some patterns were still available for matchings. The closure of the Midwinter Newport Pottery production facility meant rationalising patterns in production. An interesting memo to stockists makes reference to the *Stoneworks* range which was to be taken out of production almost immediately, which transpired to be the export name for the *Stoneware* range.

Later Careers

Jessie Tait left Midwinter in 1974 having been with the company for twenty-eight years. She moved to Johnson Brothers, another division of the Wedgwood group, and continued designing until she retired in the early 1990s. She is still busy in the industry, producing designs for Far Eastern and British companies.

Roy Midwinter left Wedgwood in 1981 and moved to Federated Potteries, producing a range of patterns which echoed the revival of interest in the work of the 1950s and made a contemporary statement. He died on the 11th August 1990.

Eve Midwinter left Wedgwood in 1986 and did freelance work until she took up a post at Royal Stafford where she produced an embossed range, *Lincoln*, which has been in production ever since.

Celebrations at the factory, 1950s.

Colour Plates

Key to the captions: items are identified first according to the shape listings (starting on page 101), for example, SC16 means *Stylecraft* shape coupe soup; the pattern name follows in bold (or bold italic when adopted names have been used); the date follows the pattern details.

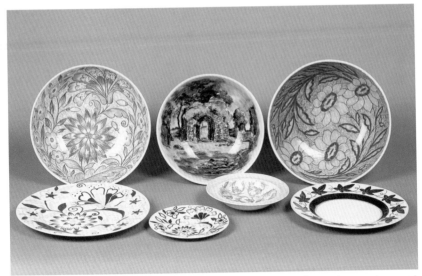

Handcrafts period 1947 onwards. Back row: three bowls – **Moonfleur** colour version; rural scene; floral design by Jessie Tait. Front row, **Moonfleur** dinnerware two colour variations, Handcrafts cereal bowl, **Parkleigh** plate.

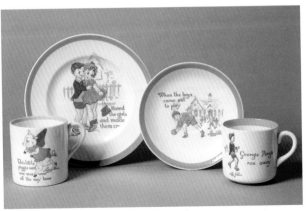

Peggy Gibbons Nursery ware. Beaker, plate, saucer and teacup 1940s to 1960s.

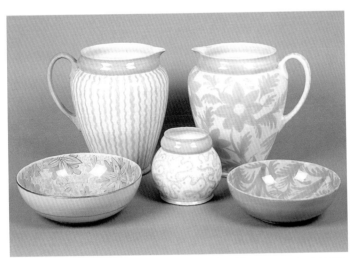

Handcraft period wares decorated in clay stains. The vase centre has the decoration incised into the pottery mould to speed up decorating. Probably all Jessie Tait designs, from 1947 onwards.

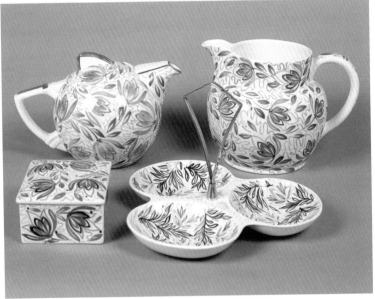

Lamont pattern on Utility teapot, large jug and cigarette box (RL), Handcraft period pattern on trefoil, from 1947 onwards.

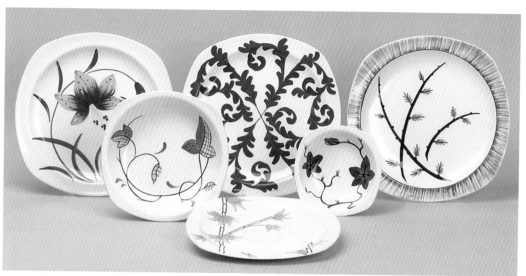

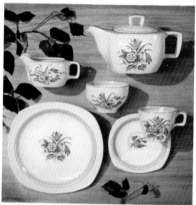

Left to right, back row: SC1, **Leopard Lily**, 1953; SC1, **Pageant,** c.1953; SC1, **Spruce**, 1953; middle row: SC16, **Sherwood**, 1953; SC14/4, *Ivy,* 1953; front row: SC3, **Silver Bamboo**, 1953.

Promotional leaflet, 1953.

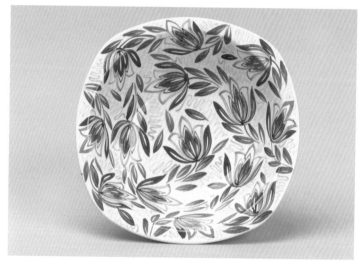

SC19, *Lamont*, hand-painted design by Robert Lamont Midwinter. This was originally a **Handcrafts** pattern which pre-dated **Stylecraft**, c.1953.

Centre right, left to right, back row: SC16, **Un-named**; SC26/M, **Arden**; SC2, **Arcadia**; middle row: SC1 on chrome foot, **Summertime**; SC43/S, **Arden**; SC13, **Woodside**; SC35, **Wild Rose**; SC43/L, **Pussy Willow**; front row: SC5/L & 6, **Mountain Lily**; SC34, **Petula**. 1953.

Bottom right, left to right, back row: SC1, **Shalimar**; SC1, **Ming Tree**; front row: SC16, **Shalimar**; SC35, **Ming Tree**; SC33, **Encore Green**; SC40, **Encore Blue**; SC49, **Encore Green**. 1953.

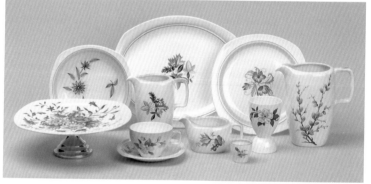

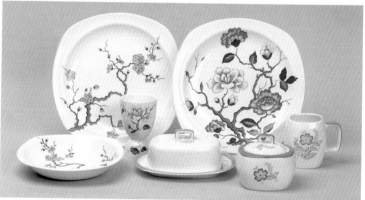

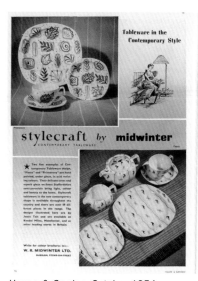

House & Garden, October 1954.

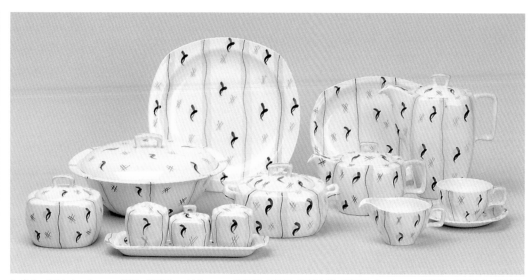

Left to right, back row: SC1, SC24; middle row: SC20, SC22, SC31/S, SC30; front row: SC40, SC36-9, SC45, SC9 & 10A/D. **Fiesta,** 1954.

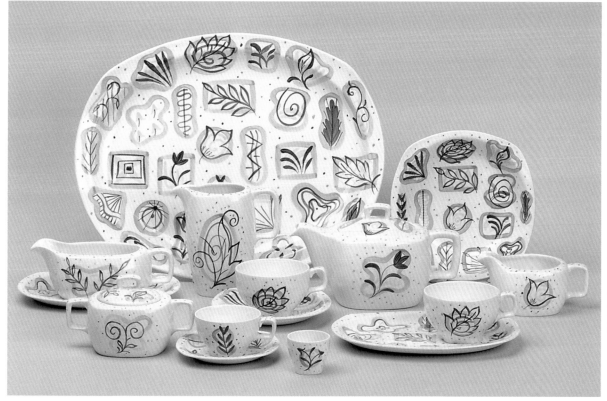

Left to right, back row: SC26/L, SC16; middle row: SC23 & 24, SC43/S, SC5/L & 6, SC31/L, SC13; front row: SC11, SC9A/D & 10A/D, SC34, SC50 & 5/L. **Primavera,** 1954.

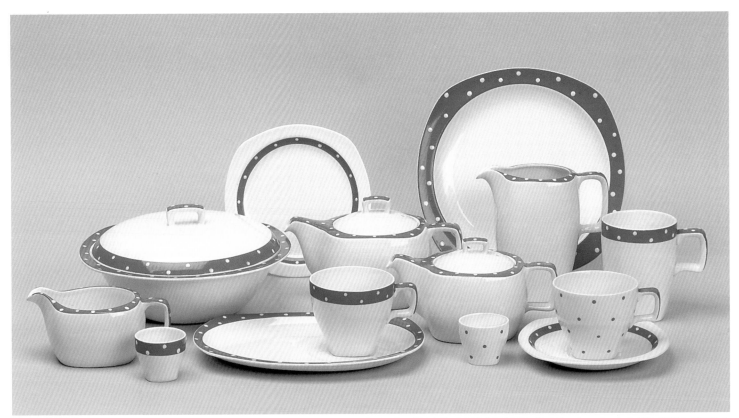

Left to right, back: SC4, *Domino variant*; SC1, **Red Domino**; middle: SC20, SC31/M, SC31/S, SC43/M, SC46, **Red Domino**; front: SC13, SC34, SC50 & 5/T, **Red Domino**; SC34, SC5/T & 6, *Domino variant*. 1953.

Left to right: F215, **Festival**, 1955; F215, **Zambesi**, 1956; SC51/5, **Riviera**, 1954; SC51/5, **Red Domino**, 1953.

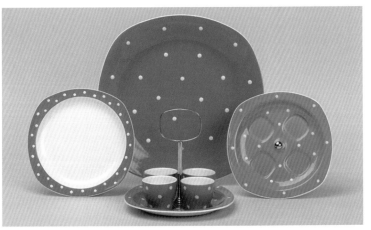

Left to right, back: SC4, **Blue Domino**; F1, *Blue Domino variant*; eggcup tray, **Green Domino**; F231, *Blue Domino variant*. 1950s.

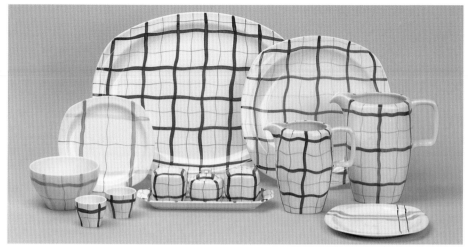

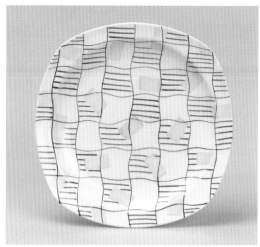

Above*:* SC3, **Tropicana**, c.1955.

Above left, left to right, back row: SC12, SC4, **Homeweave variant**, c.1954; SC26/L, **Homeweave Red**; SC1, **Homeweave Green**; front row: SC34, **Homeweave Green,** 1953; SC34, **Homeweave Red**, 1953; SC36-9, **Homeweave Red**; SC43/S, **Homeweave Green**; SC43/L **Homeweave Red**; SC4, **Un-named**, 1953.

Centre, left to right, back: SC17, SC1, SC20; front: SC5/L & 6, SC45, SC31/L, SC13, SC34. **Fantasy**, 1953.

Below left, left to right, back: SC1, **Starlight**, 1953; SC26/L, **Contemporary**; SC1, **Hawaii**; front: SC43/S, **Hawaii**; SC23, **Silver Wheat** blue; SC13, **Starlight**; SC34, **Silver Wheat** red; SC5/T & 6, **Hawaii**, early 1950s.

Below right, left to right, back row: HW3, **Trellis Green**; HW2, **Flower Mist**; HW16, **Festoon**; front row: HW12/S, **Trellis pink**; HW12/L, **Flower Mist**; HW13/S, **Trellis yellow**; HW31/L, **Flower Mist**; HW12/S, **Cherokee**; HW13/L, **Flower Mist**. 1950s-60s.

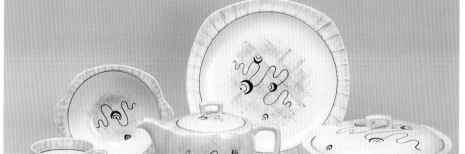

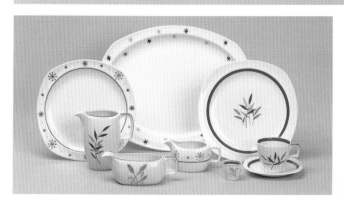

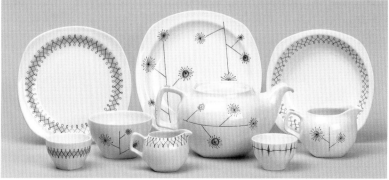

Designs by Hugh Casson.

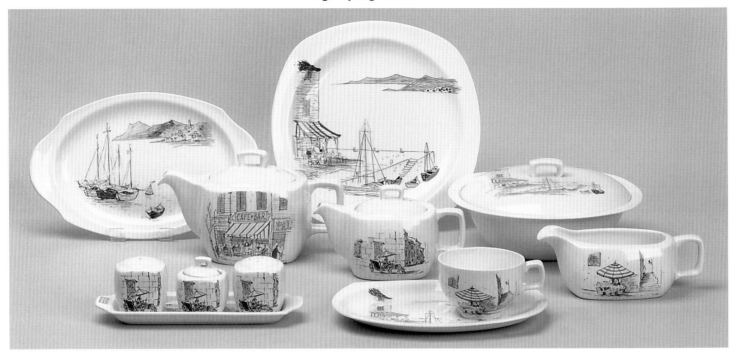

Above, left to right, back row: SC52, SC1, SC20; middle row: SC31/L, SC31/S; front row: SC36-9, SC50 & 5/L, SC23. **Riviera**, 1954.

Right, left to right, back row: F2, F26/L; middle row: F4, F58, F60; front row: F34, F9 & 10, F36-7, F235, F15. **Cannes**, 1960.

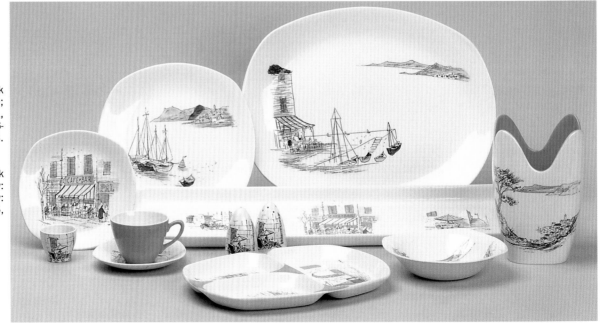

Designs by Peter Scott.

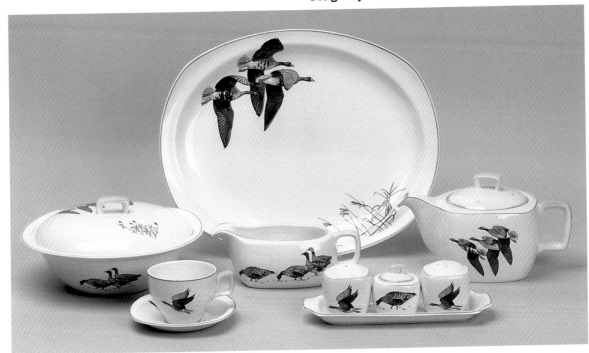

Left to right, back: SC26/L; middle row: SC20, SC23, SC31/L; front row: SC9A/D & 10A/D, SC36-9. **Wild Geese**, 1954.

Left to right: F3, F307, F34, F55/S. **Wild Geese**, 1960s.

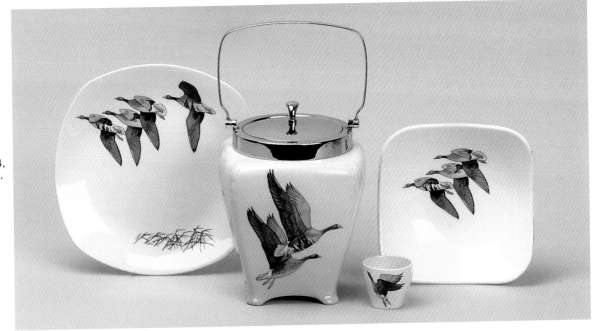

Above left: SC1, **Galaxy**, 1956.

Above right: SC1, **Cloudline**, c.1955.

Left, left to right, back row: F202 x 2, F201, F202 x 2, banded pattern, front row: F208 x 2, music score with banding and coloured dots. c.1950s.

Left: **Fashion** tray cast in terracotta with coloured slip-trailing. Vase and teapot stand thrown and decorated by Jessie Tait, c.1950s.

Below: *The Pottery Gazette*, April 1957.

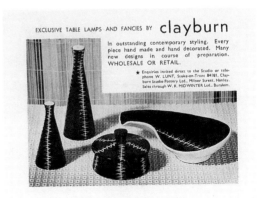

EXCLUSIVE TABLE LAMPS AND FANCIES BY **clayburn**

In outstanding contemporary styling. Every piece hand made and hand decorated. Many new designs in course of preparation. WHOLESALE OR RETAIL.

★ Enquiries invited direct to the Studio or telephone W. LUNT, Stoke-on-Trent 84181, Clayburn Studio Pottery Ltd., Milner Street, Hanley. Sales through W. R. MIDWINTER Ltd., Burslem.

Vases decorated by Jessie Tait in blue, on clay-stained body. Clayburn Pottery, c.1954.

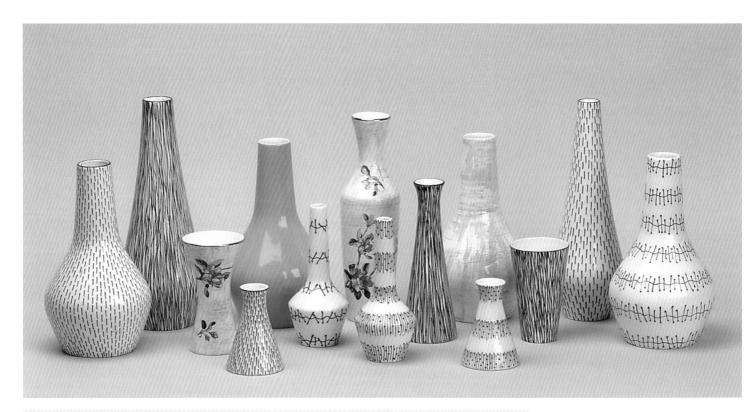

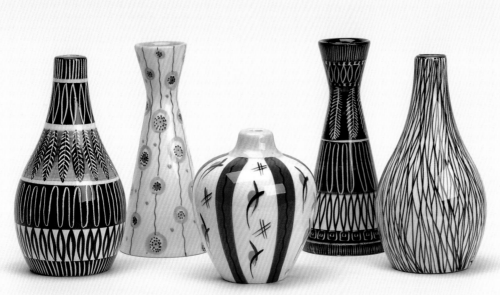

Above, left to right, back row: F203, stubble; F201, **Tonga**; F203, turquoise glaze finish; F206, **Apple Blossom Fashion**; F203, grey texture; F205, stubble; F203, music score; front row: F210, **Apple Blossom Fashion**; F208, stubble; F209, music score; F209, bands and dots; F207, **Tonga**; F208, bands and dots; F202, **Tonga**. c.1956-60.

Left, left to right: Jessie Tait design; ***Festival variant***; ***Fiesta variant***; Jessie Tait design; ***Tonga variant***. Clayburn Pottery, c.1950s.

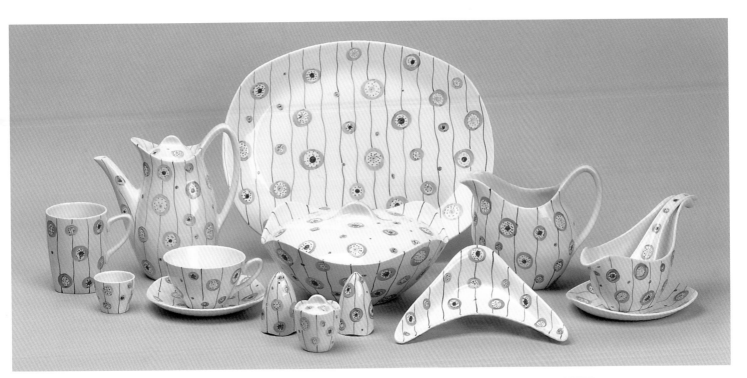

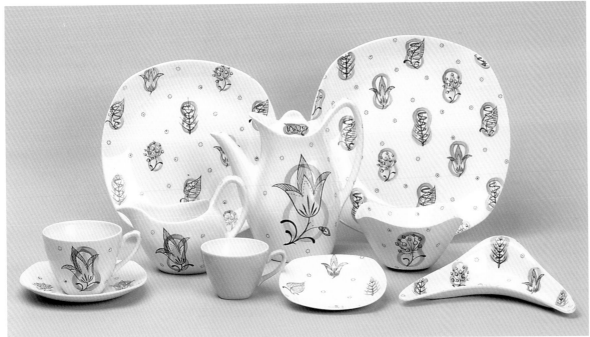

Above, left to right, back row: F46, F30, F26/L, F43/L, F23, 23/L & 24; front row: F34, F5/L & 6, F36-8, F21, F61/S. **Festival**, 1955.

Left, left to right, back row: F3, F1; front row: F5/T & 6, F13, F30, F12, F61/S, **Capri**, 1955; centre front: F9 & 10, **Bolero**, c.1960.

Designs by Terence Conran.

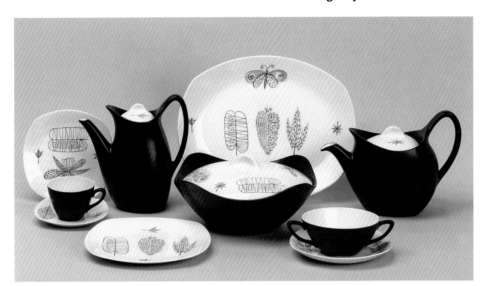

Left, left to right, back row: F4, F30, F26/M, F31/L; front row: F9 & 10, F3, F21, F51 & 52. **Nature Study**, 1955.

Below right: F263 x 3. *Pastel Salad*, c.1960.

Below left, left to right, back row: F3, F17, F28, F60, F1, F31/L; middle row: F62, F63, F61, F66, F33, F58, F55/L & F59 x 2, F54 & 54/B, F7 & 8, F5/L, handled beaker; front row: F4, F14. **Saladware**, 1955.

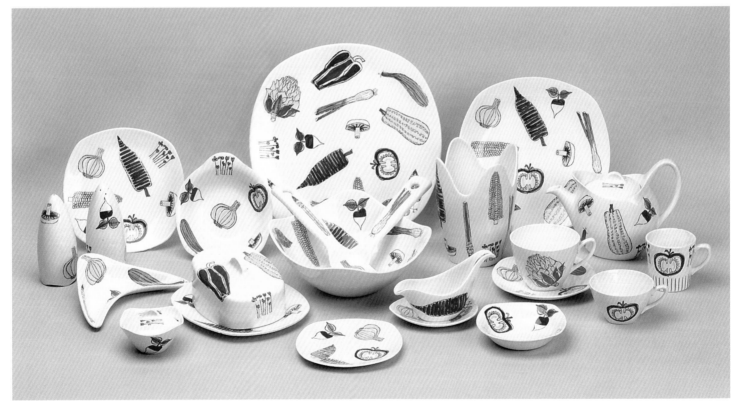

Designs by Terence Conran

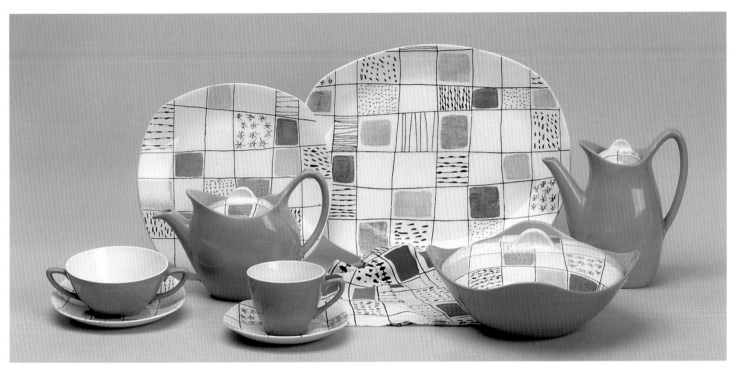

Left to right, back row: F2, F26/L, F30; front row: F51 & 52, F31/M, F5/T & 6, F21. **Chequers**, 1957. Fabric samples by David Whitehead, c.1951.

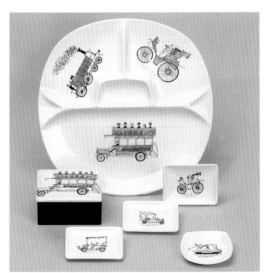

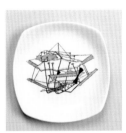

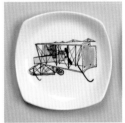

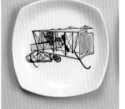

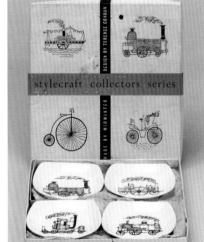

Left to right, back row: F216, F240, F241 x 3, F42. **Fashion**, c.1955.

Four **Fashion** trays, c.1955.

Boxed Collectors series, F42 x 4. **Fashion**, c.1955.

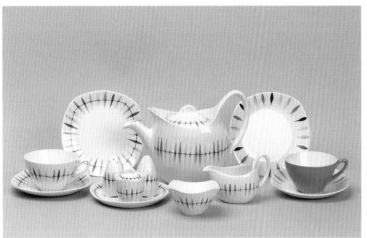

Left to right, back row: F4, F31/L, **Cherokee**; F4, *Cherokee variant*; middle row: F5/L & 6, F36-9, F44, F45, **Cherokee**: F5/L & 6, *Cherokee variant*. 1957-60.

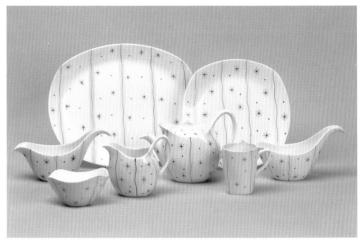

Left to right, back row: F26/L, **Elstree**; F1, **Hollywood**; front row: F23, **Hollywood**; F12, **Elstree**; F43/L, F31/L, **Hollywood**; F46, F23, **Elstree**. 1950s.

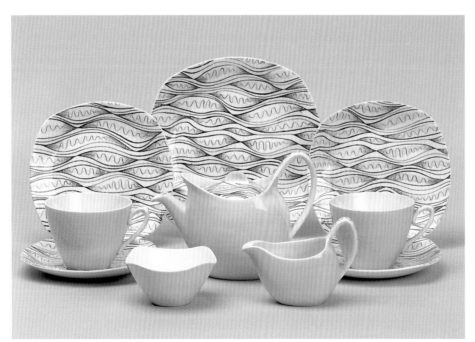

Left to right, back row: F4, F1, F4; front row: F5/T & 6, F44, F31/S, F45, F5/T & 6. **Caribbean**, c.1955.

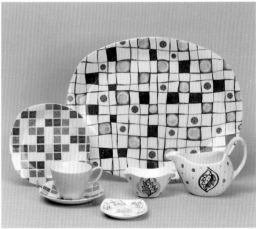

Left to right, back row: F4, **Patio**, c.1960; F26/L, **Homespun**, 1960s; front row: F5/T & 6, **Patio**, c.1960; F42, **Monaco variant**; F44, F13, **Autumn**, 1955.

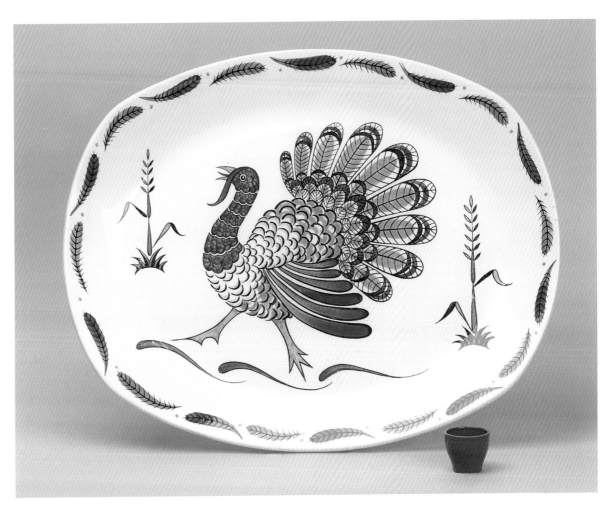

Above, left to right: F26/XL, **Gay Gobbler**, 1955, [F34, maroon glaze finish, for scale].

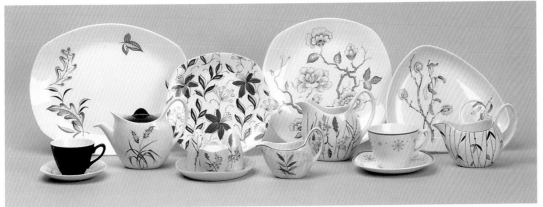

Left to right, back row: F26/M, **Falling Leaves**, 1955; F3, **Liana**, 1955; F1, *Ming Tree Fashion*, 1950s; F243, **Unnamed**; front row: F9 & 10, F31/E, **Bali H'ai**, 1960; F36-9, **Whispering Grass**, 1960; F45, *Hawaii Fashion*, 1950s; F43/S, **Whispering Grass**, 1960; F5/T & 6, *Starlight Fashion*, 1950s; F13, **Bamboo**, 1960s.

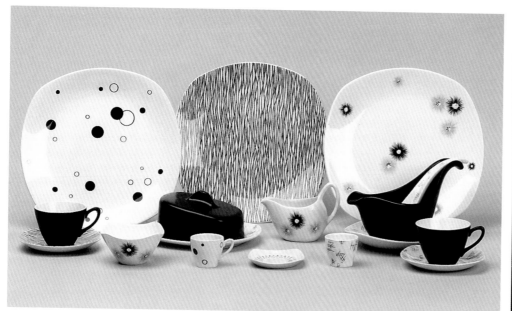

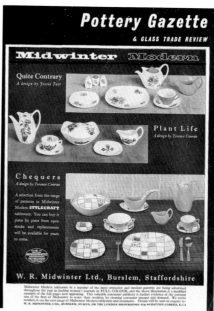

Left to right, back row: F1, **Pierrot**; F1, **Tonga**; F1, **Driftdown**; front row: F9 & 10, **Tonga**; F44, **Driftdown**; F33, **Monaco**; F34 with handle, **Pierrot**; F42, **Trellis**; F45, **Driftdown**; F34, F23, 23/L & 24, F9 & 10, **Monaco**. c.1955-6.

Cover advertisement *The Pottery Gazette*, April 1957.

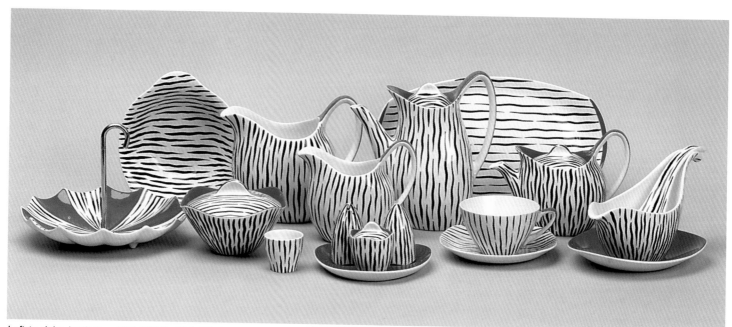

Left to right, back row: F17, F43/L, F30, F248; front row: F214/L, F11, F34, F43/S, F36-9, F5/L & 6, F31/E, F23, 23/L & 24. **Zambesi**, 1956.

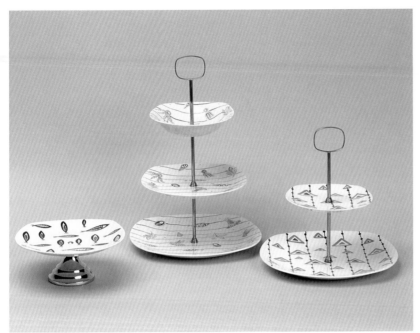

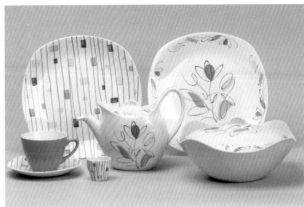

Above, left to right, back row: F2 on chrome foot, **Fish**, c.1955; F1, F2, F15 with anodised copper fitting, **Seaforms**; F1, F4 with fitting, **Triangles**, c.1955.

Above right, left to right, back row: F1, **Magic Moments**; F1, **Harmony**; front row: F5/T & 6, F34, **Magic Moments**; F31/L, F21, **Harmony**. 1950s.

Right, left to right, back row: F4, **Marguerite**, 1958; F1, **Quite Contrary**, 1957; F4, **Alpine**, c.1959; front row: F21, **Quite Contrary**, 1957; F9 & 10, **Astral**, c.1950s; F30, **Daisy Dell**, c.1961.

Below, left to right: F55/S with fitting, F55/L, F38, F237, F248, **Cuban Fantasy**, 1957.

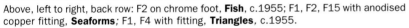

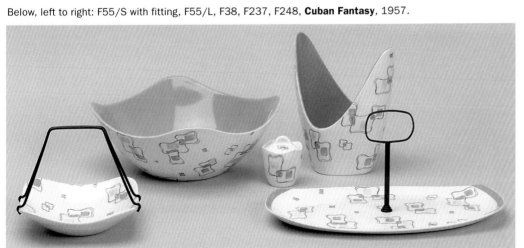

Left to right: F23 & 24, F26/L, F21, adopted name *Crossnet*, 1950s.

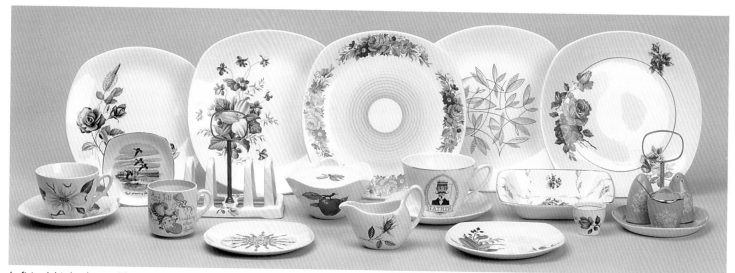

Left to right, back row: F2, **Mink Rose**, 1962; F1, *Woodside Fashion*, 1950s; F1, **Un-named**; F1, **Cassandra**, 1957; F1, **Un-named**, 1950s; front row: F5T & 6, **Dogwood**, c.1957; F70, Peter Scott fancy, 1960s; beaker, Peggy Gibbons nurseryware, 1946+; F215, **Magnolia**, 1955; F4, **Snowflake**, 1960s; F11, **Delicious**, 1950s; F45, **Roselane**, 1950s; F7 & 8, *Father*, 1950s; F4, **Cornfield**, 1960; F217/A, **Princess**, c.1962; F34, **Kashmir**, 1962; F36-9, Rhapsody, c.1960.

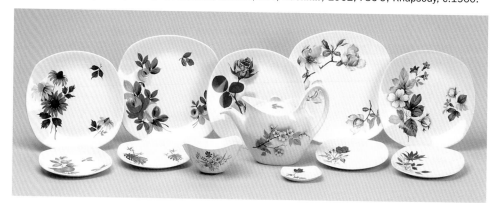

Above: paper napkin printed with the **Cassandra** pattern, 1950s.

Above right, left to right, back row: F2, **Daisy Time**, 1960s; F1, *Bargeware*, 1960s; F2, **Shadow Rose**, 1960s; F1, **Magnolia**, 1955; F2, **Glendale**, 1960s; front row: F4, **Oranges and Lemons**, 1963; F4, *Cheese Plant*, 1950s; F12, **Bouquet**, c.1960; F31/L, **Orchard Blossom**, 1960s; F42, **Fashion Rose**, 1955; F4, **Carmen**, 1950s; F4, **Nuala**, 1960s.

Design by Terence Conran
Right, left to right, back row: FN4 Midwinter seconds, **Melody**, 1960s; F1, F3, **Melody**, c.1958; front row: F4, F9 & 10, **Melody**, c.1958.

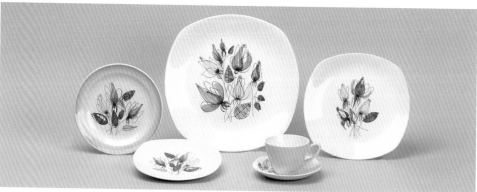

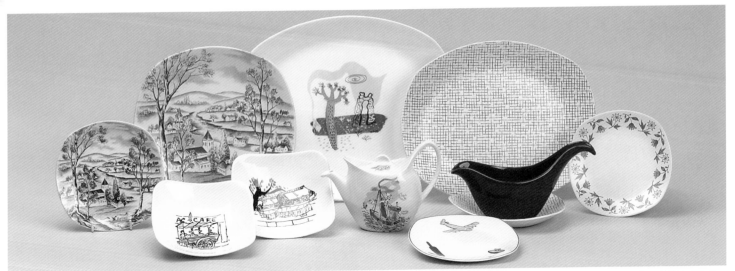

Left to right, back row: F4, **Happy Valley**, c.1960; F1, *Happy Valley variant*, c.1962; F26/L, **Desert Scene**, 1960s; F26/M **Un-named**, c.1962; F4, **Un-named**, 1960s; front row: F55/S x 2, *Market Scenes*, 1960s; F31/E, *Fishing Boat*, 1950s; F4, *Nurseryware*, 1950s; F23 & 4, **Un-named**, c.1962.

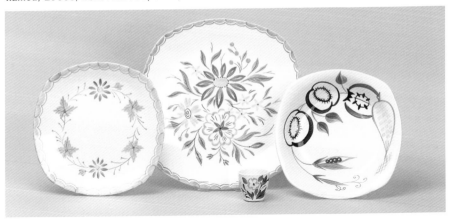

Left to right: F3, **Woodford**, c.1960; F1, **Un-named**; F34, **Bella Vista**, c.1960; F16, *Vegetables*, c.1960.

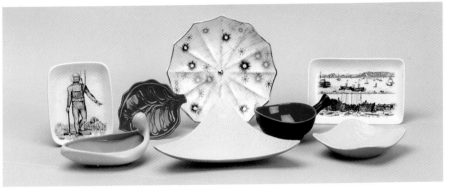

Left to right, back row: F224, diving souvenir, undated; F273, maroon glaze finish, 1960s; F214/L, **Cascade**, c.1960; F265, maroon and black glaze finish; F224/L, diving souvenir, undated; F251, yellow and turquoise glaze finish, 1960s; F261, yellow and turquoise glaze finish, 1960s; F272, yellow and turquoise glaze finish, 1960s.

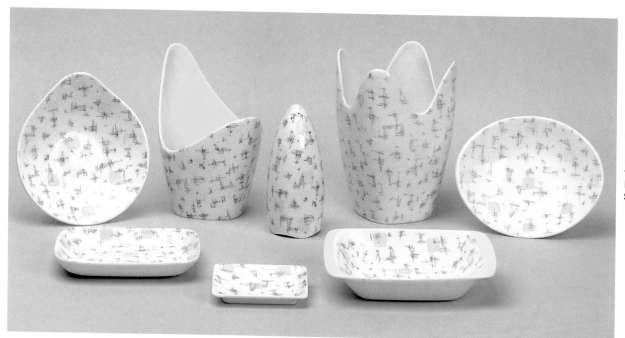

Left to right, back row: F65, lugged; F229, F63, F60, F262, plain; front row: F224, F241, F217/A. **Savanna**, 1956.

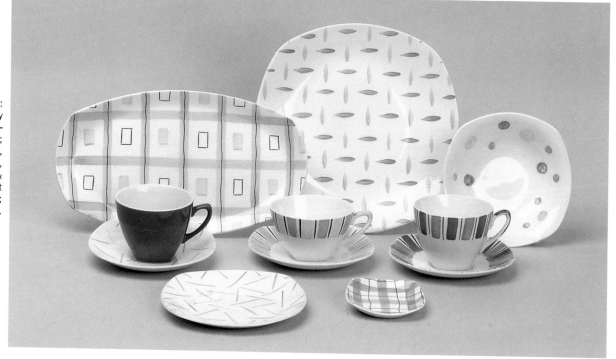

Left to right, back row: F248, trial pattern by Jessie Tait; F1, **Un-named**; F15, **Un-named**; middle row: F5/T & 6, **Chopsticks**; F5/L & 6, *Border Stripe*; F5/T & 6, *Border Stripe*; front row: F4, **Chopsticks**; F42, fancyware pattern. c.1950s.

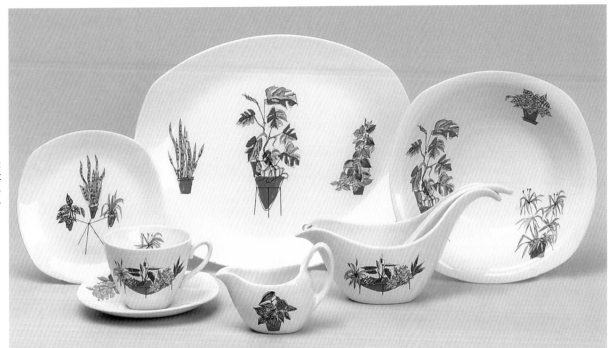

Design by Terence Conran.

Left to right, back row: F4, F26/M, F19; front row, F5/T & 6, F45, F23 & 23/A. **Plant Life,** c.1956.

Background fabric by Rosebanks. Left to right, back row: F1, F4; front row: F12, F13, F5/T & F6. **Toadstools,** c.1956.

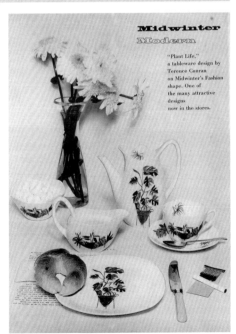

Midwinter Modern

"Plant Life," a tableware design by Terence Conran on Midwinter's Fashion shape. One of the many attractive designs now in the stores.

House and Garden, September 1956.

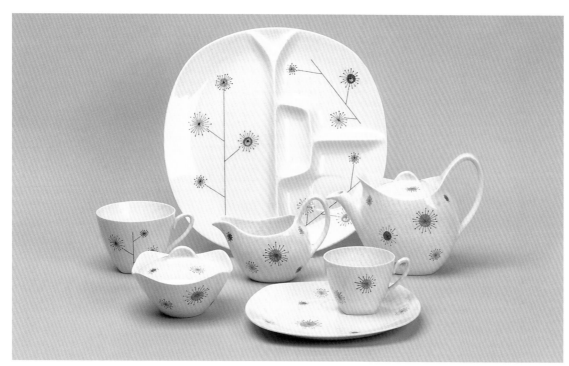

Left to right, back row: F216, **Flower Mist**, 1956; front row: F7, **Flower Mist**, 1956; F11, F13, F50, F31/L, **Stardust**, 1958.

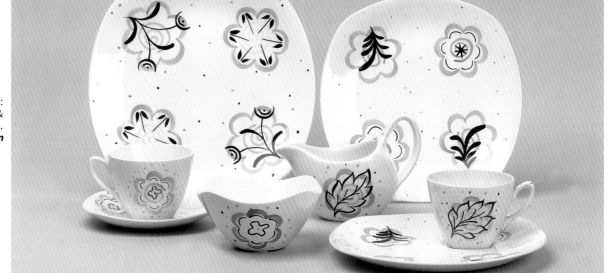

Left to right, back row: F1, F3; front row: F5/T & 6, F12, F13, F50. *Primavera Fashion* c.1955.

F1, sponged motifs in rust and yellow with brown overpainting. A trial pattern by Jessie Tait not put into production. Various colourways may exist, 1950s.

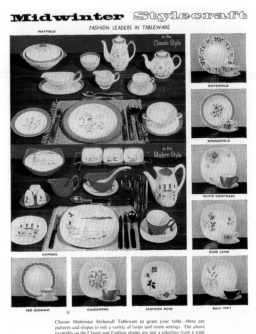

House and Garden, September 1961.

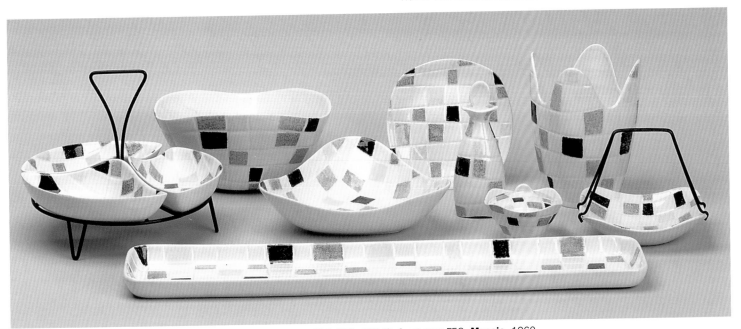

Left to right, back row: F286 x 3 on stand, F56, F288, F4, F67, F66, F60, F55/S; front row: F58. **Mosaic**, 1960.

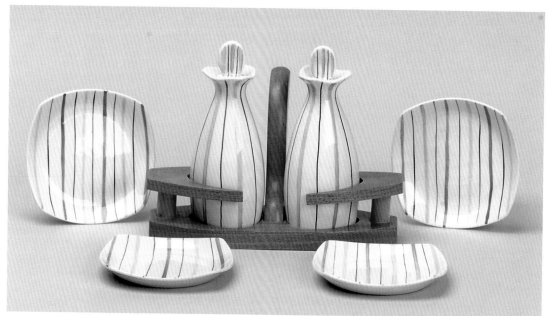

Left to right, back row: F70, F67, F67, F70; front row: F70, F70. **Simple Stripe**, 1960s.

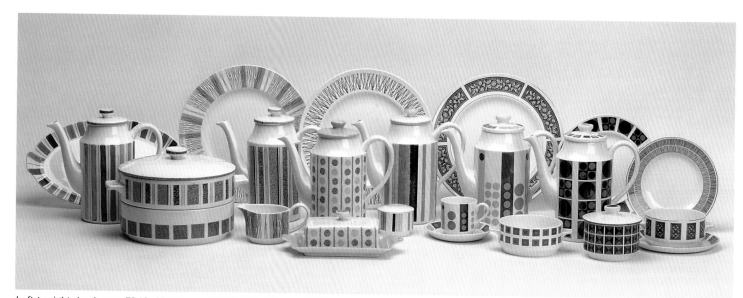

Left to right, back row: F248, **Mexicana**, 1966; FN1, **Sienna**, 1962; FN1, **Graphic**, 1964; FN1, **Palmyra**, 1963; FN3, **Focus**, 1964; FN4, **Whitehill**, 1962; front row: FN30, **Mexicana**, 1966; FN21 base, **Shetland**, 1969; FN21, **Piccadilly**, 1960s; FN45, **Sienna**, 1962; FN30, **Broadway**, 1960s; butter dish, **Oakley**, c.1968; FN38, FN30, **Queensberry**, 1962; FN10 & 11, FN30, **Tempo**, 1964; FN52, **Berkeley**, 1960s; FN30, **Focus**, 1964; FN11, **Diagonal**, FN51 & 2, **Palmyra**, 1963.

64

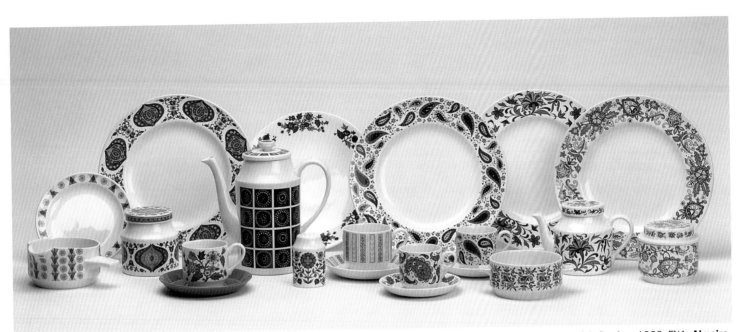

Left to right, back row: FN4, **Nordic**, 1960s; FN1, **Bengal**, 1968; FN3, **Blue Alpine**, 1960s; FN1, **Paisley**, c.1967; FN1, **Spanish Garden**, 1966; FN1, **Almeira**, 1966; front row: FN23, **Chevron**, 1969; covered jam, **Kismet**, 1968; FN9 & 10, **Gold Alpine**, 1960s; FN30, **Madeira**, 1965; FN36, **Country Garden**, 1968; FN5 & 6, **Everglade**, 1964; FN9 & 10, **Baroque**, c.1967; FN9 & 10, **Paisley**, c.1967; FN12, *Mediterranean variant*, c.1966; FN30/S, **Spanish Garden**, 1966; covered jam, **Almeira**, 1966.

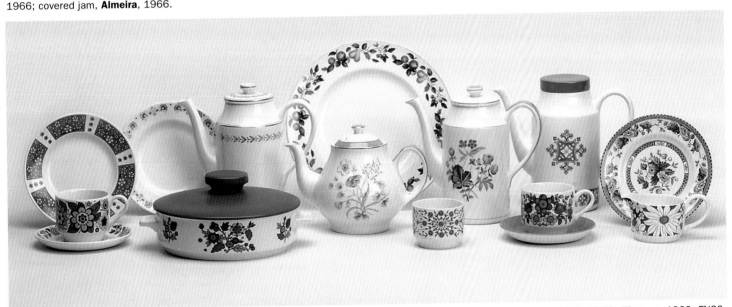

Left to right, back row: FN4, **Jasmine**, 1960s; FN4, **Mediterranean**, c.1966; FN30, **Olympus**, 1962; FN1, **Evesham**, 1962; FN30, **Kingcup**, 1962; FN30, **Lynton**, 1969; FN4, **Jacobean Brown**, 1963; front row: FN5 & 6, **Springtime**, c.1968; FN21, **Blue Alpine**, 1960s; C31/M, **Mayfield**, c.1960; FN44, **Valencia**, 1960s; FN5 & 6, **Romany**, 1960s; FN45, **Michaelmas**, c.1970.

Midwinter

country garden

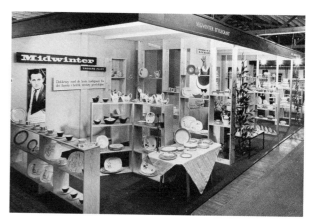

Top and centre: in-store promotional leaflets.

Top right: Scandinavian exhibition display, early 1960s.

Centre right: advertisement from *The Pottery Gazette*, 1964.

Far right: showroom display, late 1960s.

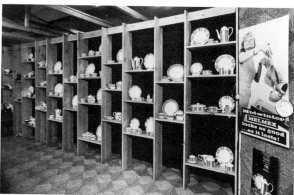

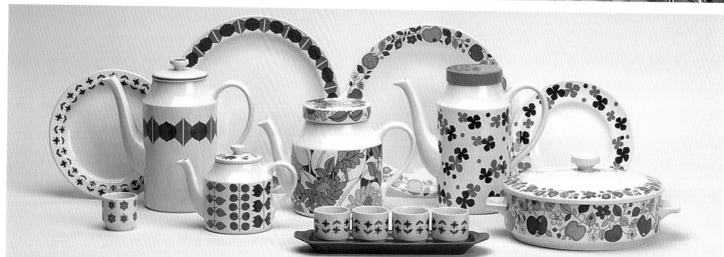

Left ro right, back row: FN4, **Roselle**, 1968; FN1, **Citrus**, 1960s; FN22, **Eden**, 1966; FN4, **Lakeland**, 1968; eggcup, **Sunglow**, 1968; FN30, **Citrus**, 1960s; FN31/S, **Cherry Tree**, c.1966; FN31/L, **Tango**, late 1960s; F292 with four eggcups, **Roselle**, 1968; FN30, **Lakeland**, 1968; FN21, **Eden**, 1966.

The Gift Buyer, February 1968.

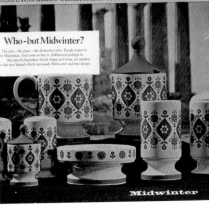

English Garden, on the **Fine** shape, c.1970.

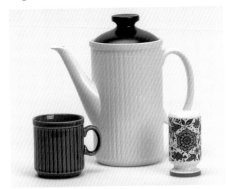

T46, brown glaze; T29, contrast glazes; **Pedestal** salt pot, possibly one of the only surviving items.

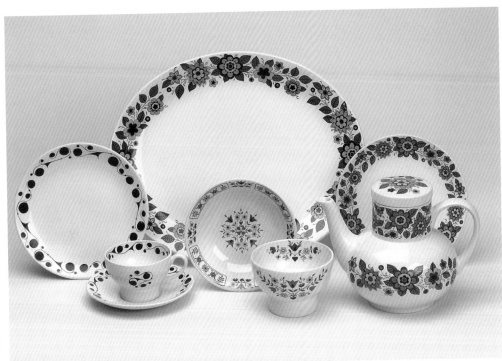

Left to right, back row: M4, **Pierrot**; M1, **April Flowers**; M5, **September Song**; front row: M6, **Pierrot**; M21, M12, **Columbine**; M15, **September Song**, c.1967.

Midwinter
bengal

Midwinter
april flowers

In-store leaflets, late 1960s.

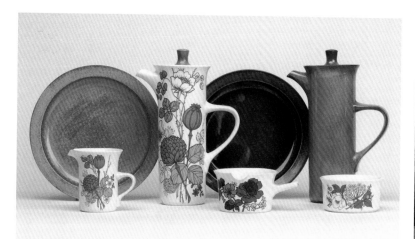

Left to right, back row: P3, **Maple**; P3, **Conifer**; front row: P9, **Countryside**; P10, **Countryside**; P15, **Roselane**; P10, **Maple**; P14, **Meadowsweet**. c.1966-7.

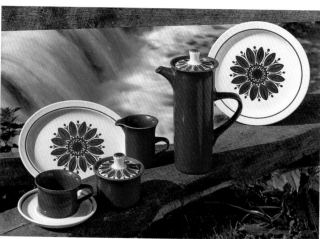

Promotional photograph, **Portobello** shape, Jessie Tait design, c.1970.

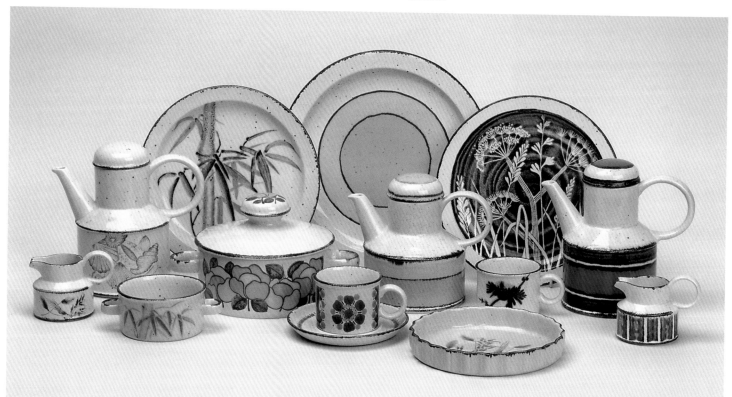

Left to right, back row: SH3, **Rangoon**; SH23, **Sun**; SH3, **Shady Lane**; middle row: SH7, **Seascape**; SH18, **Summer**; SH6, **Sun**; SH11, **Solitaire**; SH7, **Moon**; front row: SH9, **Seascape**; SH15, **Rangoon**; SH11, **Hazelwood**; Flan dish 9¹⁄₂", **Wild Oats**; SH9, **Earth**. c.1970s.

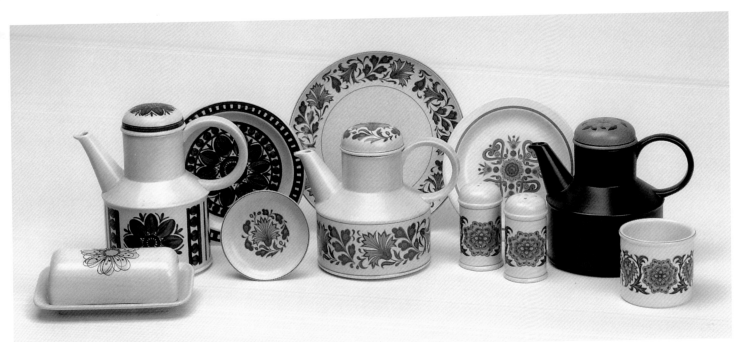

Left to right, back row: SH5, **Blue Dahlia**; SH4, **Caprice**; SH5, **Fresco**; front row: SH40, **Flowersong**; SH7, **Blue Dahlia**; SH42, **Caprice**; SH6, **Caprice**; SH19, **Woodland**; SH6, **Desert Flowers**; SH35, **Woodland**. c.1970s.

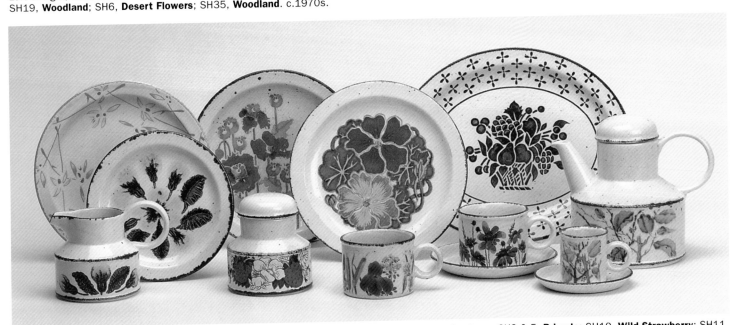

Left to right, back row: SH4, **Un-named**; SH4, **Autumn**; SH4, **Nasturtium**; SH1, **Country Blue**; front row: SH9 & 5, **Primula**; SH10, **Wild Strawberry**; SH11, **Riverside**; SH11, **Spring Blue**; SH37 & 6, **Green Leaves**. c.1970s.

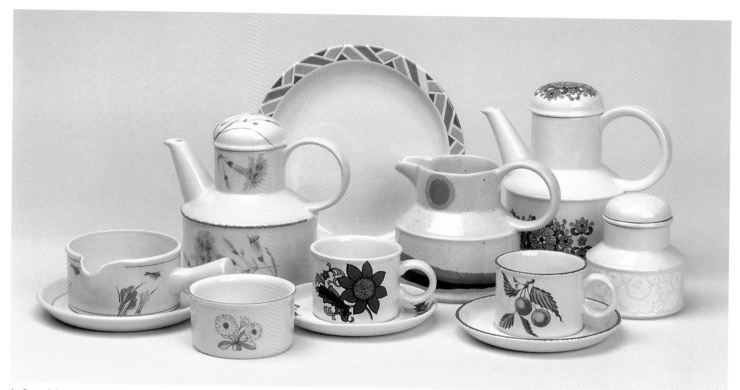

Left to right, back row: SH6, **Invitation**; SH3, **Aztec**; SH8, **Day**; SH7, open stock transfer; SH10, **Winter**; front row: SH17, **Crocus**; SH34, **Fleur**; SH11, **Unnamed**; SH11, **Wild Cherry**. c.1970s and 80s.

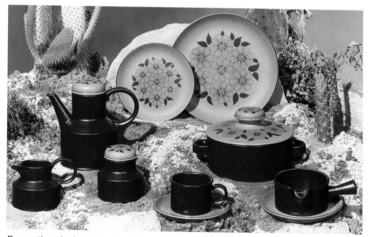

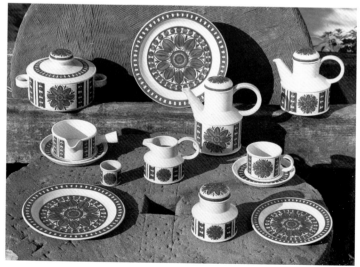

Promotional photographs. Above: **Desert Flowers**, Jessie Tait; right: **Blue Dahlia**, on the **Stonehenge** shape. 1972.

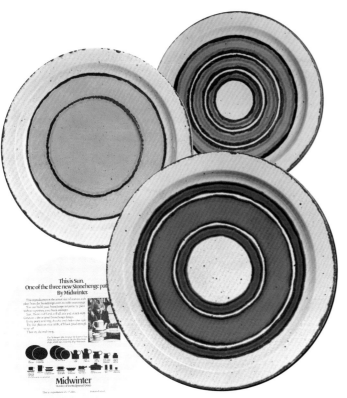

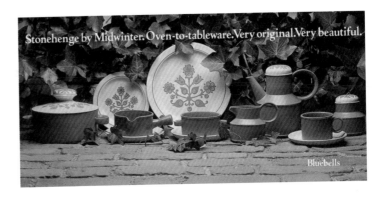

Stonehenge by Midwinter. Oven-to-tableware. Very original. Very beautiful.

Bluebells

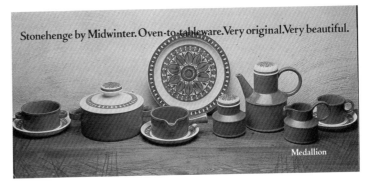

Stonehenge by Midwinter. Oven-to-tableware. Very original. Very beautiful.

Medallion

In-store leaflets and promotional 'plates' printed with pattern details, 1970s.

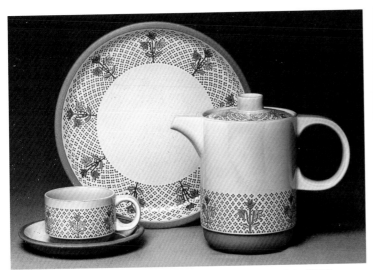

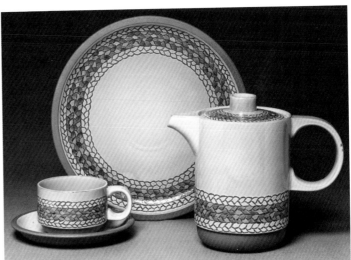

Above and right: un-named and **Braid Stoneware** patterns, late 1970s.

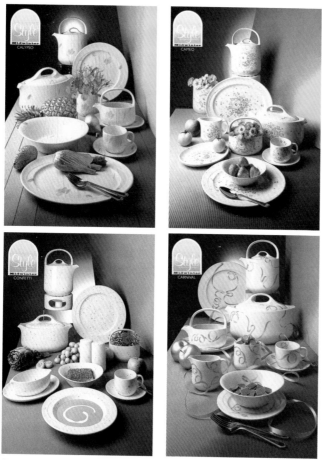

Four promotional leaflets for the **Style** range, 1983.

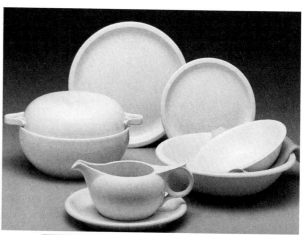

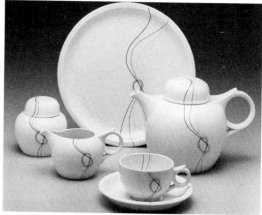

Forget-me-knot pattern on a shape by Eve Midwinter designed, c.1980s.

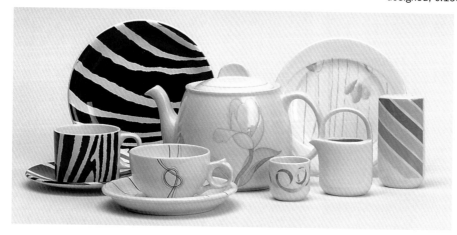

Safari teacup, saucer and sideplate by Roy Midwinter for Federated Potteries, 1980s; **Reflex** teapot; ST5, **Calypso**; **Forget-me–knot** cup and saucer; ST25, **Carnival**; ST12 [small] **White**; ST17, **Chromatics blue**, c.1980s.

midwinter pottery
Introduction to the Second Edition

The launch of the first edition of this book in 1997 was one of the most memorable nights of my life. We were preparing the exhibition in Richard's Gallery in the afternoon, the first copies of the book were on their way from the printers, would they arrive in time? We unpacked box after box of Midwinter pottery and tried to display the collection and sale pieces in chronological order. By late afternoon there was a queue forming outside whilst we were knee-deep in boxes and bubble wrap. Amazingly we fitted everything in and cleared the floor just in time for the books to arrive, phew!

By six o'clock we were ready to open the door to the crowd. The number of people was incredible – many of Richard's regular gallery visitors, collectors, the press, members of the trade and friends. The atmosphere was great – Jessie Tait, David Queensberry and Eve Midwinter were there, and my brother and a friend, Colin O'Brien, photographed the event. The crowds spilt into the road and passers-by became very curious to know just what was going on.

Looking back at the photographs there are many people who attended the launch that have become great friends – most Midwinter collectors are only too happy to share their enthusiasm for the subject. Six years on I am pleased to be adding a new section of text and photographs to the first edition at about the fiftieth anniversary of the launch of the *Stylecraft* shape.

I hope you enjoy this edition as much as I have enjoyed working on it.

S.J.
June 2003

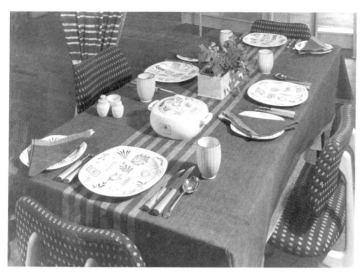
Display of **Primavera** at Heal's, c.1954.

Midwinter Pottery – six years on

A lot has happened in the collecting world since the publication of the first edition of this book six years ago. Television cameras have looked in every attic and kitchen cupboard, occasionally giving unrealistic impressions of value. The Internet has made every shop on the globe available for bargain-hunters and Internet auctions have forced collectors to fight tooth-and-nail over the 'Holy Grail' or 'missing link' in their collections.

New patterns, finds and notes

Pottery from the 1940s and 1950s has surfaced on to the market as cupboards get cleared in spring-cleaning or through boot sales and auctions – amongst these there is always the chance of something interesting or hitherto unseen coming to light. Many of the *Handcrafts* bowls have surfaced and have been of excellent quality, intricate florals, stylised leaf designs and landscapes all executed with the underglaze crayon technique. Many of the bases are unsigned or illegible but it seems that there were quite a few paintresses decorating them during the late 1940s and 1950s. Pieces decorated with the clay stain technique with brushwork and imagery very like Jessie Tait's early patterns have been found, including vases and immense jugs decorated in blue and grey.

The green clay stain was particularly difficult to use as it spread through the clay and tainted other pieces. Much of the stain decoration was used on animal figures, which have remained popular with collectors, and pre-war bookends and religious plaques have been noted. The animals were made well into the 1950s and a range of Toby jugs based on *Treasure Island* characters have turned-up in miniature and standard sizes. The latter are in a different collecting field from the tableware and deserve a detailed study in their own right. *Moonfleur* the design that was incised into the mould and tinted with these stains has also been found in new colourways – maroon and pink and lime and dark green with the backstamp including the legend 'A Jessie Tait Production'. Banded wares, similar to Susie Cooper, with the backstamp 'An Alice Barnett Production' have been noted. Jessie says that someone who had worked for Susie Cooper brought her banding skills to the Midwinter factory. This was probably during the 1940s when transfers were expensive and hand-paint talents were at a premium.

In the *Stylecraft* range there have been exciting discoveries. A photograph of an early display shows about twenty of the early patterns including a plate and teapot in a version of *Fantasy* with a stylised leaf instead of the yo-yo squiggle. Flat- and coffee wares have turned-up in this pattern – one piece in New Zealand! The other pattern twinned with *Fantasy* was a plate with an abstract motif and Maxims on the border. This is Midwinter Hotelware from the mid-1960s. Some of the early patterns on this shape have not turned-up in quantity, examples of *Catkin* and *Bulrush* are quite scarce. *Sherwood* and *Silver Bamboo* are seldom seen but the former has been noted on TV cups and trays and the latter on teaware with the addition of platinum or silver lustre. This pattern was also reworked into a colour version for the *Fashion* shape and called *Tahiti*. *Pageant* has been seen in grey and burgundy, mainly on fancy pieces and *Cottage Ivy*, it would appear, was made for the North American market as some large collections have been discovered there.

Another interesting find is a plate similar to Fiesta with little buds and a grey textured-background, possibly a one-off. As a popular pattern a large quantity of *Fiesta* was made and has become a firm favourite with collectors, as has *Primavera*. The most exciting find on these patterns is likely to be a 'lazy Susan' buffet set.

Shape-wise there have been few surprises. As expected only a small number of the large ice jugs have been found and often with disappointingly small transfer patterns like *Encore*, though *Ming Tree* works well on the shape. The pierced salad drainers, toast racks and tankards have been hard to find in good patterns and lugged sandwich plates and

covered sugar bowls are uncommon. *Red Domino* is as popular now as it was during the 1950s. Collectors and young couples are struck with the upbeat jolliness of the pattern. Thankfully produced in quantity, there is an amount of flat ware and teaware still in circulation though teapots and coffee pots are seldom seen in good condition. Beakers and mugs and cheese and butter dishes are the most difficult shapes to source and the TV cups and trays are surprisingly scarce.

Partner-patterns *Blue-* and *Green Domino* and the much harder to find *Black Domino* were obviously made in smaller quantities, the green almost exclusively on fancy shapes like egg cruets, cake stands and small sweet dishes. *Cloudline, Tropicana* and *Galaxy* are the last patterns recorded on the *Stylecraft* shape and were not produced in great quantities, despite being very successful patterns visually on the shape.

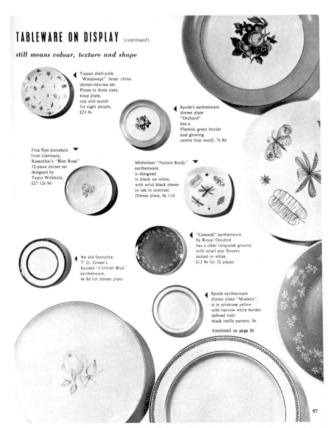

TABLEWARE ON DISPLAY *(continued)*

still means colour, texture and shape

▲ Tuscan shell-pink "Windswept" bone china dinner-into-tea set. Plates in three sizes, soup plate, cup and saucer for eight people, £23 8s

Fine flint porcelain from Germany, Rosenthal's "Blue Rose" 32-piece dinner set designed by Tapio Wirkkala, £27 12s 9d ▼

◄ Spode's earthenware dinner plate "Orchard" has a Flemish green border and glowing centre fruit motif, 7s 8d

Midwinter "Nature Study" ▼ earthenware is designed in black on white, with solid black pieces to use in contrast. Dinner plate, 6s 11d

"Cascade" earthenware by Royal Doulton has a clear turquoise ground with small star flowers etched in white, £12 8s for 32 pieces

◄ An old favourite, T. G. Green's banded "Cornish Blue" earthenware, 4s 8d for dinner plate

▲ Spode earthenware dinner plate "Modena", is in primrose yellow with narrow white border defined with black trellis pattern, 8s

Continued on page 95

57

House Beautiful, April 1957, **Nature Study** dinner plate, priced at 6s. 11d.

There has been a lot of excitement for collectors on the *Fashion* shape ranges. The Conran pieces have a keen following and *Saladware* and *Plant Life* seem to be the most popular. An interesting find was an adaptation of the *Saladware* pattern made for Simpsons of Piccadilly with classic 1950s lettering along the stalk of a shamrock. Also, a sketchy illustration in typical Conran-style has been noted. The pieces do not have a Midwinter backstamp though they are *Fashion* shape items. Another interesting set is a sweet box with four trays decorated with the biplanes in turquoise and yellow, made as an exclusive for 'Kay Brothers Ltd, Stockport, Heaton Moor 1811 – Xmas 1959' as a backstamp. The transport fancies are also found on coloured grounds. Some of the patterns by Conran have extra metal fittings such as a stand for the sugar bowl.

Toadstools has become very desirable through its sheer wackiness – teaware being particularly difficult to find in good condition. Jessie's hand-painted patterns like Festival are still very sought after. I visited a couple that had bought the pattern piece-by-piece from Selfridges when it was first on the market. They would travel into town when they had saved enough for the next part of the set: a cruet, coffee set or, by special order, some lug bowls. Cruet sets on a stand were surprisingly expensive compared to other pieces, which may explain their relative rarity, but they did involve a good deal of work in decorative terms. If you were to order a piece and didn't want the plain holloware colour, the factory would eventually make a decorated piece to order. The waiting time for many pieces was up to fifty-four weeks, so a great deal of patience was needed in order to fill the gaps in a service. This explains the pieces of *Nature Study* or *Cassandra* with decorated hollow items that are usually found in black or turquoise.

By 1960 almost any of the patterns in production on the Fashion shape were given coloured holloware to bring down costs and to unify the retail displays. *Plant Life* was given yellow cups to match *Savanna* and *Melody*, though the latter was also sold with lavender holloware to match *Whispering Grass*. It does seem from conversations with retailers and the buying public of the time that there was quite a free-and-easy, mix-and-match sales ethic to keep the buyers happy. *Cherokee* is found with black cups and the owner insists that's how she bought them. Another lady told me that *Cherokee* was really cheap at the time, 'I wouldn't have had it otherwise'.

Regarding the price of Midwinter in the 1950s, we have been lucky enough to find some original receipts that

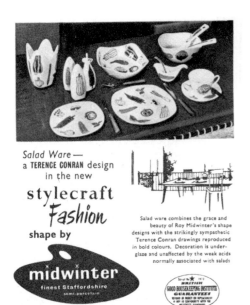

Salad Ware —
a TERENCE CONRAN design
in the new

stylecraft
Fashion

shape by

midwinter
finest Staffordshire
semi-porcelain

Salad ware combines the grace and beauty of Roy Midwinter's shape designs with the strikingly sympathetic Terence Conran drawings reproduced in bold colours. Decoration is under-glaze and unaffected by the weak acids normally associated with salads

Colour brochures and price list now available

W. R. MIDWINTER LIMITED, Dept. H.B.5, Burslem, Stoke-on-Trent

House Beautiful, July 1956.

Midwinter
Modern

Terence Conran's Nature Study pattern on Midwinter Modern Fashion Shape has the fashionable solid black satin matt finish to the Holloware combined with a simple symbolic pattern in monotone. Nature Study is well distributed in stores throughout Britain. Write for nearest stockist and leaflet: W. R. Midwinter Ltd., Dept. H.B., Burslem, Stoke-on-Trent.

House Beautiful, January 1957.

Midwinter
Stylecraft

*fashion style
your table*

Modern tableware in outstanding designs on our famous modern shape to blend with contemporary or formal living. Ask about the new 22-Piece Midwinter Teaset with the spare cup in the carry home pack. Some of our leading designs include: Cassandra, Quite Contrary, Zambesi, Nature Study, Monaco, Marguerite (illustrated bottom), Savanna (illustrated top).

Write for illustrated brochures and particulars of your nearest stockist to:

W. R. MIDWINTER LTD., BURSLEM, STAFFORDSHIRE

House Beautiful, September 1958.

purchasers kept. Rarer patterns like *Chopsticks, Border Stripe* and the *Fashion Check* were made for the boxed twenty-two piece teasets. This was a good way of selling a fashionable teaset to the buying public that could be produced in a short-run and replaced with something new, quickly, if the pattern proved unpopular. With constant use a teaset inevitably didn't last for a long time so an affordable, high-fashion set was not too much of an indulgence and fun while it lasted. As tea was made in the kitchen and often brought through to guests already poured, there was no need for a matching teapot so a durable 'brown betty' could be used behind the scenes.

Another interesting source of short-run patterns are the butter pats or pin trays – often with the backstamp 'Hand-painted produced for Artkrafts Ltd'. Patterns include checks and two colour versions of the *Monaco* pattern. Classic *Stylecraft* patterns like *Ming Tree* and *Shalimar* made the transition to the *Fashion* shape *Ming Tree*, printed in plain black or a deep blue-grey, and *Shalimar* in black with hand-colouring in either pink, turquoise or yellow. *Liana*, an all-over print of lilies was mainly used on cake stands though it has turned-up on flatware in two colourways. Cake stands were a lucrative market in North America and it is on these items that Jessie had the opportunity to go to town and produce

some of her wildest designs. *Triangles, Fish* and *Seaforms* are already known and do appear on flatware – perhaps the plates that weren't drilled for cake stands. Caribbean was given an extra flourish by adding green and yellow to a brown printed version. A pattern of fruits has been noted on a cake stand reminiscent of the work of George Briard. Other patterns with sponged fruit motifs and extra details have been discovered. The elusive coloured *Nature Study* has turned-up on dinner-size plates and three-tier titbit cake stands. Although this sounds a strange thing to do to a successful monochrome design, Jessie manages to pull it off and uses her skill to highlight parts of the design including colouring the butterfly on the backstamp.

If *Red Domino* is the success story of the early 1950s then *Zambesi* has to be its successor. Produced in great quantities it was a success and widely copied. The zebra-stripe pattern in black and white with red highlights appeals to collectors today and coffee sets are a sure investment as they keep rising in price. Rarities in the pattern like the covered sugar, ladle sets, cheese- and butter dishes and cruets are regularly fought for in the collectors arena.

Two patterns worthy of mention are the Charles Cobelle *Fishing Boat* and *Desert Scene*, the latter seems not to have been made in quantity and teaware is elusive. These and

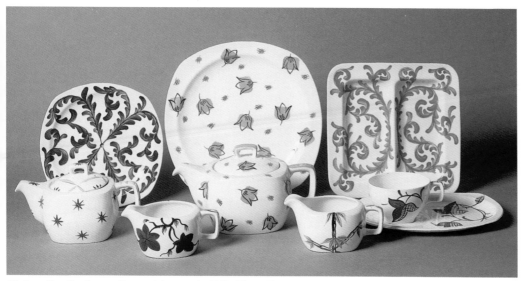

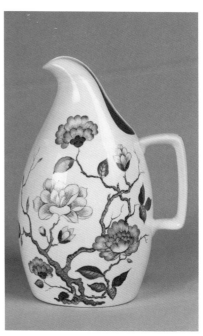

Stylecraft – Back row: **Pageant** burgundy, **Tulip Time, Pageant** grey. Front row: **Galaxy** teapot, **Cottage Ivy** milk jug, **Tulip Time** teapot, **Silver Bamboo** milk jug, **Sherwood** television cup and tray. 1953-1956. (JT).

Ming Tree ice jug, 1953. The largest and most difficult piece to find in the Stylecraft range.

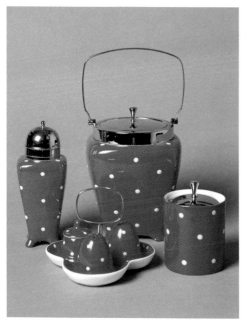

Red Domino Variant. This version was produced on more decorative items as a range of giftware. Sugar castor, biscuit barrel, cruet set on stand and jam pot. (JT).

Stylecraft – Back row: **Bulrush** plate, **Catkins** plate. Middle row: *Fantasy leaf* milk jug, side plate and coffee cup and saucer, **Cloudine** coffee pot, **Orchard** oatmeal bowl. Front row: **Primavera** cruet 1953-1956. (JT).

Plant Life and **Saladware** – Left: large milk jug, teapot, hors d'oeuvres dish **Plant Life** 1956. Right: eggcup, large and small boomerang dish **Saladware** 1955. Front right: mint sauce boat stand made for Simpsons Picadilly. 1955+. (TC).

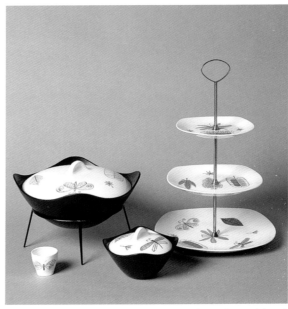

Nature Study – Vegetable dish on original metal stand, hand coloured three-tier cake stand, decorated egg cup, covered sugar bowl. 1955+. (TC).

Chequers – Teapot and cruet on stand 1957. (TC).

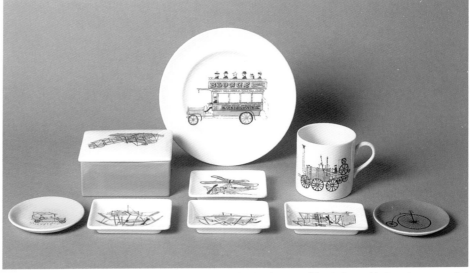

Transport rarities – Nursery plate and beaker c.1955, cigarette/Kandy box with four trays special order, left and right transport series dishes with coloured grounds. (TC).

Selection of figurines 1930s to 1950s including rare export baseball figures. The central black figure is not a Colin Melbourne design.

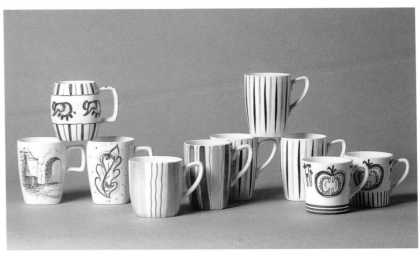

Beakers, mugs and tankards. These shapes were often decorated with one-off or variants of standard patterns. From left: **Riviera** mug (HC), **Elephant** tankard, **Primavera** mug, *Fashion stripe* beaker and mug, three colourways of **Cherokee Variant** on *Fashion* mugs (all JT), two versions of **Saladware Variants**, on beakers. (TC). 1954-1960.

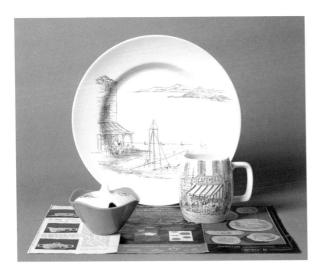

Sir Hugh Casson – **Riviera** 'trial' plate in maroon on Classic shape, 1960. Pickle dish in **Cannes** 1960 and tankard in **Riviera.** Promotional literature for customers illustrating the **Riviera** range, 1954. (HC).

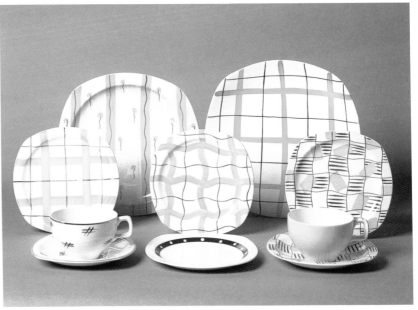

Stylecraft – Back row: *Fiesta variant*, **Homeweave** yellow. Middle row, two more variants of **Homeweave**, side plate in **Tropicana**. Front row: unknown design teacup and saucer, **Black Domino** side plate, **Tropicana** teacup and saucer. 1953-1956. (JT).

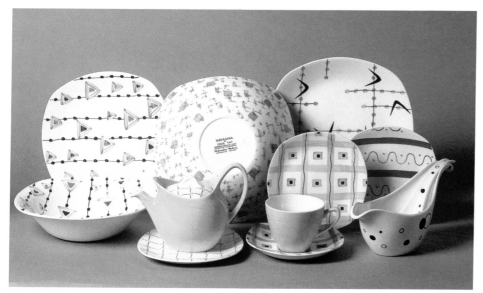

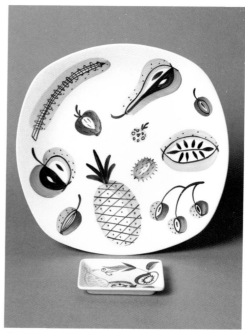

Fashion shape – Back row: ***Triangles*** plate, **Savanna** bowl in blue with turquoise interior, ***Boomerangs*** plate. Front row: ***Triangles*** bowl, **Crossnet** teapot and side plate, ***Fashion Check*** teacup, saucer and side plate, ***Unknown pattern*** hand painted on side plate, **Pierrot** sauce boat and ladle, all Jessie Tait designs. 1955+.

Fashion shape – Undrilled cake stand plate, ***Fruit*** pattern (JT) rectangular tray ***Vegetables*** (EM), late 1950s.

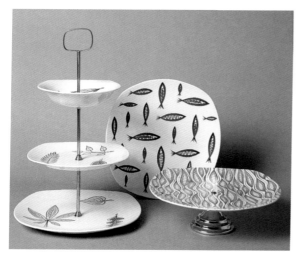

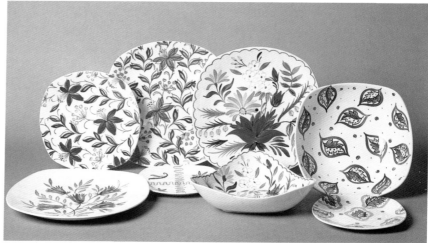

Fashion shape – Three-tier cake stand ***Primary Leaf*** pattern, ***Fish*** plate, **Caribbean** cake stand printed in brown with hand colouring in green and yellow, 1955+. (JT).

Fashion shape – Back row: **Liana,** two colourway versions (JT), **Bella Vista** (EM), **Autumn** shallow bowl (JT). Front row: ***Tulip*** design plate (JT), ***Quartered floral*** plate (JT), triangular bowl **Bella Vista,** (EM), **Autumn,** colour variant, 1955+. (JT),

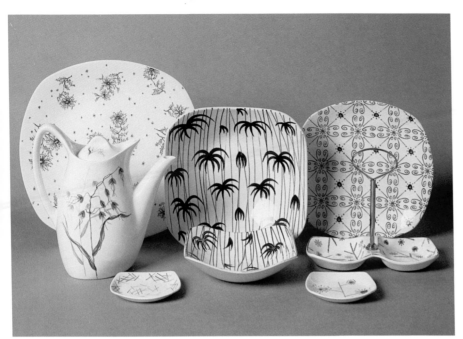

Mosaic fancies with original fittings, beaker and small dish with hand painted colour variant 1960. (JT).

Fashion shape – Back row: **Wild Thistle** plate, *Bamboo* ungilded shallow bowl 1961, **Trial pattern** plate. Front row: **Random Harvest** coffee pot, **Monaco variant** pin tray in pink and black for Artkrafts, *Bamboo* small quartic bowl with gilding, **Flower Mist** pin tray and **Spring Fern** jam dish. All Jessie Tait designs.

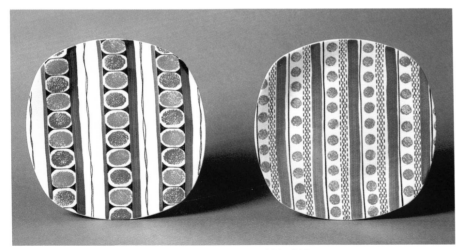

Two trial designs by Jessie Tait on *Fashion* plates c.1960-1962.

Fashion shape – **Mambo** plate (open stock transfer) and **Zambesi** cheese dish late 1950s. (JT).

Clayburn factory lampbases. Centre: version of **Tonga**, far right: a design by William Lunt (none of the other patterns can be attributed to Jessie Tait). From 1953.

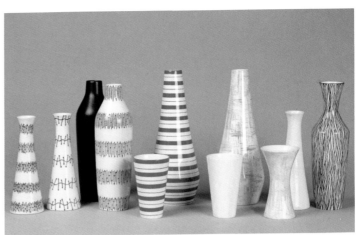

Jessie Tait vases, 1956-1960. From left: two tall candlesticks (207), two vases (204), banded beaker and flask (202, 201), beaker and flask (202, 201), waisted vase (210), tall candlestick (207) and flared neck vase (206).

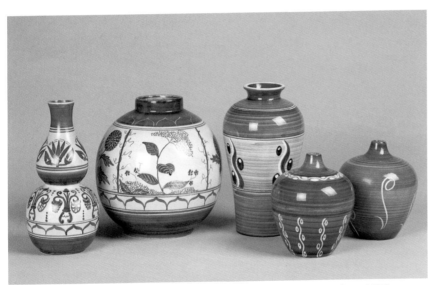

Clayburn vases and lamp bases. The two on the left are by Jessie Tait from 1953.

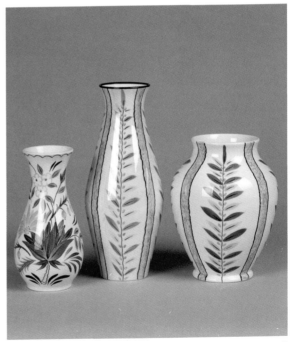

Bella Vista vase (EM) c.1960 and two lustre decorated vases, 1960s.

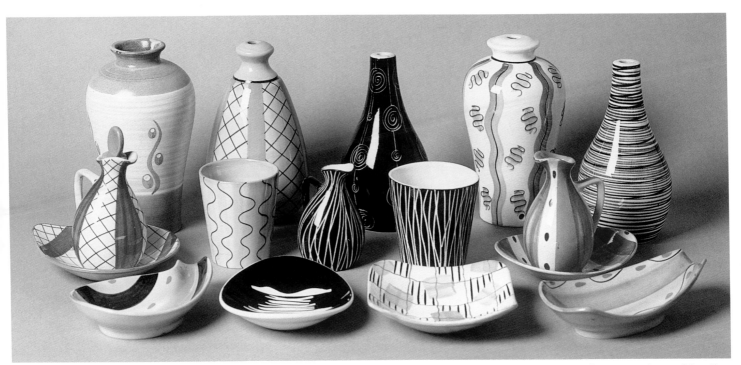

Selection of pieces from the Clayburn factory including an early vase by William Lunt back left, and a **Tropicana** quartic dish front centre (none of the other patterns can be attributed to Jessie Tait). From 1953.

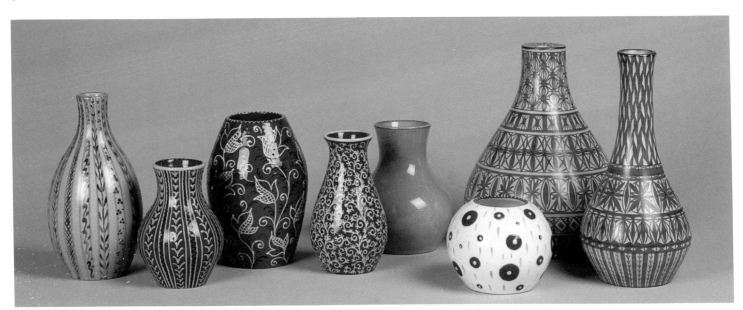

Hand thrown and decorated wares by Jessie Tait, 1950s-1962. Terracotta tube-lined in cream and black slip or glazed stoneware.

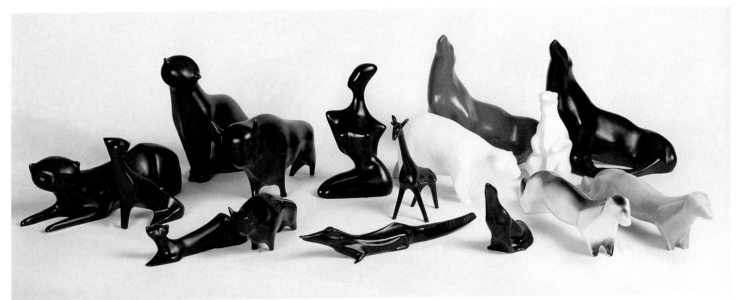

Figures by Colin Melbourne from 1956. From left, cat lying (176), cat sitting, small (182), cat sitting, (177), cat lying, small (183); bison (174), bison small (185); African woman (213), giraffe, head up (195); crocodile (189); seal, brown and black (180); bear large, (179); bear small (188); seal small (184) ferret large, aerographed and fawn (181); these have little to identify them other than the impressed mould number (see shape listings) or occasionally the W.R. Midwinter script on the base.

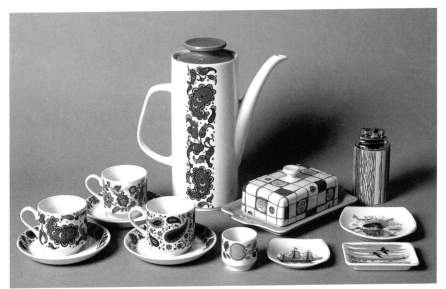

Fine shape – Coffee cups and saucers in **Baroque, Persia** and **Paisley,** coffee pot in *Studio* range J & G Meakin utilising *Fine shape* transfer stock (many later *Fine* and *MQ2* patterns turn up on this ware), **Eden** egg cup, **Homespun** butter dish, open stock ship pin tray, **Sienna** table lighter, open stock Nursery pattern tray, Peter Scott 'fancy'. 1960s.

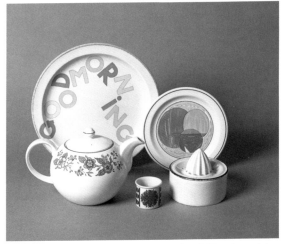

Stonehenge and later – Back row: **Good Morning** plate, **Melons** plate. Front row: Teapot, mid 1980s, **Blue Dahlia** egg cup (JT), *Stonehenge* **Creation** lemon squeezer.

patterns like *Toadstools* did not wear well and the on-glaze transfer fades and scratches quite easily.

Spring Fern, a new twist on *Flower Mist*, was discovered recently, a pattern similar to the stalky flowers of *Flower Mist* but with the addition of gold stamped stars and blue flower heads. This was probably a short-run pattern on fancy shapes for Boots the Chemist.

New shapes have also come to light – large tureens with a space for a soup ladle – boomerang dishes in two sizes, cups and teapots in varying sizes and a large three pint coffee pot.

Vases

Jessie Tait's vases produced from 1956 were every collectors dream-find five years ago but they have come out from hiding over the last two years and most collectors now have one. The black and white tube-lined version must have been a good seller as the 'onion' shape and the single bud vases are fairly common. Some of the other shapes are a little more difficult to find and the 'music score' decoration is the most seldom seen pattern. The plain coloured versions have been discovered, black, yellow, pink, turquoise and hand-painted textured grey. This may have been a way of utilising a shape that was not easy to decorate. Some experimental and rarer ones have also been noted – grey clay stain with grey and red tube lining, banding in red or blue enamel interspersed with the pattern in black (one with rows of tiny dominoes).

Clayburn

In 1953, after two years of planning and preparation, William Lunt and friend Harry Edgerton founded a small studio pottery. It was situated in Milner Street, Hanley, Stoke-on-Trent. William Lunt and Roy Midwinter were both Directors of the Midwinter Pottery so it was inevitable that Roy would be interested in the project and he joined as a third partner to deal with sales. Mr Lunt's hands-on idea was soon outgrown and he employed Mrs Mary Lunt (sister-in-law), and Mrs H. Oldacre, for casting, sponging and decoration. It was about this time that Jessie became involved on a part-time basis and free interpretation of her designs appear on a variety of Clayburn pieces. A great deal of interesting Clayburn pottery has come to light in the last few years, including some extraordinary pieces with excellent abstract decoration on vases, lamp bases, cruets and fancy ware. Little of the factory output can be attributed to Jessie Tait, except some early blue and white vases and lamp bases and some later pieces in black and white. Patterns based upon Midwinter

designs were worked by Clayburn staff and not in the Midwinter factory. Midwinter patterns were adapted by Clayburn with Roy Midwinter's consent. As Clayburn made decorative items that were not on the Midwinter price list the idea was that Clayburn pots were accessories to a Midwinter service. A *Fiesta* or *Tropicana* dinner service could be paired with a lamp base or decorative vase with similar design elements – complementary rather than an exact match. While the two companies worked together the wares were shown alongside each other in department stores. Later, when Jessie was producing vases for Midwinter and Colin Melbourne designed his contemporary animal figures, there was less need to buy stock from another pottery.

Fine Shape

The *Fine* shape seems to have lagged behind in the collector market – though some of the Op-art patterns like *Tempo*, *Focus* and *Madeira* have their following and flower-power patterns like *English Garden*, *Tango*, *Lakeland*, *Sunglow* and *Eden* are sought after. Patterns like *Sienna* and *Queensberry* were popular when new and are still in use in many homes today – a tribute to design that they have stood the test of time and durability. Meanwhile the popularity of *Spanish Garden* has not waned and it still sells to the families that bought it new in the '60s and '70s – they are just replacing the pieces that have been broken over the years. Pieces of *Spanish Garden* turn-up on later Wedgwood shapes and occasionally on *Stonehenge*. *Gold Alpine* and *Summerday* are uncommon patterns with a new design *The Hunt* based on a series of 'scissor' cuttings by the cartoonist Jon (William Jon

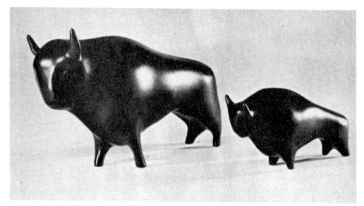

'**Bold Black Bison** modelled by Colin Melbourne are in a matt-glaze finish. They are from a new range of animal and abstract figures in either matt white or black china. The bison in black only, cost £1 2s 9d large size and 13s 6d small size.' *House Beautiful*, April 1957.

Jessie Tait, c.1964, with samples of the *Fine* shape intended for a trade show. This pattern is thought not to have been produced commercially.

adapted and decorated with the oxide edge so a great deal of variety must exist. A jam pot, avocado dish, lemon squeezer, oil and vinegar cruet and candle holder (which could be the tea warmer in the shape list) have come to light along with a wide range of larger serving pieces. As with *Spanish Garden*, the popularity of *Wild Oats* means that there is healthy competition for any unusual piece that turns-up.

Melons, Oranges and Lemons and *Crocus* are interesting for their re-styling of the Clarice Cliff originals while an export pattern *Blue Palm* is unusual in every respect, the all-over pattern of fanned leaves in dark blue utilising the reactive medium is very uncompromising and striking.

The Beverage dispenser, and some of the miniature items from the *Style* range, seem to be the favourites. With an 1980s revival going on it bodes well for the future of this range, which is as much a part of its decade as the electronic music of the day.

Similarly the *Reflex* range of patterns are a little more mainstream but very much of their time with patterns like *Blaze* – a monochrome floral with graduated vermillion shadows. Later floral patterns like *Lichfield* are completely mainstream and have little collector interest. *London Scenes* mugs were produced in a range of red and black designs. *Tempo*, another of the later ranges of patterns, was an export mix and match comprising a series of Edwardian and Art Deco border patterns in black on white.

The Midwinter backstamp is found on two oddities – a robot moneybox and a Roland Rat (TV spin-off) range of nursery/teen ware, but they have little to differentiate themselves from any other company.

Philbin Jones) have been noted. Small quantities of Eve Midwinter's striking *Flamingo* have also been snapped-up by collectors. The *MQ2* and *Portobello* shapes have not yielded any exciting finds and it seems that collector interest is mainly focused on the tea- and coffee pots - though serving pieces and cruets in *MQ2* are particularly difficult to find.

Stonehenge and after
The lesser-seen and brightly coloured patterns on this shape are the collectors favourites. The seldom seen *Shady Lane* and subtle Invitation and *Seascape* are popular but *Riverside, Nasturtium, Spring* and *Autumn* are the bold and colourful patterns on the collectors wants list. The range of shapes in the *Stonehenge* range continues to grow – almost any earthenware shape in Wedgwood's production could be

The last backstamp?

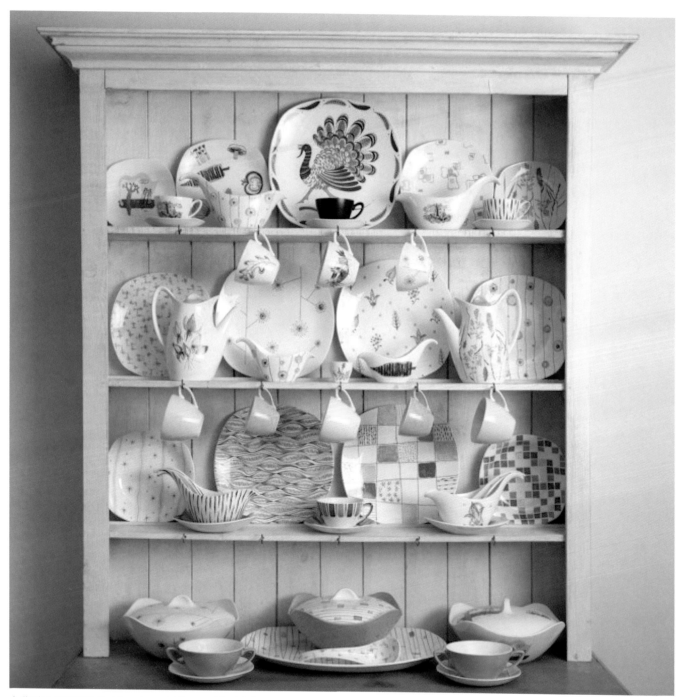

A display of 1950s Fashion shape tableware, Nigel Collins collection.

Introduction to the Third Edition

Fifteen years after the launch I am writing a new section for the third edition of the Midwinter Pottery book.

Sadly, Jessie Tait died in 2010, I am hugely indebted to her endless patience and recall which were essential in putting the factory's story together, this book would not have been written without her.

My interest in Midwinter hasn't waned and I am grateful for the opportunity to show and discuss some new pieces and have been amazed at the places that this book and the pottery have taken me. A lecture I gave at the Royal Ontario Museum, Toronto, had to be the most nerve-racking and a talk to collectors in a North London collector's club the most intimate while trips to Tokyo were both surreal and unforgettable.

S.J.
2012

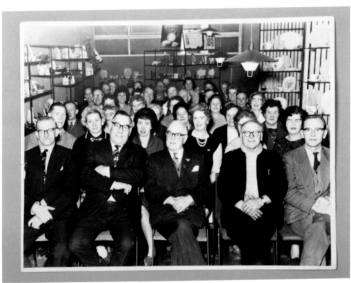

Pottery founder W.R. Midwinter with colleagues in the showroom, early 1960s.

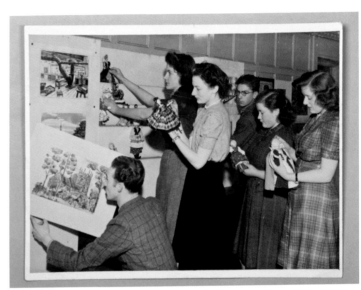

College days at Burslem College of Art, Jessie Tait second from right, c1946.

Worldwide Collections

There are now Midwinter collectors globally and pieces made in Stoke initially exported to Australia or Canada are shipped back to the UK while other pieces head across the world fifty years after their manufacture.

Ebay naturally has become the largest global marketplace for buying and selling Midwinter. Occasionally a rarity turns up and there is fierce bidding – a large service of Toadstools in Australia causing a commotion at one point. Thankfully antique fairs and flea markets have survived the internet age and prices have levelled as collectors fill the gaps in their collection or have filled every available space so have to stop. A newcomer to collecting could probably put together an impressive collection in a short space of time with patience and some inhospitable hours waiting for auctions to end in the small hours. Sharing collections has also become easier with Flickr and Facebook amazing resources for showing off collections and gloating at others prized possessions!

Midwinter in Japan

I have given two lectures in Tokyo about the factory. The first was a small group of collectors in an informal building where we all drank green tea afterwards and I was shown photographs of precious collections. (I realised many of the audience probably

XIIIth Century copper lustre jug, watercolour Jessie Tait c1946.

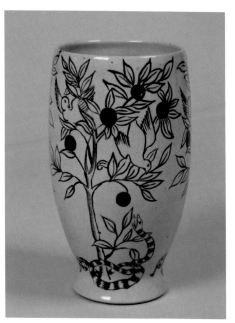

Hand-thrown vase signed D J Tait possibly from college or while Jessie Tait was working for Charlotte Rhead mid 1940s.

Clay stain vase, decoration by Jessie Tait, c1950.

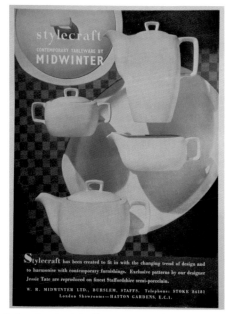

Full page advert for the new range. Pottery Gazette and Glass Trade Review February 1953.

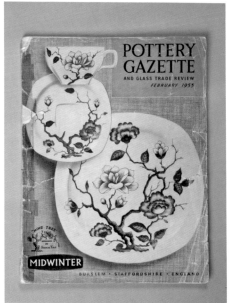

Jessie Tait's copy of the magazine that launched the Stylecraft shape, a fairly traditional pattern was chosen for the cover.

Full page advert in the Pottery Gazette to promote the new Fashion Shape, 1955.

didn't understand much of what I said but were still completely attentive). The second was in an antique mall in Ginza, central Tokyo, I had a translator and it felt like a very academic affair. A dealer in the centre specialised in Midwinter, strangely juxtapositioned between two traditional Japanese antique dealers. Once again photographs of collections were shown and I learned that a Toadstool cup and saucer was a very high status piece in a Japanese collection as were pieces that bore facsimile signatures of Jessie Tait or Terence Conran.

Conran's designs for Midwinter are still highly collectable and are considered among the best of the Midwinter output from the 1950s.

2010

Jessie Tait, the head designer at the factory from the 1950s to the 1970s, died of cancer in Stoke on Trent in January 2010 at the age of 81. She had been ill for a year. Tributes in the Stoke Sentinel describe her as modest, immaculately presented and a generous person. Eve Midwinter described her as meticulous and that she was one of the serious designers of the 50s, 60s, 70s and 80s. The Guardian also ran an obituary, Charlotte Higgins described her as 'a deeply modest, practical woman, she never lost the desire to make fresh work.'

Radio 4 broadcast a feature on Jessie during Woman's Hour (still available online at the time of writing). Cheryl Buckley, Professor in Design History and author and collectables specialist Mark Hill discussed her designs in context and her place in design history.

Jessie Tait

I first met Jessie in 1996 while researching the first edition of the book. We stayed in touch and I thought of her as a friend, we would meet a couple of times a year, usually in Stoke. She was always interested - and faintly amused - at the interest in her early work saying that it was just a job and that she never expected to see many of her designs again, let alone on show in a gallery (often for a considerable sum). Nevertheless she was happy to identify different pieces of Midwinter that I brought to her. Sometimes that triggered a story from the factory of some technical detail about the production of a range of wares. Occasionally she would draw a blank on a piece with her signature brushwork but I would sometimes receive a phone call a few days later with a 'I think that was…'.

Jessie was still designing when we first met, she had a conservatory studio that was full of pots of brushes, mountains of sample plates and endless sketchbooks and paper. Interestingly she was working for a factory in Malaysia and that some of the pottery there was still hand-painted so Jessie was cutting stencils, sponging and creating textures, techniques that had echoes of her designs from the early 1950s for their new designs. There was never any nostalgia as she was never going to re-work old patterns as her work was aimed at the contemporary marketplace. She visited the modern state-of-the-art factory and was very impressed at the production, much of the output intended for Europe. As print technology was so good very often Jessie's sponged and painted artwork translated into pottery that retained a hand-painted feel.

Halls of Residence - Staffordshire University

In 2001 Jessie Tait and Rachel Bishop, senior designer at Moorcroft, threw open the doors of the new halls of residence in Stoke-on-Trent as part of the opening ceremony. Clarice Cliff Court is a seven-house complex with each of the houses named after a prominent female ceramic designer. Eve Midwinter and Jessie Tait each have a house named after them, Charlotte Rhead, Jessie Van Hallen, Milicent Taplin, Star Wedgwood and Rachel Bishop are the other named designers. This is a welcome tribute to the ladies of the potteries and Jessie was very pleased to have been invited to the ribbon-cutting.

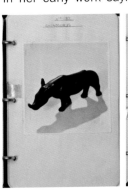
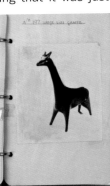
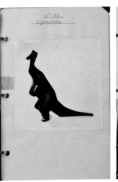
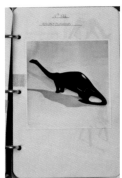

Design Festival

In summer 2010 I was asked whether I might be interested in putting on a Midwinter display as part of London's Design Festival in September. This was shortly after visiting Jessie's niece and nephew and looking through folders and folders of artwork – and we felt that some of this work should go on display and this seemed like a great opportunity. Pete Collard, a curator and design historian had found a venue for the show, a smart kitchen design showroom in East London, Bulthaup, who were happy to sponsor the show. We contacted collectors that were happy to loan work and alongside some pieces from the Tait family we managed a retrospective in a very stylish environment. A display of contemporary advertising and some of Jessie's early pieces of work and artwork for more familiar patterns completed the show. Jessie's service of Spanish Garden and Midwinter cutlery made a great centrepiece which captured the feel of the late 1960s. The exhibition was well received and was reviewed as far afield as Italy.

Going through the folders of work with Jessie's niece and nephew was very exciting. Although I was familiar with many of the pieces of work, there was much more than I had seen previously. The black book which listed and illustrated all the shapes from 1953 through to the mid 1960s was there, a fantastic resource. One of the most exciting discoveries was a sketchbook from her college days. On sheet after sheet of black or buff paper intricate florals were painted, some with stylised birds and animals. In these illustrations you can see the genesis of early patterns like Moonfleur and some of the Stylecraft patterns. The imagination and execution are exemplary. On one page where detailed anatomical drawings were worked in ink and watercolour Jessie had spread her botanical studies around and over the earlier drawings. These really are one of the nicest pieces in what we hope will become an archive of her work. Many trial patterns from the early 1960s through to the 70s are present, fittings (designs worked up to fit on a ceramic shape), colourway tests (including an early test of Spanish Garden with 'pink?' annotated on the side) and a large amount of brightly-coloured late 1960s artwork. Proposed patterns for Fine, Pedestal and MQ2 ranges and patterns adapted for J & G Meakin's Studio range after they took over Midwinter illustrate the flower-power period brilliantly in their boldness and unrestrained colour. The original artwork for Eden is also there. A collection of factory ephemera including lots of pattern leaflets from the 1950s and 60s were also in boxes and folders, some with 'discontinued' written across them, prices or production notes. I am working with the family to sort and list all these pieces, which might take some time but it will be a great window on a period of original design.

Among the artwork and folders of designs are some of Jessie's paintings, she originally wanted to become a painter and, after college she was about to apply to the Royal College of Art. Interestingly her paintings are well-observed, domestic and local scenery with none of the decorative imagery you would expect. This could have been largely due to the time they were painted (late 1940s) or perhaps the tutors who taught painting. It seems though that the decorative quality that was the basis of Jessie's career was already blossoming, her college sketchbook and doodles showing such a strong, individual style. We have to be thankful that Jessie was born and grew up in the Potteries area and was able to fully develop this talent.

Factory shape guide, contains listings for Stylecraft, Fashion, Hotelware, Classic, Fine, Trend and fancy shapes and Colin Melbourne figures, a great visual resource (also on page 90).

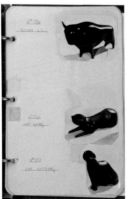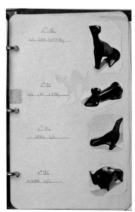

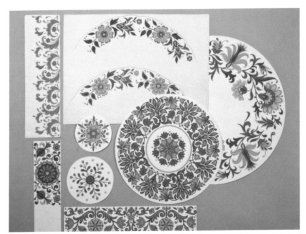

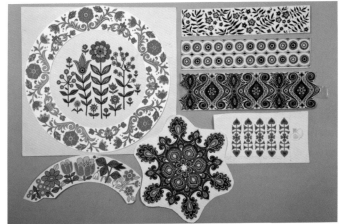

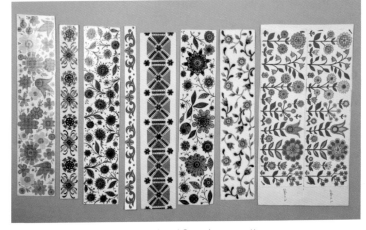

A selection of original artwork, sample transfers and colourway tests from the 1960s to '80s including Fine, Pedestal and Stonehenge patterns.
.

92

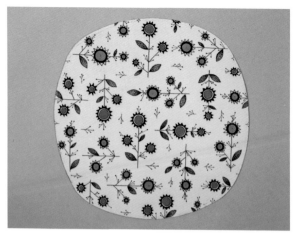

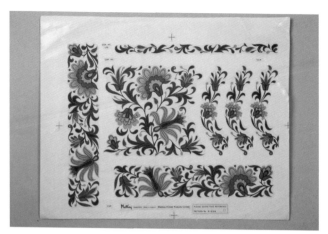

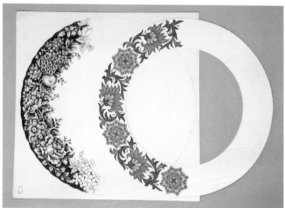

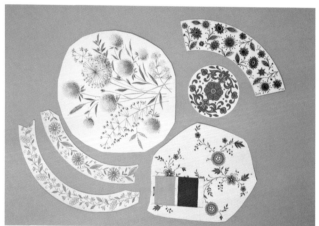

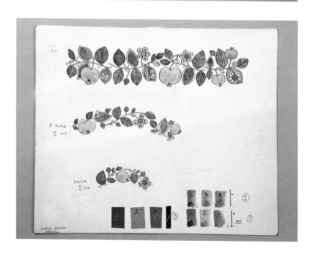

Midwinter collectors

Midwinter continues to surprise and many of the patterns overlooked by the die-hard collectors of the last decade are quietly picked up and collected by a new generation that remember family dinners at their grandparent's houses with now fashionable-again patterns like Country Garden, Queensberry or Spanish Garden. The colours on the Fine Shape seem to fit perfectly into the fashionable retro interior – and their easy availability and functionality make them perfect for daily use. The pottery is often used in period dramas on television to help set a scene and I am often told that such and such a programme had some classic Midwinter prominently displayed. I still can't help but think first of Hattie Jacques and Eric Sykes drinking out of Spanish Garden in the 1970s comedy *Sykes* or Sylvia Sims using Red Domino in *The Punch and Judy Man*.

Collectors are enthusiastic at sharing their information, which has been immensely useful in compiling the design directory. Nigel Collins allowed us to photograph his impressive collection, he started collecting as a student, falling for some Bristol kitchenware and then Woolworth's classic Homemaker pattern. Later he found a Midwinter Whispering Grass dinner service and this started a new collection. Some fifteen years on he has an impressive display of 1950s pieces and practical services in 1960s Mexicana and Diagonal for daily use. He collects and deals in the pottery he is passionate about, he says that '...eBay has been a bit of a double-edged sword, it has opened the market and increased awareness but people always like to see and touch the pieces. Midwinter is an odd market, there are two extremes, the desirable pieces will always fetch money and then younger people buy to use rather than collect.' He feels that at some point a contemporary take on classic Midwinter patterns will turn up in M&S or somewhere similar, made for the buoyant retro and vintage marketplace. He doesn't feel that there will be much change in collecting – and his biggest regret? Selling a tea for two in Bolero, though as you can see he still has quite an impressive collection (page 87).

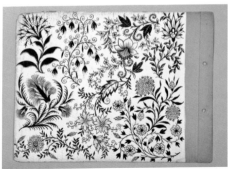
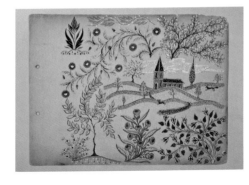
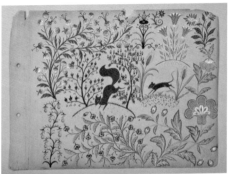
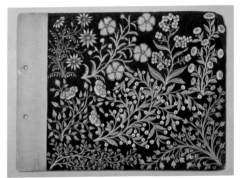
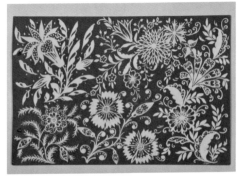

Jessie Tait's college sketchbook, pages and pages of intricate gouache paintings and pen and ink drawings, even the anatomical studies became embellished.

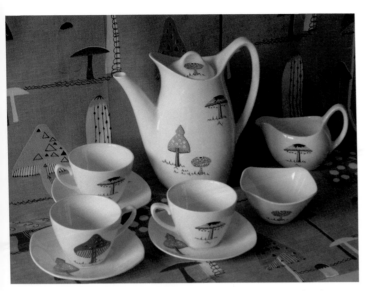

Toadstools coffee set against Rosebanks fabric in an unusual colourway c1956.

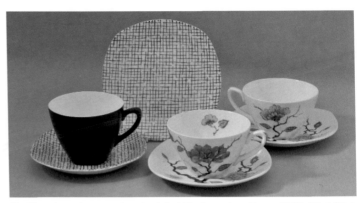

Fashion shape teaware, hand-painted black mesh pattern c1961, Ming Tree variant c1955.

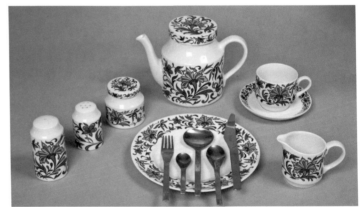

Spanish Garden and Midwinter cutlery, Jessie Tait's own service.

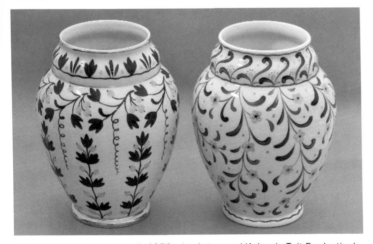

Pair of Midwinter vases early 1950s, backstamped 'A Jessie Tait Production'.

From left to right:
Pedestal sample, 1967/8.
Unusual hand-thrown terracotta jug, Jessie Tait.
Hand painted Midwinter vase (shape 207), similar to the Caribbean pattern c1956.

95

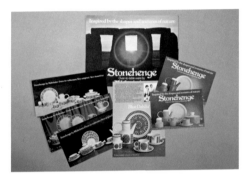
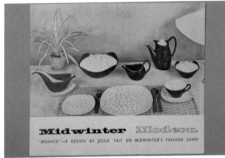
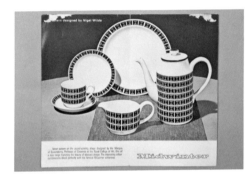
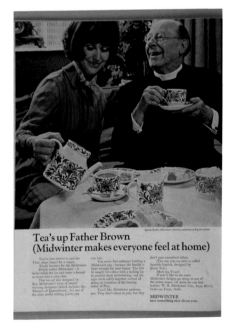
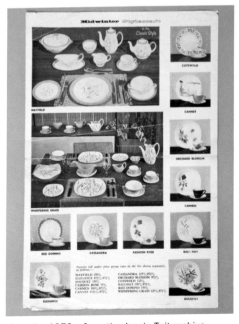

Promotional leaflets and adverts from the 1950s through to the 1970s, from the Jessie Tait archive.

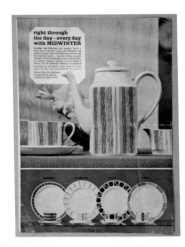

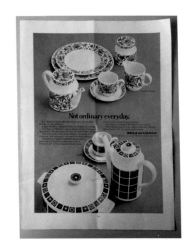

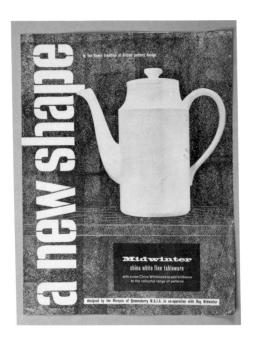

stylecraft *Fashion* tableware

"DRIFTDOWN" - A Jessie Tait design

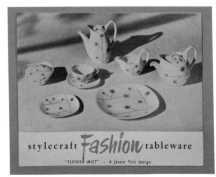

stylecraft *Fashion* tableware

"FLOWER MIST" - A Jessie Tait design

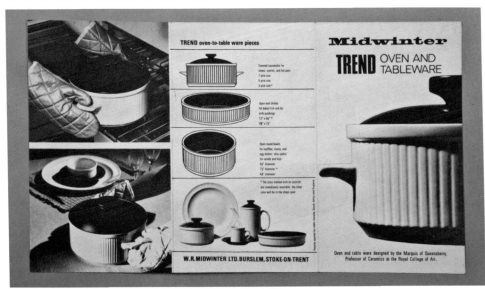

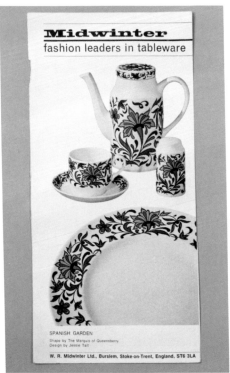

Jessie Tait as inspiration

A quick look at contemporary design/craft on the internet and you will soon find people citing Jessie as a major influence on their work. Printmakers, illustrators, textile and interior designers have grown up with her work or discovered something she designed at a flea market that spoke to them. With designs covering five decades there is a wealth of styles, colour inspiration and decorative detail to pore over. One of the strangest homages to the 1950s are doll's house miniature teasets and vases in Festival or Zambesi.

Not just the professionals are attracted to her work, cooks often use classic Midwinter plates to set the scene for a food article. Interior and style magazines often refer to Midwinter and Jessie Tait, *World of Interiors* ran a feature on Jessie, *Living etc* and *Elle Deco* both mention Jessie alongside Lucienne Day as one of the best of the Mid-Century designers. A German interiors magazine also ran a feature on Midwinter as a design classic. It seems very little was exported to Europe during the 1950s and 60s but pieces still turn up in the most unexpected places.

Jessie's niece, Henrietta, has taken one of her floral designs and adapted it for ecclesiastical embroidery, vestments for the London Oratory. The priest who will wear and use them met Jessie at family occasions and visited the exhibition in Clerkenwell. Henrietta had also asked Jessie for a design for embroidery for her eldest child's christening robe.

As part of the celebrations for the 60th anniversary of the Festival of Britain at the South Bank, London during the summer of 2011, a room set was constructed in the Festival Hall. This evoked the spirit of the post-war age and featured spindle-legged furniture, lots of bright, decorative fabric and, of course, Midwinter pottery. It was interesting to hear the comments from people that had lived through the period who now dislike the style as it evokes the attendant rationing and austerity and that of younger visitors who (generally) soaked it up, loving the energy and exuberance of the style.

Right:
Fashion shape dinner plate, hand-painted sample pattern for print.

Finds

Sadly I haven't heard of any amazing discoveries but occasional rarities come to light and appear on the market. Some of Jessie's work for Clayburn Pottery and her terracotta pieces have surfaced. These are usually fought over though a fair number of pieces of terracotta with tube-lined decoration have been seen. A quantity of Stylecraft Tropicana dinner and teaware turned up at auction, a very short production pattern. Patterns that migrated from Stylecraft to Fashion often underwent colour changes and a modernised Ming Tree has been noted hand-coloured in lavender, pink and green. A set of tennis sets in Pierrot printed in different colours was a lucky find, and the Riviera/Cannes ranges appear with or without the honey glaze and even with the wrong backstamp. An interesting hand-painted trial Fashion plate with balloon motifs seems to have been intended for transfer production but perhaps wasn't made, the decoration too detailed for paintresses to produce consistently.

A trial piece has emerged from the Portobello range and an extremely rare sample from the Pedestal range, produced before the takeover by J & G Meakin in 1968.

Transfers intended for the MQ2 shape are often found, or variants of, on Meakin's Studio shape which Jessie produced patterns for after the takeover.

Finally some Stonehenge pieces with open stock transfers have been noted – traditional floral patterns.

I'm sure there is still a wealth of unrecorded pieces and oddities that made it out of the factory, it's just being in the right place at the right time...

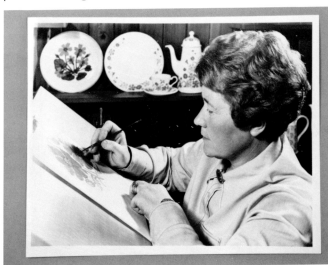

Jessie Tait working at Johnson Bros, part of the Wedgwood Group.

Midwinter Design Directory

Guide: This is a list of known and verified Midwinter designs that were trialed or put into full production. Without the pattern books a complete and accurate list is practically impossible to assemble as new 'finds' are coming to light regularly and the pattern listing would be almost endless. In the pre-*Stylecraft* and later *Fashion* years many patterns utilised open stock transfers from other manufacturers and can be difficult to identify as the factory may have been using old stocks or fulfilling a private order. The author would like to thank everyone who sent information to update and extend this listing.

Entries are listed in the following form:
Pattern name/(pattern no.) where known; description; [designer if known]; earliest date of production.
Bold italics indicates an adopted pattern name.

Index of Designers: [JT] – Jessie Tait; [EM] – Eve Midwinter; [HC] – Sir Hugh Casson; [TC] – Sir Terence Conran; [JR] – John Russell; [DQ] – David Queensberry; [NW] – Nigel Wilde; [BB] – Barbara Brown; [JB] – Joti Bhowmik; [PS] – Pat Speak; [CL] – Carol Lovatt; [AA] – Angela Atkinson; [RW] – Robin Welch; [TT] – Tom Taylor.

Hudson Shape (Old Classic) – (1946+)

Brama – all-over transfer 'chintz' pattern of floral sprays.
Coral chintz – all-over transfer 'chintz' pattern of floral sprays.
Indian Tree – traditional print and enamel design.
Kingsway – maroon and gold border pattern.
Landscape – traditional print and enamel design.
Lorna Doone – all-over transfer 'chintz' pattern of birds and flowers.
Maytime (3645) – full colour transfer floral spray(s) with gilded line to centre.
Moonfleur – incised design of stylised organic forms decorated with clay stains in beige, grey and blue. Mainly found on fancy shapes but also produced in teaware. Variants are known. [JT].
***Painted Floral* (3697)** – maroon, teale and gold floral border pattern. [JT].
Palace – gold decoration.
Parkleigh – teale green border pattern of hand-painted ivy leaves with gilding and teale green band to inner rim. [JT] 1952.
Regal – maroon banding with radiating leaf motif in maroon and gold. Also known with a laurel leaf border. Variants are known. [JT].
Ribbed Banding – graduated bands in grey with inner band of maroon, yellow or green to form border.
Rockwood – banded border with gold stamping available in a variety of colours.
Roshan – teale blue border.
Spring Bouquet – transfer pattern of floral sprays in blue, yellow, pink, green and black.
– Spring Bouquet variant – multi-coloured transfer floral motifs and ribbed banding in grey to form a border.
Springtime – all-over transfer 'chintz' pattern of floral sprays.
Willow – traditional print available in blue or brown.
Windsor – traditional print and enamel design.
Wynnewood – maroon border pattern of hand-painted leaves with gilding and maroon band to inner rim. [JT] 1952.
Yang – transfer pattern in yellows and oranges of willow pattern style motifs.

Un-named – floral transfer of peony rose with purple, blue, yellow and pink flowers. Gold flowers on pink band to form border.
Un-named – all-over transfer 'chintz' pattern in pink, blue, orange and yellow.
Un-named – transfer pattern of autumn leaves and blue flowers.
Un-named – transfer of rosehips.
Un-named – maroon band with gold stamped shields, also found with a yellow and maroon band.
Un-named – gold stamped floral border.

Stylecraft Shape – (1953+)

Apple Blossom – naturalistic apple blossom on white background, also known with gold stamp background, or grey brushstrokes, *(Fashion* only).

Arcadia – stylised floral transfer in yellow, greens, pink and blue, banded in grey with a black line to edge, sometimes with a gilded border. This transfer forms *Spring Bouquet* on pre-*Stylecraft* pieces. Often with ribbed washband edge in grey. This pattern was used on fancy items and *Fashion* shapes well into the sixties. 1953.

Arden – stylised transfer of leaves in pinks, green, brown and grey with banding in grey and a maroon line to edge. 1953.

Bulrush – a hand-painted pattern in green and brown of two bulrushes and leaves radiating from the base of holloware or one side of the flatware. [JT] 1953.

Camellia – transfer floral motif in greens, yellow and black, of white flowers with greenery.

Catkins – hand-painted design in lime green and brown of naturalistic catkins on a branch. [JT] 1953.

Cloudline – hand-painted grey 'stripes' similar to *Zambesi* interspersed with random dots in dark red. [JT] c.1955.

Contemporary – border pattern of coloured stars/spots.

Cottage Ivy – hand-painted foliage in green and brown similar to *Spruce* with leaves and no border. [JT] 1953.

Crinoline Lady – traditional pattern with central transfer and gold stamp border.

Delight – transfer-printed floral motif with gold stamping.

Encore Blue – stylised floral transfer in blue and grey with banding in grey and blue line to edge. 1953. Also know on earlier wares.

Encore Green – stylised floral transfer in green and grey with banding in green and grey line to edge. 1953.

Fantasy – hand-painted design in grey and brown edged in grey brushstrokes and a brown line, nicknamed 'cod's eye' in the factory. [JT] 1953.

– *Fantasy Leaf* – variation of above with central motif in yellow on brown with stripe border.

– *Maxims* – an abstract central motif hand-painted in brown with a border pattern as *Fantasy* but the logo for Maxims painted on the top rim. Example known on 10" plate.

Fiesta – yellow stripes with a central brown wavy line between a pattern of random brush-strokes in green, brown and yellow alternating with hashes in green. Variations known. [JT] 1954.

Fir – naturalistic transfer print in greens and browns of foliage and cones. [JT] c.1955.

Galaxy – hand-painted stars in red with grey brushstrokes forming a check pattern on the flatware. Holloware had free floating stars. [JT] 1956.

Golden Brocade – gold stamped floral pattern with a gold line to the inside rim of flatware and 'halfway' line on holloware. A utility grade pattern available exclusively through a stockist in Stoke-on-Trent. 1955.

Hawaii – stylised transfer of leaves in red, yellow and blue with a black outline and shading, and a red band inside the rim. Also known on *Fashion* with a grey brushstroke background. The transfer was produced by Johnson Matthey & Co. as *Miranda* and was used on ware from other factories.

Homeweave Green – all-over plaid pattern in wide green lines and thin red lines. Variations are known in grey, red and black with varying spacing of pattern. Small *Fashion* trays are known with checks in pink, black and grey. [JT] 1953.

Homeweave Red – all-over plaid pattern in wide red lines and thin black lines. Variations are known in grey, red and black with varying spacing of pattern. A yellow version has been noted. [JT] 1953.

– *Homeweave variant* - vertical lines in yellow and horizontal bands in turquoise form a plaid between fine black lines.

Leopard Lily – hand-painted floral in light and dark green, orange and maroon. The pattern covers most of the central area of the flatware. [JT] 1953.

Ming Tree – print and enamel design of flowering branch in brown with red, yellow and green hand-painting. Also printed in dark blue or black on *Fashion* shape. [JT] 1953.

Mountain Lily – naturalistic transfer print in colours of white flowers with an aerographed border in green. Handles also have a transfer running down them and cups have a transfer inside. 1954.

Mountain Rose – transfer of white wild rose and bud with green leaves, and transfer also found on handles.

Old England – print in black of rustic scenes hand-painted in yellow, green, red and blue. 1953.

Orchard – hand-painted fruit and foliage motif in shades of greens, red and brown. Handles are decorated with bright green brushstrokes and each shape has a different composition of fruits. [JT] 1953.

Pageant – hand-painted heraldic leaves in dark green to form an all-over pattern on the flatware, mainly used on fancyware. Also known in grey or maroon. [JT] 1953.

Petula – stylised transfer motif of pink flowers and green leaves with thick green and thin pink band to edge. 1953.

Primavera – all-over pattern of stylised organic motifs in green, grey and yellow surrounded with green and grey spots. Single larger motifs were used on tea and coffee pots but lids generally have two or more motifs. A variant of this pattern was produced on the *Fashion* range. [JT] 1954.

Pussy Willow (65) – naturalistic transfer print of sprigs of pussy willow. Transfers were adapted and re-coloured as the pattern moved through different shapes, 1953.

Red/Blue Domino – hand-painted border or rim in red, (or blue) with relief white spots applied in an alternating pattern. Blue was first available in January 1956. Green was produced for fancy items. [JT] 1953.

– **Red Domino variant** – relief dots in red are applied all-over the holloware with solid red lines to handles, lids etc. Saucers and plates have a thin band inside rim and a single row of relief dots in white. Adapted from the Jessie Tait design.

– **Black Domino** – flatware has a thin band inside rim and a single row of relief dots in white. Presumably black holloware corresponds to the *Red Domino variant*. [JT].

Riviera – print and enamel design with turquoise, yellow and brown hand-painting. Seven different drawings were used for different items: a café scene, a flower seller, barrels and archway, harbour with cafe, mountain scene, pony and trap and view of bay and rooftops. The glaze on this range was honey coloured, but when the designs were re-worked for the *Fashion* shape, the body colour was white and the design re-named *Cannes*. Also known on the *Classic* shape. [HC] 1954 [c.1960 on the *Fashion* range].

Shalimar – print and enamel design of flowering branch in brown with turquoise and old gold hand-painting. Also printed in black on *Fashion* shape. [JT] 1953.

Sherwood – hand-painted design of *Tudor* style leaves in brown and red, half of each leaf has brown spots on red, and the other half green highlighting on a brown window-pane check. This is thought to have been a short run pattern. [JT] 1953.

Silver Bamboo – hand-painted design with brown bamboo stalks and grey leaves (with or without silver lustre). This was re-worked for the *Fashion* shape as **Tahiti**. [JT] 1953.

Silver Wheat – stamped design of grasses in silver with a band of red and a silver line to edge. Also known with a blue band substituting the red. [JT] 1953.

Spruce – hand-painted sprigs in brown with green shoots edged in green brushstrokes and a brown line, [JT].

Starlight – stamped snowflakes in gold interspersed with red dots with a red band around inner rim. Also known with a blue band and on the *Fashion* shape. [JT].

Summertime – a floral bouquet transfer-printed in colours. [JT] 1953.

Trellis/Festoon – black or red transfer pattern 'loop' design, the black version having a yellow, green or pink band over the design, mostly found on *Hotelware*.

Tropicana – hand-painted window-pane check in brown, alternate squares have green lines and a diagonal pattern of yellow brushstrokes. Mainly found on cake stands etc. Other trial colourways are thought to have been made. [JT] 1954.

Tulip Time – sponged apple green squares and yellow dots with hand-painted floral decoration, 1953-1954.

Wild Geese – transfer print in colours with grey-blue line to edge. Like *Riviera* these were adapted from drawings by the artist Peter Scott. A number of different naturalistic studies of geese and clumps of grasses appear on the ware. This was in production on the *Fashion* shape into the late sixties. Other paintings were used on a range of decorative ware on the *Fashion* shape, including ashtrays. [PS] 1955.

Wild Rose – transfer print of white rose with yellow centre and green leaves, transfer is also used inside cups and down handles. 1953.

Woodside (2008) – naturalistic transfer print in colours of bunches of violets and flowers with an aerographed border in green. Handles also have a transfer running down them and cups have a transfer inside. Also available on the *Fashion* shape without a border.

Un-named – all-over pattern of orange and black brushstrokes with a gold line to edge. This is thought to have been adapted from a motif on *Fiesta,* perhaps to produce a cheaper range for a particular buyer.
Un-named – stylised transfer motif of sunflowers in colours with a band in pink, and red line on inner rim. Also found on *Fashion* shape with no banding.
Un-named – transfer print of pink roses, one in bud, one in flower.
Un-named – poinsettia transfer floral motif.
Un-named – two broad hand-painted bands in turquoise across length of plate with two thin black bands at right angles intersecting at one corner. Thought to have been a pattern to train paintresses.
Un-named – hand-painted border pattern with six fine lines decorated with simple leaves and dots.
Un-named – banded rim in bright green with two fine bands inside rim in blue green.

Fashion Shape – (1955+)

Alpine – transfer stylised floral in pink, grey and turquoise with holloware available in pink or turquoise. c.1960.
Anemones – transfer floral pattern on fancyware.
Autumn – transfer-printed leaves, dots and spirals with hand-painting in rust, green and yellow. An early *Fashion* design. [JT] 1955.
Azalea – transfer floral pattern.
Bali H'ai – a design of grasses transfer-printed in black with yellow hand-painting and matt black holloware. Relatively common on most shapes except salad items. Export sets are found with yellow holloware. [JR] 1960.
Bamboo – a hand-painted design in black with vertical lines and black and white leaves forming an all-over pattern. The design is also known with gold lustre on the white leaves and a gold line to edge. Variations known. This possibly had black holloware. [JT] 1962.
Bargeware – transfer prints of cabbage roses in bright colours from paintings in a loose 'brushstroke' style. Late 1960s.
Bella Vista – an Eve Midwinter design adapted by Jessie Tait. Hand-painted floral spray with a scalloped border; sometimes found with a lilac scalloped border around the green to form a two colour border on flatware. [EM] 1960.
Blue Harebells – a stylised transfer print of bunches of flowers with turquoise holloware. Also known with pink harebells, with pink holloware.
Bolero – adaptation of *Capri* with yellow and turquoise hand-painting and yellow holloware. [JT].
Border stripe – hand-painted border in broad strokes of green and maroon interspersed with thin black lines. Also known in turquoise and yellow. Many versions are known on mugs and beakers. This design was the forerunner of *Mexicana*. [JT].
Bouquet – transfer floral of mixed items in blues, greens, yellow and black. This was based on an Eva Zeisel Hallcraft pattern used in America. The bouquet differs from piece to piece, dinner plates having a large transfer. c.1960.
Camellia (2293) – transfer print of white flowers with yellow centres.
Cannes – a re-working of the *Riviera* design of 1954. The transfers were printed and hand-coloured with a clear glaze, (i.e. a white body colour instead of the honey coloured finish of *Riviera*) and the holloware was turquoise to modernise the pattern. holloware is also known in matt black. This design was possibly available well into the 1970s. [HC].
Capri – print and enamel design of leaves and dots in grey with rust, grey and yellow hand-painting. A single larger motif taken from the transfer was used on teaware, the flatware retaining the all-over transfer. Re-worked as *Bolero* with bright yellow holloware. [JT] 1955.
Caprice – transfer floral centre with lilac band.

Caribbean – an all-over transfer print in black with hand-painting in yellow of stylised leaves or seaweed in horizontal lines. Handles have a black swirling line. The holloware is yellow. Version known in brown with green and yellow hand painting. This pattern is often found with a *Stylecraft* backstamp and was possibly produced for fancyware, i.e. for cake stands before the *Fashion* version. This was the first Midwinter pattern to utilise the Murray Curvex printing method. [JT] c.1955.

Carmen (2353) – a design of red and black roses sometimes with black holloware. [JR] 1961.

Cascade (2303) – transfer-printed 'stars' as found on *Driftdown* in pink, turquoise, grey and black against a grey brushstroke background, (occasionally without), and gold stamped motifs. Used mostly on Fancy items. Adapted from a Jessie Tait design.

Cassandra – an abstract studio transfer in grey and turquoise with holloware in turquoise. One of the most commonly found non-naturalistic designs on the *Fashion* shape. Paper napkins were produced with this transfer to co-ordinate with tableware. 1957.

Cathay (2312) – transfer motif of two pink roses and two buds with maroon centres.

Chequers – a design of a stylised check with lines and dashes in some squares and sponged blocks of colour filling others. Painted in grey, yellow and olive green, The holloware is either grey or yellow, grey being the original colour. Based on a David Whitehead fabric of 1951. [TC] 1957.

Cherokee – a hand-painted design in rust, turquoise, yellow, grey and black. A radiating brushstroke border is linked with a black line and dashes. The brushstrokes appear in the centre body of pots and tureens and run horizontally down the ladle. [JT] 1957.

– **Pastel Cherokee** – a hand-painted design with radiating brushstroke border in pink, turquoise, yellow and grey, holloware in turquoise. Also known in navy, brown, pale blue and yellow with mink holloware. [JT].

Cherry Blossom (2310) – transfer floral pattern.

Chopsticks – a hand-painted design of scattered brushstrokes in yellow and green or turquoise and grey to form an all-over pattern. The holloware was in green, yellow or turquoise. [JT].

Contemporary – a studio design featuring either different coloured stars or polka dots around the edge of flatware and all-over holloware. Also found on *Stylecraft*.

Cornfield – a pattern of corn and leaves in shades of red browns with matching holloware. [JR].

Countryside – a transfer-printed design of berries, poinsettia and a white rose. [JR].

Crinoline Lady – surprisingly this pattern survived well into the fifties and the transfer with gold-stamped border was used on the *Fashion* shape.

Crossnet – a hand-painted all-over design with a 'net' pattern in black with crosses at the intersections in alternating turquoise and yellow. A trial or short run pattern. [JT].

Cuban Fantasy – transfer-printed amoebic/fingerprint patterns are hand-painted in yellow and turquoise with holloware in turquoise. This design is mostly found on fancyware though also produced in tea and dinnerware. [JT] 1957.

Daisy Dell – floral in pink and turquoise similar to *Alpine* and *Quite Contrary*. c.1960.

Daisy Time – a transfer-printed design of a bunch of large scale daisies in ochres, brown and greens. [JR].

Davies Rose (2179) – a floral transfer of pink roses.

Deer – hand-painted study of deer sitting and leaping painted in black. Example known on a 14" plate.

Delicious (2037) – a transfer pattern of red apples on branches. Used on *Salad* shapes and fancyware. Mainly export. 1955.

Desert Scene – a transfer print from Charles Cobelle's artwork in bright pink, black, lime green and turquoise of a cactus against an archway and smaller plants. Known on a range of dinnerware.

Dogwood (2028) – this large scale transfer-printed design was taken from a Jessie Tait painting and produced primarily for the Canadian market and was very successful. [JT] c.1957.

Driftdown – transfer-printed design in grey and black. Small star shapes are placed randomly all over the ware. These were also used on the fancyware pattern, *Cascade*. [JT] 1956.

– **Astral** – version of *Driftdown* with pink and turquoise 'stars'.

Dutch Rose (2305) – transfer floral print.

Elegance (2351) – transfer print of three peach roses and leaves.

Falling Leaves – a transfer print of stylised leaves in yellow, grey, brown and maroon are scattered on the ware. Also made with grey background. [JT] 1955.

Fashion Check – hand-painted plaid in grey with yellow and turquoise squares with black centres. [JT].

Fashion Rose (2030) – a transfer pattern of stylised red roses with green leaves.

Father – a transfer print of moustachioed man in boater with a 'frame' in yellow and ochre, the word 'Father' in a cross stitch style in blue. Found on breakfast size cup with plain saucer, gold line to edge. Presumably part of a gift range. A traditional transfer motif entitled 'Mother' is also known on this ware. 1957.

Festival – this pattern owes its name and inspiration to the Festival of Britain where molecular structure was the theme for a group of designers to source from. The pattern is hand-painted in grey, rust, yellow and green and has 'cells' scattered in an all-over pattern with vertical green lines between them. Sauce ladles and lids had the 'cells' free-floating without the green lines. The design was also used by the Clayburn factory on lampbases substituting lime green for yellow. [JT] 1955.

– *Seaforms* – variant of *Festival* with underwater life forms represented in place of the 'cells' including a fish motif later found used on its own in a new colourway. This is likely to have been mainly a fancy pattern because of its complexity.

– *Triangles* – variant of *Festival* with triangular cells in grey with alternating centres of dark green, yellow and red. These are floating against strings of brown dots. Again, probably a fancy pattern though dinnerware is known.

– *Fish* – hand-painted in dark blue, with brown, red and yellow detail, stylised fish are set at right angles to each other to form an all-over pattern. The motif is also seen on *Seaforms*. [JT].

Fishing Boat – a transfer print of a lively illustration of a boat at sea by Charles Cobelle. Found on dinner and teaware.

Flower Mist – a transfer print in black of spiky flowers with a hand-painted ring of colour around the flowers in rust, turquoise and yellow. This is sometimes found with black holloware. This design was also used on *Stylecraft* Hotelware accredited to Weatherby, Staffordshire and the same transfer has been noted on German porcelain of the period. This pattern and *Starburst* were highly influenced by the work of American companies such as Hallcraft. [JT] 1956.

Fruit – hand-painted pattern of stylised fruits intended for cake stands. [JT].

Gay Gobbler – this striking print and enamel design was produced for the American market. The central motif is a turkey with a border of stylised feathers and the black print is highlighted with hand-painting in ochre, green and maroon. A large plate is the most popular item found in this design. A naturalistic pattern called *Turkey* (W.R. Midwinter) was produced prior to this with an all-over engraving and hand-colouring on a traditional shape. The backstamp is similar to the central design of *Gay Gobbler*. Larger items have corn stalks on them. [JT] 1955.

Glendale – a design of floral sprays with bright turquoise holloware. [JR]. Withdrawn c.1969.

Golden Glory (2343) – transfer print of two yellow roses.

Happy Valley – a semi-naturalistic study of a landscape printed in dark green and hand-painted in colours. Motifs are picked out and enlarged for holloware and bowls have an all-over transfer inside. Johnson Bros. had a similar pattern at this time. Advertised c.1960 but possibly earlier. [JT].

– *Happy Valley variant* – known in blue on a matt glaze with glossy white holloware. [JT] c.1962.

Harmony – a transfer print in grey, pink, turquoise and yellow of stylised floral motifs with a scrolling calligraphic grey line. A simplified version of this forms the border motif. Originally the pattern was applied to holloware as well, later this was bright yellow.

Hollywood – a hand-painted design in yellow, grey and brown. Yellow vertical lines with thin brown lines through the centre are interspersed with grey stars and small brown circles. Lids have free floating stars and circles. [JT].

– *Elstree* – a variation of *Hollywood* with turquoise stars used instead of grey. [JT].

Homespun – a print and enamel design in brown. The all-over check is partly cross-hatched, or has a brown circle in the squares. A hand-sponged ochre circle is placed in the squares randomly across the design. The holloware is ochre. [JT].

Kaleidoscope – transfer motif in olive and turquoise of geometric shapes to form a star shape. Mid- to late-1960s

Kashmir – a transfer pattern of pink-edged white magnolia flowers with brown/green foliage. [JR].

Kew Rose (2295) – a floral transfer of a red and yellow rose.

Liana – a print and enamel design with an all-over floral in a repeat pattern with hand-colouring in maroon, yellow and green. This was loosely based on *Leopard Lily*. Variations known. [JT] c.1955.

Magic Moments – a hand-painted design with vertical lines in green and random squares in yellow, rust and turquoise. The holloware is turquoise. [JT].

Magnolia – a stylised transfer print of pink flowers. Another design of the same name with mustard flowers was produced in the 1960s. [JR].

– **Magnolia (2000)** – a pattern of dark yellow flowers with green holloware. [JR].

Mambo – transfer print in black, red and grey of foliage and stalks with black holloware.

Marguerite – a studio design of stylised flowers and leaves in a central transfer-printed motif. Holloware is pink. 1958.

– **Seville** – as *Marguerite* with yellow replacing the pink in the design, and yellow holloware. c.1960.

Market Scenes – transfer prints with stalls of produce in loose sketchy style outlined in black. Probably open stock transfers.

Meadow – transfer print of blue flowers with brown grasses.

Melody – a design of a bunch of roses drawn in a lively style and transfer-printed in black, pink, yellow and green. The holloware is known in three colours, pink, lilac and a soft yellow. American markets had a preference for a speckled glaze and this pattern was produced with the *Stardust* finish. [TC] 1958.

Mink Rose – a transfer-printed design in mustard and grey of roses and foliage. Light brown holloware. [JR] 1963.

Monaco – a print of random cross-hatched lines in black all-over flatware and lids, the holloware being matt black. Originally the pattern was hand-painted, pieces were later transfer-printed. A variant is known on fancyware with two colour hatching in turquoise and black. [JT] 1956.

Morning Glory (2313) – transfer print of blue trumpet-shaped flowers.

Morning Glory pink (2313a) – transfer print of pink trumpet-shaped flowers.

Mosaic – an unusual design for this period as the ware is incised with a random grid pattern. The squares are then sponged in black, olive green, grey and yellow, or painted in green, orange and grey in another version. This was mostly intended for salads and casual meals. [JT] 1960.

Nature Study – has a transfer print in black of leaves, butterflies and moths drawn in a naive style with the corresponding holloware (cups, pots and tureen bases) in a matt black finish. Possibly inspired by a furnishing fabric called 'Woodland' of 1954. (Also known on *Stylecraft* plates, possibly the old shape was used to fulfil an order). Pieces are known in dark green and coloured versions on cake stands, [TC], 1955.

Nuala – a transfer print of red poinsettia-style flowers with greenery found on all dinner and tea shapes.

Nurseryware – transfer motifs of cricket bat, spinning top, aeroplane and drum with dark red line to edge. Other shapes in this pattern were a small beaker and a bowl. *Stylecraft* tankards with hand-painted pink elephants holding each other's tails were another part of the range. [JT].

Nuts in May – a transfer-printed design of leaves in greys and browns with ochre holloware. [JR] 1962-1970.

Oranges and Lemons – a transfer-printed design of fruit with mink brown holloware. Relatively common on dinner and teaware. [JR] 1962-1970.

Orchard Blossom – transfer of white blossom on branches with brown, grey and olive leaves. c.1960.

Patio – a transfer-printed design in black of 'tiles' in an all-over pattern with yellow sponged squares. Holloware is in yellow or black. [JT] c.1959.

Petite Rose – a transfer pattern of red rose buds with black and grey leaves. [JR].

Pierrot – transfer print in black with rings and circles forming an all-over pattern. Hand-painted variations are known. [JT] 1955.

Plant Life – a design transfer-printed in colours, (predominantly rust and green). Studies of houseplants in a sketchy style (including Conran's own designer plant pot on three legs) were placed inside and outside ware. Holloware is occasionally found in black, or more commonly pale yellow. The pattern was named after a class in art school. A variant is known in greys and blues on flatware, possibly a misfired example. [TC] 1956.

Primavera Fashion – a variation of *Primavera* with similar motifs with turquoise, black, yellow, lilac and grey. A coloured swirl was the background for a snowflake, leaf or floral motif. The pattern was applied to the holloware. [JT].

Primula (2340) – a floral transfer in yellow and green with sketched black outlines of other details.

Princess – a stylised floral transfer with gold leaf and stem decoration forming a border. A fancyware design. [JT] 1961.

Pussy Willow Fashion (2269) – as *Stylecraft*. This pattern was in production until 1973.

– Spring Willow – a transfer-printed design. A variant of *Pussy Willow* with a matt glaze. Usually on fancyware. The buds are more yellow than the earlier version and the holloware is in a dull yellow or light brown. [JT].

Pygmalion – no information. [JT] 1960.

Quite Contrary – a lively transfer-printed design of exploding stars in pink, black and turquoise with turquoise holloware. This design is relatively common in tea and dinnerware. [JT] 1957.

Random Harvest (2187) – a transfer print of stylised grasses in blue and brown, [JT].

Red Domino variant – with a band of red and applied dots bordered either side with a gold line. As the *Domino* range was so popular many minor variations occur, possibly some were special orders or short trial runs.

Rhapsody – white floral transfer set against a turquoise aerographed or glazed background. Lustre line to edge.

Riverside – a transfer-printed design of bulrushes, cow parsley, leaves and grasses with dark green holloware. Probably the most commonly found design on the *Fashion* shape as it sold in such large quantities. [JR].

Roselane (2330) – stylised transfer of a pink and yellow rose motif with black leaves. 1960.

Rose Marie (2178) – transfer print of red and/or yellow roses. Sometimes found with yellow bud roses with olive leaves. 1958.

Rosewood – a transfer-printed design with cerise holloware. [JR].

Rosita (2360) – red rose and bud transfer motif.

Ruby Mist – blue floral transfer set against a maroon aerographed or glazed background. Lustre line to edge.

Saladware – this design was produced on a wider range of shapes than the general output, and was also available on teaware. A black transfer print was hand-painted in maroon, green and yellow. Later in its production, possibly the early sixties, the design was re-coloured for an hors d'oeuvres set of three dishes, the colours were changed to pastels and the outside of the dishes were pink, lemon and pale turquoise. Banded versions in dark green or striped versions are known, [TC].

Savanna – a transfer print of black cross-hatched gridlines and yellow sponged squares all-over flatware and lids, with yellow holloware. Used on all *Fashion* and fancy shapes and produced in a turquoise version for the Canadian market. A test piece was produced on the *Classic* shape with blue sponging. [JT] 1956.

Shadow Rose – this transfer-printed design of a pink rose with cross-hatched shadow was tremendously popular well into the 60s. [JR] 1955-1973.

Sharon (2307) – transfer print of three pink flowers.

Simple Stripe – alternate stripes in green and yellow interspersed with a thinner line in black, Also found in combinations of turquoise, yellow, lilac, grey and red. A fancyware pattern mainly found on small trays. [JT].

Spring Fern – print in black with hand-painting and gold stamping similar to **Flower Mist**, probably made for Boots the Chemist, late 1950s.

Springfield – a central floral transfer in red, green black and yellow also known on *Classic.*

Starburst – a design similar to *Flower Mist* in style and colouring. Free-floating 'sputnik' shapes are printed in black all-over the ware with hand-sponged circles of colour added around the transfers. [JT] c.1958.

– Stardust – a variation of *Starburst* with a speckled finish, the glaze has brown spots. An exclusive design for the Canadian market. [JT] 1958.

Tahiti – a version of **Silver Bamboo** in black and lilac, [JT].

Tapestry Chintz – floral pattern.

Toadstools – a transfer print of lively coloured toadstools in a pseudo-cartoon style are placed over the ware. These motifs were adapted from a contemporary fabric. [JT] 1956.

Tonga – an all-over transfer print in black of entwined vertical lines with matt black holloware. A design originally tube-lined onto the range of studio vases. Possibly 1955 design as backstamp is same as *Pierrot*. [JT] c.1955.

Vegetables – hand-painted design of peas, cut fruit etc. in blue, black, green, maroon and yellow. [EM].

Whispering Grass – a transfer-printed design of grasses hand-coloured in lilac and yellow. The holloware is lilac in Britain but black for the export market. [JT] 1960.

– **Pampas Grass** – variant with no hand-colouring.

Wild Rose (2117) – a floral transfer of white dog roses with black holloware.

Wild Thistle – all over print in dark blue with yellow hand-painting. [JT].

Willow – a colour version of the traditional pattern.

Woodford – hand-painted floral with scalloped edge in grey and maroon, flowers in maroon and yellow, grey leaves, stalks in brown spots in turquoise. [JT].

Zambesi – a popular hand-painted design in black and red with tribal influenced stripes all over the outside of holloware and flatware. There is a red line to handles and inner rims of teapots, coffee pots and tureens. This is similar to the *Stylecraft* pattern *Cloudline*. The stand for the sauce ladle and cruet is all-over red. [JT] 1956.

Un-named – a print and enamel design of catkins in brown with lime hand-painting. [JR].

Un-named – a mesh pattern printed in royal blue on a matt glaze with holloware in deep blue gloss glaze. This is also known in fawn with matching holloware. [JT].

Un-named – transfer print of poodle with red bow and yellow collar in loose style drawing. Also known on Alfred Meakin ware.

Un-named – hand-painted weave effect with grey vertical dashes and yellow horizontal dashes. [JT].

Un-named – transfer print of stylised floral motifs in blue to form a border, finished with a matt glaze. [JT].

Un-named – abstract hand-painted texture in grey, a finish Jessie Tait used for the vases and other studio ware, transfer patterns were later added using the pattern as a background.

Un-named – partly open yellow rose with green leaves.

Un-named -- floral similar to *Woodford* with scallop border. [JT].

Un-named – sponged spots in yellow, grey and turquoise. [JT].

Un-named – ribbed, banded centre in grey, floral transfers to edge.

Classic Shape – (1960+)

Bella Vista – as on *Fashion* shape.

Cotswold – transfer floral of white flowers with yellow centres and green-blue leaves to form a border. 1960.

Fish – naturalistic transfer print of fish, different transfers were used to make up a set.

Garland – red floral border (possibly fancyware only).

Indian Tree – traditional open stock transfer pattern.

Mayfield – transfer floral in pink, gold, grey and white outlined in sage. Also found on *Fine* shape. 1960.

Meadow Sweet – transfer white floral on a turquoise ground. Also available on a maroon ground.

Princess – as *Fashion*. 1961.

Springfield (4400) – as *Fashion*. 1959.

Un-named – transfer rosehips (possibly fancyware only).

Un-named – transfer of autumn leaves and blue flowers originally on post-war ware.

Un-named – broad band of burgundy overprinted with gold shield motifs with central motif in gold. Variant with floral motif in centre and gold floral border.

Un-named – transfer gold floral motifs on cream ground.

Un-named – border pattern of gold shields on a yellow ground, burgundy band to inner rim.
Un-named – grey ribbed banding with inner band in red or yellow.
Un-named – border pattern of gold shields with inner red band and central transfer yellow rose, transfer also used inside cups.

Fine Shape – (1962+)

Almeira – twin pattern to *Spanish Garden* but not as successful, stylised leaves and flowers in yellow and green. [NW] 1966.
Berkeley – border pattern of squares in alternating olive and turquoise with alternating centre colour. [JT] 1969-1974.
Blue Alpine – a stylised floral in blues, purple and olive greens. Lids and saucers blue. [JT] Withdrawn 1975.
Blue Ribbon – no information. [JT] 1962.
Broadway – border pattern of textured stripes in blue and olive with brown lines between.
Calypso – mustard and lime version of *Tango*.
Cameo – alternating panels of olive oblongs and brown circles containing floral motifs.
Casino – re-working of *Red Domino* for the *Fine* shape. [JT] Stylist tableware.
Cherry Tree – transfer motif rows of stylised fruit and leaves on branches on holloware and single branches form a border on flatware. [NW].
Citrus – alternating onion shapes in turquoise and olive, with a white stripe through the turquoise motif. [NW].
Contrast – a pewter black and satin white glaze pattern. [JT] 1963.
Country Garden – large stylised blue flowers, edged in green with smaller flowers in green, pink and blue. [JT] 1968-1978.
Diagonal – op-art design in brown and black forming triangles, difficult in production and presumably withdrawn from stock. [NW] 1964.
Eden – transfer design of 'collage' fruit motifs with 'mis-registered' black key line. [NW] 1966.
English Garden – screen-printed transfer floral in blue, grey and green, border pattern on flatware. [JT] 1967.
Everglade – a transfer-printed design of flowers in black and white on a mustard and blue background. [JT] 1964.
Evesham – border pattern of fruits and leaves in naturalistic colours, gold line to edge. [JR] 1962 (8000).
Flamingo – Eastern feathery motif in orange and blue, available until April 1972, [EM].
Focus – op-art pattern of circles in squares in grey, brown and black. A bestselling pattern. [BB] 1964.
Gold Alpine – as *Blue Alpine* but yellow and orange flowers. Lids and saucers light sage-green. [JT] Withdrawn 1970.
Golden Leaves – narrow bands of leaves on stem. [DQ] 1962.
Graphic – a transfer print border pattern of black lines with matt black saucers, lids etc. [JT] 1964.
Green Frieze – no information. 1962.
Jacobean Blue – narrow geometric border with central and border floral motifs in blue, green, pink and yellow. Adapted from an earlier pattern called *Windsor*. 1963.
Jacobean Brown – as blue version with outlines in brown. 1963.
Jasmine – green panels with stylised floral in yellow, orange, green and white. [JT] c.1968-1974.
King Cup – design in taupe and grey with yellow and pink flowers and grey leaves, gold line to edge. 1962.
Kismet – border pattern of onion shaped motifs in brown, blue, orange and mustard. [JB] 1968-1974.
– Bengal – as *Kismet* but in blue, purple, green and mustard. 1968-1970.
Lakeland – a transfer print floral in turquoise and dark olive resembling cut out paper shapes. Saucers and lids turquoise. [JT] 1968.
Lynton – transfer motif in olive and brown. [JR] 1969.
Madeira – border pattern of geometric patterns in blues and purples in black squares, pattern appears all over holloware. [NJ] 1965-1974.
Mayfield – adapted from *Classic* shape pattern pink, white, yellow, green and grey floral with gold leaves.
Meadow – central floral transfer with beige band to edge. 1962.

Mediterranean – border pattern of abstracted 'paisley' shapes in green, blue and black. (First promoted on a 'new' shape that was never put into production, presumably a version of MQ2),1966.

Mexicana – hand-painted vertical stripes in olive, rust, mustard and grey interspersed with thin black lines. Also printed on later pieces. [JT] 1966.

Michaelmas – a transfer print of white flowers with orange centres against a brown background to form a border. [JT] c.1970-1974.

– **Nordic** – stylised floral motif in blue alternates with a geometric pattern in brown to form stripes on flatware and all-over pattern on holloware. [JT].

Chevron – as *Nordic* but tan and black motifs. [JT] 1969.

Oakley – pattern of ochre stripes with rows of grey, brown and mustard dots. Produced exclusively for Boots. Stylist tableware. [JT].

Olympus – laurel leaf pattern forming a band of decoration in gold with gold banding. [DQ] 1962.

Paisley – a traditional paisley motif in bright colours forms a border on flatware and an all-over pattern on holloware. Also foundon Meakin's Studio shape, [JT].

Palmyra – border of engravings in panels featuring leaves and flowers, gold line to edge. [DQ] 1963.

Park Lane – all-over floral similar to *Springtime*. [JT].

Persia – all-over paisley-style pattern in earthy colours, border pattern on flatware. [JT] 1966.

Piccadilly – as *Broadway* but in red and black with grey lines. Stylist tableware. 1968.

Queensberry – stripes in varying widths in olive, grey and black, a very successful pattern. [DQ] 1962-1978.

Reverie – stylised floral in mustard and blues.

Romany – floral in a 'bargeware' style in shades of blue, blue line to edge. [JR].

Roselle – floral border pattern in blues and greens alternating upright and inverted motifs with lids and saucers royal blue, (later white with fine lines in blue and green). [EM] 1968.

Shetland – a design with squares in orange and brown overprinted with a 'tweedy' texture in brown. [JT] 1969.

Sienna – a transfer print of stripes in green and orange with overlaid black lines. One of the most popular *Fine* designs. [JT] 1962-1978.

Sorrento – no information.

Spanish Garden – a transfer print of stylised leaves in greens and blues. The best selling *Fine* pattern. [JT] c.1968-1982+.

Springtime – transfer pattern first used as *April Flowers* on the *MQ2* shape and adapted as an all-over pattern for *Fine*. Withdrawn 1974.

Summerday – orange and yellow version of *Country Garden*. [JT] 1968.

Sunglow – a transfer-printed floral of alternating orange and brown flowers with alternating centre colours. Lids and saucers are mustard. [JT] 1968.

Tango – bold stylised floral in orange, yellow and olive. [EM] c.1969-1974.

Tempo – studio transfer by Johnson Matthey. Border pattern of olive and turquoise circles in grey oblongs. Holloware has vertical stripes of the pattern. 1964.

Valencia – stylised floral motif forms central 'star-shaped' motif and border, ironstone. [JT].

Viking – no information. [JC] 1963.

Whitehill – a hand-painted border pattern in two shades of green overlaid with lithographic transfer of radiating white lines. [JT] 1962.

Un-named – turquoise, brown and green 'tadpole' shapes.

Wilkinson tableware – (1964+)

Avila – border pattern of stylised floral motifs alternating in green and brown.

Rural England – traditional engraving in brown, blue, green or red of rural scenes with floral border. Also on *Classic* shape.

Trend/Fluted Shapes – (1966+)

Mainly found with white gloss holloware and matt black lids and saucers, although other colours have been noted.

Arethusa – black and white engraving with matt black finish on 'fluting'. Used on fancy items. [TT].
Sherwood – geometric pattern in blue, green and black with green glazed holloware. [JT].

MQ2 Shape – (1966+)

April Flowers – as *September Song* but in greens and blues. [JT] 1967.
Columbine – panels in shades of blue with alternating floral spray of harebells and forget me nots. [JT] 1967.
Pierrot – abstract motifs in blue form border and central 'tadpole' motif. [NW] 1967.
September Song – border pattern of floral motifs in yellow, orange, gold and brown. [JT] 1967.
Banding – banded patterns are known.

Portobello Shape – (1967+)

Conifer – brown and green glaze. 1966/70.
Countryside – transfer pattern of seeds and leaves in shades of brown. [JR] 1966-1972.
Maple – warm golden brown glaze finish. 1966/70.
Meadowsweet – stylised transfer motif of cow parsley and philadelphus. 1967.
October – transfer pattern of seeds and sunflower head in green, brown and yellow. 1966/70.
Roselane – transfer pattern of flowers and leaves in browns with yellow leaves. 1967.
Sunflower – transfer print. [JR] 1966/70.

Stonehenge Shape – (1972+)

This range was produced with three distinct finishes, indicated in brackets after the pattern name:
[1]. Glossy cream with flecks in brown forming an 'oatmeal' finish originally called *Stella* and later *Creation*. The edges have a brown, texture created with iron oxide.
[2]. Matt coloured glazes. Maize: pale cream 1972-1975; sage: pale blue green 1972-1975; cocoa: dark brown 1972-1975; nutmeg: deep orange 1972-1975; and cinammon: pale orange 1972-1982. Olive, mustard, honey and dark beige are also known.
[3]. Glossy white glaze. (White *Stonehenge)* [export]. 1972-1983+.

Autumn [1] – red poppies and olive green seed heads. [EM] 1974-1982.
Aztec [3] – geometric border pattern in blue, green, pink and purple.
Blue Dahlia [2 sage] – large blue flower motif with blue circles between bands of blue on rim. [JT] 1972-1975.
Bluebells [2] – stylised floral in blue and brown with dark beige holloware. [JT] 1972-1974.
Blue Palm – stylised all over leaf pattern in blue. [JT] 1972-1974.
Cafe au lait – glaze colour. Withdrawn 1978.
Caprice [2 sage] – stylised floral similar to *Spanish Garden*, leaves and flowers in blue, purple and greens. [JT] 1972.
Country Blue [1 with blue edge] – basket of fruit with repeat border. [Export].
Country Brown [1] – variation of *Country Blue*. Withdrawn 1982.
Creation [1] – this plain version was used in mix and match patterns but was also popular in its own right as a design. [EM] 1973-1983+.
Crocus [3] – yellow and orange border pattern of crocus sprays. [AA].
Desert Flowers [2 honey] – stylised floral central motif on plates with smaller flowers surrounding in orange and olive, leaves in glossy brown. Lids have single motif, other items are plain cocoa. [JT] 1972.

Earth [1] – central cream circle with graded brown bands, cups have vertical bands and saucers are plain. [EM] 1973-1982.

Ermine – no information. Withdrawn 1982.

Fiesta – no information. [JT] 1973.

Fleur – daisy motif with green band to edge.

Flowersong [2 maize] – stylised daisy in yellow and orange with petal detail in black. Plates and lids have pattern, saucers have a brown band to rim, other items are matt mustard. [JT] 1972-1976.

Fresco [2 maize] – plates have a central floral motif in cinnamon and olive surrounded with hearts and flowers. There is a green line to inner rim. Other colour details not known. [JT] 1972-1974.

Good Morning – pastel coloured lettering spelling out Good Morning scattered on the ware.

Green Leaves [1] – leaves on branches in shades of green. [EM] 1974-1983+.

Hazelwood [1] – six-petalled floral motif in cinnamon and green with tapestry effect border. All items have pattern. [JT] 1973-1976.

Inca – banded pattern with plait design.

Invitation [Cookware] – pink carnation with leaves as *Stonehenge* tableware. [EM].

Invitation [3 with green edge] – pink carnation with leaves. [EM] 1974-1982+.

Maize – new export for 1982.

Medallion [2 maize] – large floral motif in brown with border of brown circles between bands of brown on rim. [JT] 1972-1975

Mood Indigo [export] – simple banded pattern in blue, withdrawn 1983.

Moon [1] – concentric circles in shades of blue and black. Saucers are plain. [EM] 1973-1982.

Nasturtium [1] – stylised floral study in orange, yellow and red with brown detail and olive leaves. Thought to have been withdrawn because of cadmium used in some colours but matchings were still available. Jessie Tait's last design for Midwinter. [JT] 1974-82.

Night [2] – lines in blues and grey with stylised sun motif resembling a horizon view. [EM] Withdrawn 1979.

Day [2] – version of *Night* in red, orange and brown. [EM] Withdrawn 1979.

Penny Lane [3 maize] – sprays of wild flowers in yellow, pink and blue with an orange brown band to edge. [PS] 1982+.

Primula [1] – yellow primulas with olive leaves, holloware has a flower bud and leaves. [EM] Withdrawn 1980.

Rangoon [1] – bamboo canes with hand-painted yellow stroke and with leaves in shades of green. Saucers are plain. [EM] 1974-1983+.

Ratatouille [Cookware] – prints in brown of still life studies.

Riverside [1] – a study of leaves, flowers and grasses in pink, yellow, brown, blue and greens. [EM] Withdrawn 1983.

Seascape [1] – printed pattern of shells in brown, brown line to edge.

Shady Lane [1] – flowers, seed heads and grasses printed in resist through a brown wash. [EM].

Solitaire [1] – seedhead in Chinese style with orange detail, withdrawn 1982.

Spring [export] – withdrawn 1983.

Spring Blue [1] – floral study in blue with daisies and grasses, (and a butterfly on larger pieces). [EM] 1974.

Still Life [Cookware] – realistic studies of fruits and vegetables. Motifs vary from piece to piece.

Still Life [?] – pattern of fruits and flowers with olive leaves. A different illustration was used on the different items. [CL] 1982+.

Strawberry [1] – study of strawberries, yellow and white flowers and green leaves. [EM] Withdrawn 1980.

Summer [1] – floral motif in orange, beige and brown. [EM] Withdrawn 1980.

Summerset [2] – stylised floral in gold and brown with cocoa holloware. [JT] 1972-1974.

Sun [1] – concentric circles in orange, yellow and brown. Saucers are plain. Terrifically popular design still in production in 1983. [EM] [export] 1973-1983+.

Wessex – no information.

Wild Cherry [3] – sketch of brown leaves, branches and fruit. [EM]. Withdrawn 1982.

Wild Oats [1] – transfer-printed grasses in brown. [EM] 1974-1983+.

Wild Orchid [1] – with pale flecks and grey-green edge. Stylised floral border in mauve, lilac, yellow and peach.
Winter [1] – embossed flowers on self-coloured background with brown line to edge. [EM] 1974-1979.
Woodland [2 beige] – eight-sided floral and leaf motifs in orange with brown and olive detail, all items have pattern. [JT] 1972.

Un-named [3] – stylised flowers in blue and lilac.
Un-named [3] – large floral motif in red-brown with mid-brown centre.

Stoneware Shape – marketed as Stoneworks in the US (1972+)

Blueprint – simple floral border in blue.
Brownstone – no information.
Denim – blue textured finish. Glazed.
Hopsack – textured finish to body.
Natural – two-tone finish. Glazed cream and unglazed beige body.
Orbit – blue and purple rainbow pattern.
Petal – simple floral border in brown.
Provence – diamond pattern forms border.

Beige Mist, Blue Mist, Black ice, Coral Mist, Rose Quartz, Coral Sand, Marin – glaze colour patterns with un-glazed edge.
Blackstone, Bluestone, Tealstone, Blue Lapis – glaze colour patterns with un-glazed edge.

Style Shape – (1983+)

Calypso – vertical lines with petals and buds in pinks and yellows and leaf details in grey, cover the ware.
Cameo – floral transfer in pastel colours with 'confetti' glaze finish.
Carnival – streamers in blue, green, orange and purple unfurl over the ware.
Chromatics-blue – transfer bands of colour at 45 degrees in blues graduate across the ware.
Chromatics-brown – transfer bands of colour at 45 degrees in brown graduate to pink across the ware.
– *Chromatics variant* – transfer prints of animals were used on this range, probably open stock.
Confetti – speckled glaze finish in pastel colours.
Coral Mist – simple banding with graduated pink detail.
Crystal – oakleaf design in white and grey.
White – clear glazed body.

Reflex Shape – (c.1986+)

Patterns on this shape at the time of the factory's closure.

Avignon, Monmartre, Versailles, Venice – textured band with colour to edge.
Blue Crosses – border pattern with crosses and blue band to edge.
Enchantment, Rhapsody, Symphony, Blaze – stylised floral transfer.
Duet
Nocturne
Orbit
Quatro
Tempo
White
Lichfield

Midwinter Shape Guide

These entries are taken from the shape booklets used by the Midwinter factory staff. Two copies remain and this is the compilation of those two books. Small drawings were entered next to each shape - some of these have been lost. Notes in brackets are original and an x refers to a shape that was deleted. Due to shrinkage in the clay body and the length of time some pieces were in production, sizes of items can vary a great deal.

Stylecraft catalogue listing

Basic items (sizes are approximate)

SC1	Plate 10"
SC2	Plate 9"
SC3	Plate 8"
SC4	Plate 6"
SC5/L	Tea cup low
SC5/T	Tea cup tall
SC6	Tea saucer
SC7	Breakfast cup
SC8	Breakfast saucer
SC9A/D	Coffee cup
SC10A/D	Coffee saucer
SC11	Covered sugar (two handles)
SC12	Open sugar bowl
SC13	Cream jug
SC14/4	Fruit 4" (5¼" actual)
SC14/5	Fruit 5" (6⅛" actual)
SC15	Oatmeal bowl 6"
SC16	Coupe soup 7½"
SC17	Lug soup 6"
SC18	Cress dish (no.16 pierced)
SC19	Open vegetable or fruit bowl
SC20	Covered vegetable bowl
SC21	Covered casserole/veg dish
SC22	Individual casserole
SC23	Gravy boat
SC24	Gravy boat stand (biscuit plate)
SC25	Baker 7"
SC26/L	Meat plate large 16"x 12½"
SC26/M	Meat plate medium 14"x 11"
SC26/S	Meat plate small 12"x 9½"
SC27	Service plate
SC28	Chop plate 12"
SC29	Coffee pot 2½ pt
SC30	Coffee pot 1½ pt (hot water pot)
SC31/L	Teapot Large (40)
SC31/M	Teapot medium (30)
SC31/S	Teapot small
SC31/E	Teapot early morning (15)
SC32	Handled mug (low)
SC33	Covered butter dish 7"x 5¾"
SC34	Single eggcup
SC35	Double eggcup

SC36	Salt
SC37	Pepper
SC38	Mustard
SC39	Cruet tray (eggcup stand)
SC40	Covered jam
SC41	Divided baker 9"
SC42	Divided baker with cover
SC42	New item - cheese dish
SC43/L	Milk jug large
SC43/M	Milk jug medium
SC43/S	Milk jug small
SC44	Individual sugar bowl
SC45	Individual cream
SC46	Handled beaker (tall)
SC47	Ice jug
SC48	Tankard 1pint
SC49	Tankard ½ pint

SC50	TV cup and tray 9"x 6¾"
SC51/3	Toast rack 3 bar
SC51/5	Toast rack 5 bar (brass fitting)
SC51/7	Toast rack 7 bar (brass fitting)
SC52	Sandwich tray with lugs 10"x 6¾"

Stylecraft Hotelware

Basic items (sizes are approximate)

HW1	Plate 10"
HW2	Plate 9"
HW3	Plate 8"
HW4	Plate 6"
HW5/L	Tea cup low
HW5/T	Tea cup tall
HW6	Tea saucer
HW9	Coffee cup 3½oz
HW10	Coffee saucer
HW12/S	Open sugar bowl small
HW12/M	Open sugar bowl medium
HW12.L	Open sugar bowl large
HW13/L	Cream jug large
HW13/S	Cream jug small
HW13/DL	Individual cream
HW14/5	Fruit 5"
HW15	Oatmeal bowl 6"
HW16	Coupe soup 7½"
HW25/L	Divided baker large size
HW25/S	Divided baker small size
HW30	Coffee pot large (30)
HW30	Coffee pot small (20)

Stylecraft

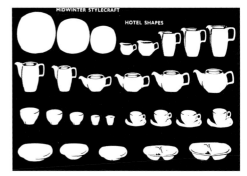

Hotelware

HW31/L	Teapot large
HW31/M	Teapot medium
HW31/S	Teapot small
HW31/E	Teapot early morning
HW34	Single eggcup
HW43/L	Milk jug large
HW43/M	Milk jug medium
HW43/S	Milk jug small

Fashion catalogue listing

Basic items (sizes are approximate)

F1	Plate 10"
F2	Plate 9"
F3	Plate 8"
F4	Plate 6"
F5/L	Tea cup low
F5/T	Tea cup tall
F6	Tea saucer
F7	Breakfast cup
F8	Breakfast saucer
F9	Coffee cup
F10	Coffee saucer
F11	Covered sugar
F12	Open sugar bowl
F13	Cream jug
F14	Fruit saucer
F15	Oatmeal bowl
F16	Coupe soup
F17	Lug soup [disc. c.1960]
F18	Cress dish (no.16 pierced)
F19	Open vegetable or fruit bowl
F20	no entry
F21	Covered vegetable bowl
F22	Bread and butter plate
F22/P	Bread and butter plate with chrome foot
F23	Sauce boat
F23/A	Sauce boat ladle
F24	Sauce boat stand
F25	no entry
F26/L	Meat plate large
F26/M	Meat plate medium
F26/S	Meat plate small
F27	Service plate
F28	Chop plate
F29	Coffee pot 2½ pt
F30	Coffee pot 1½ pt
F31/L	Teapot large (40)
F31/M	Teapot medium (30)
F31/S	Teapot small
F31/E	Teapot early morning (15)
F32	Handled mug (low)

F33	Covered butter dish
F34	Single eggcup
F35	Double eggcup
F36	Salt
F37	Pepper
F38	Mustard
F39	Cruet tray
F40	Covered jam
F41	Individual covered sugar
F42	Pickle
F43/L	Milk jug large
F43/M	Milk jug medium
F43/S	Milk jug small
F43/E	Milk jug early morning (disc. c.1960)
F44	Individual sugar bowl
F45	Individual cream
F46	Handled beaker (tall)
F47-9	no entry
F50	TV cup and tray
F51	Cream soup cup
F52	Cream soup stand
F53	Covered hot milk 1½ pint
F54	Mint boat [disc. c.1960]
F54/A	Mint boat ladle [disc. c.1960]

Fashion

F54/B	Mint boat stand
F55/L	Salad bowl large [disc. c.1960]
F55/S	Salad bowl small [disc. c.1960]
F56	Triangular bowl deep
F57	Triangular bowl shallow
F58	Long Tom buffet tray also cheese dish
F59	Pottery salad servers
F60	Celery nest 4-prong
F61/L	Boomerang tray large
F61/S	Boomerang tray small
F62	Tall salt
F63	Tall pepper
F64	Tray square

F65	Tray oval
F66	Covered relish
F67	Vinegar bottle
F68	Soup tureen
F69	Cream soup (see 51 and 52)
F70	Large butter pad

Fancy Shapes

Some of these shapes are traditional and were in production from the 1940s through to the 1960s. Some numbers are overwritten so a *Fashion* item would be replaced with a *Classic* or *Fine* if made obsolete or withdrawn from the range.

F174	Bison	Melbourne
F176	Cat lying	Melbourne
F177	Cat sitting	Melbourne
F179	Bear large	Melbourne
F180	Seal	Melbourne
F181	Ferret large	Melbourne
F182	Cat sitting small	Melbourne
F183	Cat lying small	Melbourne
F184	Seal small	Melbourne
F185	Bison small	Melbourne
F186	Cat standing	Melbourne [Humpy]
F187	Rhinocerous	Melbourne
F188	Small bear	Melbourne
F189	Crocodile	Melbourne
F190	Iguanodon	Melbourne
F191	Stegosaurus	Melbourne
F192	Brontosaurus	Melbourne
F194	Giraffe head down	Melbourne
F195	Giraffe head up	Melbourne
F196	Panther	Melbourne
F197	Giraffe large	Melbourne
F200	no entry	
F201	Water flask h.11"	JT design
F202	Beaker	JT design
F203	Vase	JT design
F204	Vase	JT design
F205	Vase h.10¾"	JT design
F206	Vase	JT design
F207	Candlestick tall	JT design
F208	Candlestick small	JT design
F209	Vase	JT design
F210	Vase	JT design
F211	Vase	Melbourne style
F212	African man	Melbourne
F213	African woman	Melbourne
F214/L	Umbrella tray - new line	
F214/M	Umbrella tray - new line	
F214/S	Umbrella tray - new line	

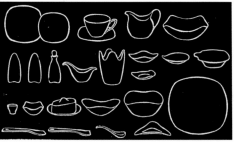

Fashion

F215 Toast rack 4 bars plus brass fitting (5)
F216 Buffet set with cup 12" wide
F216/A Buffet tray only, no recess for cup
F217 Hors d'oeuvres set metal stand with 3 dishes
F217/A Hors d'oeuvres dish only
F218 obsolete
F219 Cruet dome shape clover base chrome handle
F220 obsolete
F221 Mitre cruet chrome fittings
F222 Cylinder cruet wire frame
F223 Twin jam listed obsolete
F224 Hors d'oeuvres dish s/sided [no ears]
F225 Toast rack Chrome fitting
F226 Long Tom buffet tray see also no.F58
F227 3 compartment tray
F228 5 compartment tray
F229 Celery jar 1 prong listed obsolete
F230 Butter base chrome lid Fine/Classic
F231 4 eggcups on Stylecraft base, chrome handle
F232 obsolete
F233 obsolete
234 Figure Melbourne style semi abstract
235 Small 3-compartment tray
F235/P Small 3-compartment tray with handle
F236 obsolete
F237 Celery vase 2-prong listed obsolete
F238 Round cake plate
F239 Cake slice
F240 Candy box and lid
F241 New English tray small footed oblong
F242 obsolete
F243 New TV tray saucer - square or round well
F243/A TV tray, no recess

F244 Ash tray square upturned sides on oblong base
F245 Salad servers, wooden fittings, ceramic handles
F246 Large bowl w.14",h.2³/₄", foot 8", traditional
F247 Ash bowl 1, 2 and 3 indents for cigarettes
F248 Supper tray with fitting, Fine follows Fashion
F249 Sugar and Cream stand Fashion chrome fiting
F250 Candlestick tapered shape
F251 Contemporary tray knop handle
F252 Contemporary tray knop handle
F253 Contemporary tray knop handle
F254 Vase ovoid
F255 Vase tapered neck
F256 Vase classical shape
F257 Contemporary bowl assymetric
F258 Small square tray overturned top
F259 Triangular tray overturned detail on top
F260 Large oblong tray overturned top
F261 Triangular tray with sacking effect
F262 Oval tray with sacking
F263 Hors d'oeuvres dish overturned sides
F264 Honey pot tapering sides
F265 Soup bowl undulating top, lug handle
F266 Vase flared middle small neck
F267 Vase waisted neck
F268 Cylinder vase
F269 Large vase wide middle flared neck
F270 Large vase faceted sides flared foot
F271 Oval tray with sacking
F272 Square tray with sacking
F273 Small leaf [old fashioned type]
F274 Marigold honeypot relief floral decoration
F275 Divided tray with two indents [see 304 same]
F276 Vase small foot wide middle
F277 Vase flared foot wide shoulders flared neck
F278 Fashion tray square now fluted [see 315]
F279 New biscuit barrel pottery lid
F280 New dripstand (tea strain base)
F281 Butter ring with pottery base s/sided knop
F282 Honey barrel with pottery lid s/sided
F282/A Old dripstand for Boots The Chemist
F283 no entry

F284 no entry
F285 no entry
F286 Small triangular tray 3 to make triple set
F287 Large oblong tray wire stand, two side handles
F288 Biscuit barrel
F288 Three-sided low bowl Mosaic Fashion item
F289 Tall honey pot Fine shape
F289 Celery nest Mosaic item
F290 Low honey pot Fine
F291 Jam dish Fine
F292 Egg set tray Fine
F293 Large tray Fine
F294 Small tray Fine
F295 Lighter base Fine fancy item
F296 no entry
F297 no entry
F298 no entry
F299 Honey pot [Classic?]
F300 Large square Fashion tray with fitting x
F301 Large leaf tray as 273
F302 Sugar dredger trad shape h.7¹/₄" w.2"
F303 Cylinder vase h.6¹/₂" w.4"
F304 Divided tray oblong
F305 Three-compartment tray
F306 Mitre honey trad shape two handles
F307 Mitre biscuit
F308 Mitre salad
F309 Mitre dredger
F310 Bread dish h.3" w.12"
F311 Rim soup Classic
F311/L Rim soup large Classic
F312 Boat - fast stand
F313 Cruet tray [sic]
F314 Lamp stand Classical h.11¹/₂"
F315 Large square tray fluted w.5¹/₂"
F316 Large round tray fluted w.6¹/₂"
F317 Square tray 4¹/₄" square
F318 Biscuit barrel with cover h.4¹/₂" w.4¹/₄"
F319 New tankard pewter glaze traditional
F320 Pie-funnel blackbird
F1005 Honey barrel chrome lid s/sided
F1008 Round sweet large traditional shape
F1009 Large sweet, with chrome handle and spoon
F1010 Oval sweet large trad
F1011 Round sweet small traditional
F1012 Square sweet traditional
F1013 Oval sweet traditional
F1029 Large bowl and handle traditional

F1047	Triple tray	
F1047/P	Triple tray fashion handle clover shaped	
F2014	Large oblong tray Chrome centre handle	
F2019	Bowl traditional	
F2021	Squared oval dish centre handle chrome, traditional	
F2024	Three-compartment dish traditional	
F2025/L	Square bowl rounded corners large	
F2025/M	Square bowl rounded corners medium	
F2025/S	Square bowl rounded corners small	

Classic catalogue listing

Basic items (sizes are approximate)

C1	Plate 8"
C2	Plate 7"
C3	Plate 6"
C4	Plate 4$\frac{1}{2}$"
C5	Tea cup low-tall
C6	Tea saucer
C7	Breakfast cup
C8	Breakfast saucer
C9	Coffee cup
C10	Coffee saucer
C11	Covered sugar
C12	Open sugar bowl
C13	Cream jug
C14	Fruit 4"
C14/5	Fruit 5" (6$\frac{1}{8}$")
C15	Oatmeal bowl
C16	Coupe soup
C17	no entry
C18	no entry
C19	Open vegetable or fruit bowl
C20	Covered vegetable bowl
C21	Covered casserole/veg dish
C22	Bread and butter plate
C23	Gravy boat
C24	Gravy boat stand
C25	no entry
C26/L	Meat plate large
C26/M	Meat plate medium
C27	no entry
C28	no entry
C29	Coffee pot 2$\frac{1}{2}$ pt
C30	Coffee pot 1$\frac{1}{2}$ pt
C31/L	Teapot large
C31/M	Teapot medium
C31/S	Teapot small
C31/E	Teapot early morning
C32-40	no entry
C41	Individual covered sugar
C42	no entry
C43/L	Milk jug large
C43/M	Milk jug medium
C43/S	Milk jug small
C44	Individual sugar bowl
C45	Individual cream
C46	Handled beaker
C47-50	no entry
C51	Cream soup
C52	Cream soup stand

Fine catalogue listing

Basic items (sizes are approximate)

FN1	Plate 10$\frac{1}{2}$"
FN2	Plate 7"
FN3	Plate 6"
FN4	Plate 5"
FN5	Tea cup 8$\frac{1}{2}$oz
FN6	Tea saucer
FN7	Breakfast cup 10$\frac{1}{2}$oz
FN8	Breakfast saucer
FN9	Coffee cup 5oz
FN10	Coffee saucer
FN11	Covered sugar 12oz
FN12	Open sugar bowl 12oz
FN13	Cream jug 12oz
FN14	Fruit saucer 5$\frac{3}{4}$"
FN15	Oatmeal bowl 6$\frac{3}{8}$"
FN16	Coupe soup 7$\frac{1}{4}$"
FN17	no entry
FN18	no entry
FN19	Open vegetable or fruit bowl
FN20	no entry
FN21	Covered vegetable dish
FN22	Bread and butter plate 9"
FN23	Gravy boat
FN24	Gravy boat stand 8"
FN25	
FN26/L	Meat plate 16"x 12$\frac{1}{2}$"
FN26/M	Meat plate 14"x 11"
FN26/S	Meat plate 12"x 9$\frac{1}{2}$"
FN27-8	no entry
FN29/L	Coffee pot 60oz
FN30/S	Coffee pot 40oz
FN31/L	Teapot 40oz
FN31/M	Teapot 30oz
FN31/S	Teapot 15oz
FN32-35	no entry
FN36	Salt
FN37	Pepper
FN38	Mustard
FN39-42	no entry
FN43	Milk jug
FN44	Individual sugar bowl

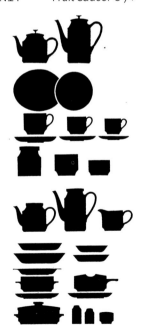

Fine

Trend

Portobello

FN45 Individual cream
FN46-50 no entry
FN51 Cream soup
FN52 Cream soup stand 6³/₈"
FN248 Sandwich tray 12"x 6½"
FN311 Rimmed soup plate 9"

Trend catalogue listing
Basic items (sizes are approximate)
T1 Plate 10"
T2 Plate 9" (not made)
T3 Plate 8"
T4 Plate 6"
T5 Tea cup
T6 Tea saucer
T11 Covered sugar or preserve
T12 Open sugar bowl
T13 Cream jug
T15 Oatmeal bowl
T23 Gravy boat
T24 Gravy boat stand
T28 Chop dish
T29 Coffee pot
T31(i) Large teapot
T31(ii) Small teapot
T32 Handled mug
T34 Eggcup
T35 Double eggcup
T36 Salt
T37 Pepper
T41 Individual covered sugar bowl
T42 Pickle
T43 Milk jug
T46 Beaker
T74 Onion soup
T400 Oval dish small
T401 Oval dish large
T402 Casserole small
T403 Casserole medium
T404 Casserole large
T405 Round bowl small
T406 Round bowl medium
T407 Round bowl large

Fluted catalogue listing
Basic items (sizes are approximate)
T1 Vase large
T2 Vase medium
T3 Vase small
T4 Fruit bowl
T5 Tart plate
T6 Large jar and lid (biscuit barrel)
T7 Tall jar and lid

MQ2

T8 Jar medium (low box)
T9 Jar small (cigarette box)
T10 Salt
T11 Pepper
T12 Mustard
T13 Lighter base
T14 Ashtray large
T15 Ashtray small

'New shapes' catalogue listing
Basic items (sizes are approximate)
T1P New vase round small
T2P New vase round large
T3P New vase square large
T4P New vase square small
T5P New vase oblong
T6P New vase triangular large
T7P New vase triangular small

Portobello catalogue listing
Basic items (sizes are approximate)
P1 Meat plate 14"
P2 Meat plate 12"
P3 Plate 10½"
P4 Plate 9"
P5 Plate 7"
P6 Tea cup and saucer
P7 Tea sugar
P8 Covered sugar
P9 Tea cream jug
P10 Coffee pot

P11 Tea pot large
P12 Open scollop
P13 Oatmeal
P14 Cream soup and stand
P15 Gravy boat and stand
P16 Covered vegetable dish
P17 Beaker

MQ2 catalogue listing
Basic items (sizes are approximate)
M1 Meat plate 13½"
M2 Meat plate 11"
M3 Plate 10"
M4 Plate 9"
M5 Plate 7"
M6 Tea cup and saucer
M7 Coffee cup and saucer
M8 Milk jug 1½ pint
M9 Tea cream jug 10oz.
M10 Coffee cream jug 8oz.
M11 Covered tea sugar 10oz.
M12 Open tea sugar 10oz.
M13 Covered coffee sugar 8oz.
M14 Open coffee sugar 8oz.
M15 Tea pot 2 pint
M16 Tea pot ³/₄ pint
M17 Coffee pot 2 pint
M18 Open scollop or fruit bowl
M19 Coupe soup bowl
M20 Oatmeal
M21 Fruit
M22 Gravy boat and stand
M23 Covered vegetable bowl
M24 Salt pot
M25 Pepper pot

Stonehenge catalogue listing
Basic items (sizes are approximate)
SH1 Oval plate 13½"
SH2 Oval plate 12"
SH3 Plate (dinner) 10½" (26.5cm)
SH4 Plate (sandwich) 9" (22.5cm)
SH5 Plate (side) 7" (17.5cm)
SH6 Teapot 2 pint
SH7 Coffee pot 2 pint

Stonehenge

SH8	Milk jug 1½ pint
SH9	Cream jug or small sauce boat 14oz.
SH10	Covered sugar or jam pot
SH11	Tea or coffee cup and saucer 8oz.
SH12	Mug 14oz
SH13	Fruit dish 6"
SH14	Oatmeal bowl 6½"
SH15	Cream soup and stand
SH16	Open serving bowl 9"
SH17	Gravy boat and stand ¾ pint
SH18	Covered casserole 3½ pint
SH19	Salt and pepper pot
SH20	Eggcup or mustard pot

Additional items

SH21	Round plate 30.5cm
SH22	Cake plate 30cm
SH23	Plate (salad) 19.5cm
SH24	Sandwich tray 33.5x21cms
SH25	Sandwich tray 32cm
SH26	Salad bowl 24cm
SH27	Angled fruit bowl 14cm
SH28	Angled cereal bowl 16.5 cm
SH29	Angled coupe bowl 19 cm
SH30	Straight fruit bowl 11.5cm
SH31	Straight cereal bowl 14 cm
SH32	Open casserole 18 cm
SH33	Open casserole 20 cm
SH34	Open sugar (tea)
SH35	Open sugar (coffee)
SH36	Breakfast cup and saucer 0.24 litre
SH37	Continental cup and saucer 0.08 litre
SH38	Tureen and lid 2.85 litre
SH39	Covered sugar (coffee)
SH40	Oblong butter dish and lid
SH41	Round butter dish and lid
SH42	Butter pad
SH43	Tea warmer

Oven-to-Tableware accessories

Basic items (sizes are approximate)

OT1	Avocado dish
OT2	Corn-on-the-cob dish
OT3	Flan dish 12"
OT4	Flan dish 9 ½"
OT5	Flour shaker
OT6	Grapefruit bowl
OT7	Orange squeezer
OT8	Oil and Vinegar set on stand
OT9	Ramekin
OT10	Souffle 7½"
OT11	Souffle 6¾"
OT12	Sole dish oval

OT13	Storage jar
OT14	Crescent salad
OT15	Additional items
OT16	Party plate 19½"x12½"
OT17	Round covered casserole (fluted)
OT18	Oval covered casserole 5 pint (fluted)
OT19	Rectangular flan 9½"x5¼" (fluted)
OT20	Rectangular flan 10"x8" (fluted)
OT21	Oval flans (fluted) 34, 29 and 23cms
OT22	Round flans (fluted) 30, 24 and 20cms
OT23	Soup bowl 15oz
OT24	Ramekin (fluted)
OT25	Round eared dishes 21, 19 and 16 cm
OT26	Oval eared dishes 28x15cm, 24x13cm, 23x12cm
OT27	Covered pâté dish
OT28	Souffles (fluted)) 20, 18, 15 cm
OT29	Napkin ring

Stoneware catalogue listing

Basic items (sizes are approximate)

SW1	Plate 10¼"
SW2	Plate 8¾"
SW3	Plate 8"
SW4	Plate 7"
SW5	Fruit dish 5"
SW6	Cereal bowl 5¾"
SW7	Soup 8¾"
SW8	Teacup and saucer
SW9	Coffee cup and saucer
SW10	AD coffee cup and saucer
SW11	Oval meat plate 12"
SW12	Oval meat plate 14"
SW13	Round dish 12"
SW14	Open vegetable dish 21.5cm
SW15	Covered casserole 1.7 litre
SW16	Sauce boat
SW17	Sauce boat or soup stand
SW18	Soup cup
SW19	Salt/pepper 3-hole
SW20	Salt/pepper 5-hole
SW21	Eggcup/open mustard
SW22	Teapot
SW23	Coffee pot
SW24	Covered sugar
SW25	Open sugar
SW26	Cream jug 0.38 litre
SW27	Jug 1 litre
SW28	Sandwich tray 20cms
SW29	Mug

Style

Style catalogue listing

Basic items (sizes are approximate)

ST1	Oval meat plate 31cm
ST2	Plate 27cm
ST3	Plate 23cm
ST4	Plate 20cm
ST5	Plate 18cm
ST6	Cream soup and oval stand
ST7	Soup dish 22cm
ST8	Teacup and saucer 0.2 litre
ST9	Coffee can and saucer 0.08 litre
ST10	Beaker 0.3 litre
ST11	Gravy boat and oval stand
ST12	Beverage dispenser 1.25 litre
ST13	Jug 1 litre
ST14	Spill vase
ST15	Vase large, medium and small
ST16	Continental covered sugar
ST17	Salt/pepper 1-hole
ST18	Salt/pepper 3-hole
ST19	Covered butter tray
ST20	Cereal bowl 17cm
ST21	Covered mustard
ST22	Covered casserole 1.7 and 2.85 litre
ST23	Cream soup and stand round
ST24	Napkin ring
ST25	Egg cup
ST26	Bell
ST27	Teawarmer
ST28	Open casserole 1.7 litre
ST29	Sandwich tray 20cm

Bibliography

British Bulletin of Commerce Part 1, 1954, 'A Brief Account of W.R. Midwinter Ltd'
Eatwell, Ann 'Streamlined Ceramics' *The Antique Dealer and Collectors Guide,* May 1986
Eatwell, Ann taped interview with Roy Midwinter, March 1985
Frances, Hannah *Ceramics, Twentieth Century Design,* E.P. Dutton, 1986
Gift Buyer, The, 1950-65
Ind, Nicholas *Terence Conran, The Authorised Biography,* Sidgwick and Jackson, 1995
Jackson, Lesley *The New Look, Design in the Fifties,* Thames and Hudson, 1991
Niblett, Kathy *Dynamic Design,* The Stoke-on-Trent City Museum, 1990
Peat, Alan *Midwinter, A Collector's Guide,* Cameron and Hollis, 1992
Pottery Gazette, The, 1948 - 1972
Pottery and Glass, 1948 - 1968
Royal Society of Arts Journal, 'Memory Lane', December 1992
Tableware International, 'Midwinter's Ascent', April 1972

Jessie Tait, Steven Jenkins and Eve Midwinter, taking a break during the book launch, 1997.

Backstamps c.1950-1987

c.1950+

1953-5

1954

1955

1955

c.1955

Driftdown

1956

1955

1957

From 1959 with appropriate date

c.1960 onwards

1962 onwards

Late 1960s

1972

1986-7

120